A HORSE IN
THE COUNTRY

Clive Aslet is the award-winning editor of *Country Life*. His most recent book is *The Story of Greenwich*, also published by Fourth Estate. A frequent contributor to newspapers, he writes widely on the changing face of Britain, and often appears on radio and television programmes such as *Newsnight* and *The Moral Maze*. He is married with three young children.

For more information on Clive Aslet visit
www.4thestate.com/cliveaslet

A HORSE IN
THE COUNTRY

A DIARY OF A YEAR IN THE
HEART OF ENGLAND

CLIVE ASLET

FOURTH ESTATE • *London*

This paperback edition first published in 2002
First published in Great Britain in 2001 by
Fourth Estate
A Division of HarperCollins*Publishers*
77–85 Fulham Palace Road
London W6 8JB
www.4thestate.com

10 9 8 7 6 5 4 3 2 1

A catalogue record for this book is available from the British Library

ISBN 1–84115–376–1

Typeset by Palimpsest Book Production Limited,
Polmont, Stirlingshire

Printed in Great Britain by
Clays Ltd, St Ives plc

Contents

SPRING

SUMMER

AUTUMN

EPILOGUE

Preface

This diary of a year in the heart of England ends in winter 2000. Already, in the late spring of 2001, it has come to seem almost nostalgic in recording an era before Britain went mad.

Easter should be a time of the lamb. Lambs jumping in the fields should form the background to country Easter egg hunts. Renaissance painters showed the risen Christ accompanied by by a lamb. Christ had been hailed as the Lamb of God, whose sacrifice would recall the lambs sacrificed by the Children of Israel at Passover. This Easter, alas, the image of the lamb has been perverted by the nightly television pictures of lorryloads of lambs and sheep being dumped into the burial pits dug by the army, as part of our strangely medieval attempt to arrest foot and mouth disease.

On Good Friday, the whole of the front page of the *Daily Mail* was occupied by a photograph of a mud-covered lamb that looked as if a *confiseur* had just dipped it in a vat of chocolate. Media stardom won this lamb – Lucky, as it came to be called – a reprieve but thousands of others died a few days after birth because they could not be moved from their waterlogged fields. The government stopped releasing the numbers for the mostly healthy animals that it designated for slaughter. As I write, the tally is heading for over four million. It could be more.

Published in 1928, Siegfried Sassoon's *Memoirs of a Fox-Hunting Man* evokes the security that the author found in the ritual of the British countryside, before that cosy world was overturned by the First World War. Foot and mouth disease can hardly be compared to the trenches. But to me the year covered by my diary now, quite unexpectedly, represents a time of lost

innocence, before the tarry, acrid stink of the pyres settled on Cumbria, leaving the whole of the countryside with a taste that it has yet to spit out.

Clive Aslet
Geddington
Easter 2001

Acknowledgements

There are many people I must thank for help or tolerance during the year of my diary: my friends and neighbours at Geddington, the Masters of the Pytchley Hunt, Sue Muirhead and her team at Naseby, my colleagues at *Country Life*, and Clive Priddle at 4th Estate. It is particularly heroic of a pregnant wife, never absolutely swept away by a grand passion for the East Midlands, to make a home there. So my love and thanks pour out to Naomi, who has been a more or less willing partner in so many country adventures. This book is for her and the boys.

The Eleanor Cross

On 28 November 1290, Queen Eleanor died at Harby, Nottinghamshire. She was unusual in the annals of royal matrimony in having loved her husband, Edward I. She accompanied him on many of his travels. She went on pilgrimage with him to the Holy Land in 1270, and there is a story that she sucked the poison from a wound made in her husband's arm by an assassin's knife. A more probable account portrays her as having to be dragged from the room, hysterical with grief and fear, when the doctors said they would have to cut out the inflamed flesh. For his part, King Edward loved her in life, and would go on loving her after her death.

Edward had been with her when she died. Afterwards he ordered that Eleanor's body should be taken to Lincoln, embalmed and then carried to London. He himself led the procession as the chief mourner. Leaving Lincoln on 4 December, the progress made by the cortège was slow. It was not until 17 December that she could be buried in Westminster Abbey. You can still see the funerary monument from her tomb in the museum there. Her features are not unlike those of a supermodel, symmetrical and expressionless, with rivulets of golden hair flowing over the pillows. (The king bought 350 gold florins from the merchants of Lucca to gild the effigy.) I like to think that this icon reflects something of the living woman, since contemporaries praised her beauty.

Years before, King Edward had passed through France. There he may have seen the series of crosses between Paris and St-Denis, erected to commemorate the last journey made by the mortal remains of St Louis. King Edward resurrected this idea

as a memorial for his dead wife. At every place that her corpse had rested on the way from Lincoln to Westminster he erected a cross. There were twelve of them altogether, made by different craftsmen to varying degrees of elaboration. In a later century, the Puritans managed to pull down most of them, and only three now survive. Of these, one has been re-erected, one has been over-restored and one is more or less in its original condition. This last is at Geddington, in Northamptonshire. Slender yet elaborately worked, with every surface carved with decoration, it is an extraordinary piece of architecture to find in the middle of the countryside – as sophisticated as anything of its date in Europe. On each of the three faces of the monument is a statue of Queen Eleanor, her robe swaying slightly in the elegant Gothic way, her expression still as sweet as the Virgin Mary, for whom in later centuries she was no doubt mistaken. In the days when people cared rather more about picturesque scenes than they do today, *The Shell Guide to Northamptonshire* (1968) called the square in which it stands 'one of the most photographed spots in England'.

Square is too grand a word for it. It might be described as *place* in France, but the little triangular space in which the Eleanor cross stands is just that – a triangular space, with a pub called, for some reason, the Star on one side. One of the cottages tried to follow continental practice by opening as a café, or – more English – a tearoom, and the iron sign of the teapot still hangs outside it. But I suppose Geddington people did not take to sitting on pavements reading *Le Monde*, and there were not enough visitors. At all events, it has reverted to a private residence. And that is typical of Geddington. For despite its allure for photographers of the picturesque school it is not a showpiece of prettiness. It is one of three villages that survived the first half of the twentieth century under the generally benign influence of the Dukes of Buccleuch, who controlled any development. But when changes in tenancy law made owning villages seem less attractive Geddington was the one they sold. Now it can rejoice in having shed most of the trappings of feudalism, but must blush at some of the developments in which the village is now wrapped.

A hundred yards from the cross is a bridge. It is only wide enough for one car to pass over it, but any pedestrian who does not want to be flattened against the parapet has the convenience of three recesses, projecting over pillars, into which he can hop. This bridge has been continuously used for traffic since the thirteenth century. Just next to it is a shallow ford, where children paddle in summer. Overlooking the ford stands the former working men's club, built in 1901; beyond it, the playground, some terraced houses, a paddock of vehicles that, in their various degrees of dismemberment, announce the presence of a motor repair garage, and another pub. Finally, censured sternly by *The Shell Guide* as 'big suburban excrescences on the Kettering Road', comes that part of the village which people of refined aesthetic sensibility drive through with averted eyes. The village can boast a shop and a primary school, and the vicarage, thoughtfully rebuilt by the Church of England on the noisy main road, which has its own vicar, albeit his ministrations are shared with other parishes. On the other side of the Kettering road – beyond *The Shell Guide*'s pale – is a miniature industrial estate, containing a printer's, a maker of burglar alarms and a restorer of Oriental antiquities. While the newer buildings in Geddington tend to be in brick or pebble-dash, most of the older ones are built of the beer-coloured local stone. Joining hands around the cross, the old cottages look as though they are wearing unbleached country smocks, a little frayed around the hem.

Wooden shacks probably stood in place of these stone dwellings which were not there when King Edward erected the cross. People had been living in the area for a thousand years. The village, which must have grown up because of the river crossing, was big enough to hold a market in medieval times: no doubt the cross was built in what would have been the market place. But this was not the reason why Queen Eleanor's burial procession made Geddington a stopping place. To the north-east of the church stood a royal hunting lodge. Geddington lay within one of the vast forests created by William the Conqueror for the pursuit of game. Like the Arab potentates of today, the Normans enjoyed the skill and beauty of hawking. They also hunted stags with

dogs, some of which may have been the ancestors of the modern foxhounds which used to meet at the Star.

In the autumn of 1999, my wife, Naomi, and I bought one of the little cottages next to the cross at Geddington, and this book is the diary of our first year in it. The previous 22 years of my life had been spent not living in the country, a state that deserves comment only because for the whole of that period I was working for the magazine *Country Life*. By 1999 I had been editor for quite a few years. There is every reason to live in London when your office is there. Yet the logic of this – perfectly apparent to my wife – was apt to be missed by the tweedy people whom I would meet at three-day events, polo matches and county shows. I would go out of town during the week, and the countryside seemed to wink at me, as though to entice me back at weekends. Eventually, with two young children, we reached a point at which the enveiglements could no longer be ignored. A finger beckoned, and it pointed to the Heart of England.

For that is exactly where Geddington is. If you were to cut out a map of England, stick it on cardboard and spin it on top of a pin, the head of the pin would probably emerge just beneath the dot that represents the Eleanor Cross. Or so, with apologies to Menden in Warwickshire and other places that claim to be England's geographical centre, I was told, and like to believe. But centripetal force was not the pull that drew us to this area. I already knew a part of Northamptonshire. Some people have a country house; I had proudly owned, for some years, a country horse. The horse was – is, I should write – a hunter, he lives in Northamptonshire, and by the time of our cottage-buying I subscribed to a pack of hounds. I would like to say that this gave me an intimate knowledge of the landscape we hunted over, but that would not quite be correct: out hunting, I generally belong to that part of the field that do not know where they are or what has happened in the course of the hunt. Nevertheless, I had crossed a certain amount of the county in a state of heightened excitement, and it had created an emotional bond. The cottage had to be somewhere near the horse.

I was not brought up to hunt, or even to ride. It took a

campaign of some years, beginning after I joined *Country Life*, to so much as get me on to a horse. That campaign was waged, with a persistence for which I am now more grateful than I was at the time, by my elderly colleague (long past retirement age) Gordon Winter. Gordon was in all senses a polished man. He had a face that gleamed as though it had been buffed up with a soft cloth. His shoes invariably shone, thanks to the shoe cleaning equipment that he kept in his desk. His teeth shone, as a result of ministrations in the gents, which involved removing some of them. His suits ought to have shone, since, with the economy of the wartime generation, he always wore the same ones – grey in summer, green tweed in winter. To look at, he was as perfect as a pebble: seas could wash over him but he would always carry his tightly rolled umbrella. Like a pebble he endured. His fixity of purpose wore away my objections, and I went off to take riding lessons.

I should say that 'we' went off. My wife shared the adventure, but fell by the wayside. Literally, this particular wayside being the sandy floor of a riding school in Berkshire. I was left to pursue my equestrian destiny alone. In the course of time, it took me – as the days of 1991 began to shorten – to Calcutt's riding shop at Sutton Scotney in Hampshire, where I bought a second-hand black hunting coat, some remarkable old jodhpurs (of a thick reddish cloth: they started somewhere down by my ankles, ballooned out like a crinoline around the thighs and terminated, in braces, at the armpits), spurs (they came in a rather nice cedar box), white hunting stock, Tattersall check waistcoat and some stirrups (in case the horse I proposed to hire did not come with ones big enough). Thus equipped, I could drive down to Wiltshire, with the martial passages from Bellini's *Norma* playing very loudly on the car stereo to keep my spirits up, for my first day's proper riding with hounds.

I imagine that the Duchess of Richmond's Ball, held on the eve of the Battle of Waterloo, radiated an aura of determined insouciance comparable to breakfast in my friends' extravagantly thatched cottage. Men joked, but it was as though they were about to make a parachute drop behind enemy lines at any

minute. When Sandy, the colleague who had organised the outing, rose to fasten his stock, which, being about 16 yards long, seemed to foam down his chest like waves on a beach, he lightened the atmosphere by saying: 'You realise that the purpose of the stock is to stop one breaking one's neck.'

There were one or two last minute adjustments to my rig. The buckles of the garter straps at the top of my boots had to fasten on the off-side. Spurs had to be correctly positioned, pointing down. The brooch I had borrowed from my wife was not a recognised pattern of stock pin, but it was too late to change it. There was, it struck me, so much to get wrong, even before we strolled (self-consciously in my case) out to the meet. That took place only 50 yards from the cottage. Hounds bounded out of their wooden-sided lorry, excitedly defecating on the grass. Iron horseshoes struck bright notes from the tarmac. Several men offered a Belgian countess a glass of port. My friends got on their horses, and I was hurried down a lane to meet my hireling. I had asked for a steady horse. He turned out to be a magnificent grey gelding with the doubtful name of Gunner, who seemed to be hunting's equivalent of the eager warhorse in the Book of Job: 'He saith among the trumpets, Ha, ha; and he smelleth the battle afar off . . .'

'Here he comes,' the doctor in Swindon hospital said, as I swam back into consciousness a few hours afterwards. He asked me my telephone number and I could give it straight off, fortunately. I heard Sandy discussing something with the nurse, out of sight. I greeted him like a long-lost friend when he came into view. He was still wearing his hunting clothes. I was under a blanket, in vest and underpants. I asked him about the progress of the day. 'You got over the first jump fine,' he said, without quite the warmth of sympathy that the occasion might have deserved. 'Unfortunately not the second.' My fall had, I'm afraid, deprived him of the rest of his day's hunting. Stoutly, he had come with me in the Land Rover summoned up by the Master on his mobile phone. The next day, at the old Westminster Hospital, I was seen by an orthopaedic specialist, which seemed rather grand. He said that my hip was probably not fractured, and gave me painkillers and

crutches, and a very tall blonde nurse showed how to get along by putting the points forward and hopping in between. I deduced that the correct form when I phoned work was to be nonchalant and brave. 'But to look on the bright side, it is a large nose and most of it is not broken.' Above an aubergine-coloured cheek glowed what had been the white of one eye, gone completely red. Naomi was distressed by the number of people who phoned to assure her that the horse was perfectly all right.

In 1994 *Country Life* published a guide to top riding establishments in Britain. To prepare this, those of us who rode set out on a fact-finding mission. I did not in the least mind my colleagues' suggestion that I ought to try one at Naseby, in Northamptonshire, which gave courses on hunting. By that stage, I had bought my own horse and she went along too. I have had a horse there ever since.

Five years later, we did not intend our plunge into country property to take us to the expensive depths of purchase. We wanted to rent a cottage, and thought, for that purpose, we could hardly do better than try the Boughton Estate. It is owned by the Duke of Buccleuch, who has inherited a devotion to improving the landscape from ancestors such as the eighteenth-century second duke, 'Planter John', which would guarantee beautiful surroundings. There is a good train service from Kettering and Naseby is near at hand. The estate had two houses to offer us, both too big for our needs but worth thinking about. One was a barn whose beautiful conversion was just being finished in the deliriously pretty village of Grafton Underwood. The other was a severe Victorian house, hidden behind a tall evergreen hedge, in what they diplomatically described as the 'working village' of Geddington. I saw both of them, then Naomi did, and we came back to make our decision. We were met at Kettering station by a Peugeot estate with a Countryside Alliance sticker in the rear window. Inside was Mr Whiskard, surprisingly young for a land agent, but then I was once surprisingly young for a journalist on *Country Life*. As we drove through the stately park at Boughton House, we passed a shepherd whistling to his dog as it nudged a flock of sheep over the eighteenth-century bridge. Two herons

stood like Giacometti sculptures beside the lake. We thought: Arcadia lives.

'Shall we go to Geddington first?' asked Naomi. 'You mean Grafton Underwood,' said Mr Whiskard. 'Not Geddington, surely? We thought you were interested in Grafton. The Geddington house has gone. It is such a pity, because the person who has taken it phoned just ten minutes before you arrived to confirm. No, I'm afraid there really is nothing we can do now.' When we reached Grafton Underwood, passing the Please Slow Down Because of Ducklings on Road sign, a lady painter stood by her easel outside 'our' house; it is that sort of place. We walked around, me gushing, Naomi glum. 'It's so isolated, and I don't like the country,' wailed Naomi. The prospect of weekly fish and vegetable deliveries was not a sufficient vision of convenience shopping to console her. I had thought she would like the new kitchen. Instead, the gloomily un-aired Geddington house, with its algae-coloured carpets patterned like raspberry ripple ice cream, its notice on the fireplace instructing cold inhabitants to Remove Plastic Bag Stuffed Up Chimney Before Lighting and its slightly overgrown garden which had been tended so devotedly by the old couple who were its last occupants – that was the one she had wanted. It spoke to her as somewhere that people had loved.

There was a cottage at Weekley that had become too big for the elderly woman, recently widowed, who lived there. It looked perfect for us, and not so expensive as the Grafton Underwood property, but it depended on the estate being able to find a bungalow into which the tenant could move. Weekley would be a good place of residence for the editor of an hebdomadal magazine, but we did not want to wait.

We were driven back to the station, but we did not catch the train. Instead, we decided, out of pique, to walk back into Kettering and look at what the estate agents had to offer. The first one said she had nothing to suit us – had we tried the Boughton Estate? As we followed her directions up Market Street, towards Keeble and Company, our expectations were low. We wanted somewhere to rent. But there, in the staid, black-painted window,

with its Victorian glazing bars, was a notice for a little stone cottage with a thatched roof and a rug of clematis thrown over the garden wall. It seemed a miracle. This was just what we were looking for, in the place we had just been looking at. We could have a go at talking a mortgage company into meeting the asking price (no one could call this county fashionable). So we flustered dignified Mr Keeble by asking to see it at once. By the time we had got back to St Pancras we had decided to buy it. And with that decision began my year in the country complete with family, horse, estate car and every other essential for life in the middle of England.

The year covered by my diary was both momentous and ordinary. It was the year of the Millennium. The year that I joined the Geddington Volunteer Fire Brigade and was awarded the Pytchley Hunt buttons. A year of despair for farmers and record rainfall when parts of England threatened to float away altogether. The year when the Star almost ceased to twinkle. A year in which people came and went around the cross, as they have done since it was built. The year in which the prime minister decided to outlaw the sport of hunting, continuously practised around Geddington for nearly a thousand years.

AUTUMN

A day of two openings
(though I missed one of them)

This should have been, with rich symbolism, the day of two openings. The opening meet of the Pytchley Hunt, and the opening of the door of our cottage. To achieve the latter meant collecting the key from the estate agent before it closed at lunchtime, so I would only have been able to attend the former on foot, watching the hunt for a while without joining in, but better than nothing. However, as I drove down the M1, the rain formed a kind of three-dimensional mass – a sculpture of glass needles – and I felt mocked by the warning signs that flashed a speed limit of 50 m.p.h. Our average speed was 0 m.p.h. By the time I had crawled to an exit ramp there was no point in hitting the steering wheel, or making more calls on the mobile to parties who were not interested in my slow progress: I had missed the meet. On the other hand, I was too early for Naomi's train, and so I diverted to Milton Keynes.

Milton Keynes is England's last great garden suburb and if this leafy metropolis could ever be beautiful, it is so now the rain has stopped. In their autumn shimmer, the trees look as though they have been washed in by a watercolourist of the Norwich School. One happy day it won't be possible to see Milton Keynes at all.

Once inside Milton Keynes, it is very difficult to find the way out. You might think that the city fathers want to trap you in the parallel world that they have created. Their road signs do not point to Northampton, Oxford, Aylesbury – real places, outside the magic kingdom – but only to local destinations, like Cricketer's Field Lane or Badger's Brook Close, names that evoke a John Majorish vision of long shadows on county cricket

3

grounds and maiden ladies bicycling to church. What existed before this countryside of the imagination was constructed? Well, perfectly good Saturday country for the Whaddon Chase Hunt. I reach the main road feeling that I have acquired the motoring equivalent of the rolling gait of the sailor who has accustomed himself to the pitch of the sea, only in my case it is round-abouts.

The country that I am heading for is not a construct, like Milton Keynes. It is visibly old, with fields whose stripes and bumps may date from the eleventh century. Brier-roses flower in the hedgerows like shards of old tea cups, cow-parsley stands rampant on the verges, thatch is pulled down low over buff-coloured stone walls. These, at least, are the things you would mention to a visitor from overseas. They are there if you look. But even though England has some of the most stringent planning laws in the world, Northamptonshire has come out as a muddle. It must have looked more consistent when Percy Pilcher, a harbinger of the modern world, took off in 1899 from Stanford Hall in the Hawk, the latest of his hang-glider-type flying machines (fourth in a line that included the Bat and the Gull). Below him would have been nothing but old grass and fearsomely big hedges. The plane crashed and his friends built a monument to Pilcher, the first aviator to have been killed in this country.* You cannot visit the monument: it is in the middle of an enormous ploughed field.

Agriculture has had its go at changing the face of Northampton-shire, leaving only a tenth of the bumpy fields that existed after the Second World War. So have industry and other development. Driving along the main roads, I sometimes wonder if an enor-mous giant has not been walking around with a punctured bin liner full of housing estates and factory units, and they have spilled out in an ugly trail. But then you turn off the road and immediately find youself folded into a soft eiderdown of gardens and parkland, and think that there was never anything

* With him when he took off on his last flight was a triplane with an engine. This was before the Wright brothers had even started to glide. There is a full-sized replica of the Hawk at Stanford Hall.

so perfect or unchanging. It is real country. You could not make it up.

I am only ten minutes late for Naomi's train at Kettering, and there is great joy and excitement at the boys' reunion with me, even though we all saw each other earlier this morning. Naomi runs in for the keys from the estate agent, and after only half an hour or so emerges with complicated information about the Geddington ducks. We must take bread for them. There used to be about 50 but – matter of local controversy – all but 10 have migrated down river to Grafton Underwood. She also has a map, marked with the highlights of Kettering as a shopping paradise.

We hurry off to Geddington, past a notice for a jumble sale at Warkton at 2.30. 'But do they deliver,' we joke. We squeeze through the bollards on the bridge at Geddington only to find that a Volvo is approaching from the other direction. After reversing back with some difficulty, we give the children the treat of going through the ford, spraying the celebrated ducks who are surprisingly leisurely in their evasive action. (Then there were nine . . . What a start in the village that would make.)

I try the key in the lock of the cottage; it works. The cottage is there, minus only our predecessors' possessions. Yes, it is truly there.

Our cottage is the one next to the former Tea Shop and is attached to Church Farm. On a map, the site it occupies might well look like a nick accidentally taken from these neighbouring properties when the map-maker's pen slipped. Originally, in the days when people were extremely small, it was two cottages. There is now more room laterally, but even as I walk around swiftly, in the first flush of possession, to check that it really hasn't blown away, I fail to lower my head sufficiently when stepping out of the room I intend as my study, hear a sound like a coconut being knocked off a shy, and realise this is my skull, which I leap around clutching for a few moments, in the manner of Archimedes after a major discovery.

The garden wall of our cottage – yes, it has a dogleg of garden, on the Tom Thumb scale of everything else – is topped with its own thatch, made of ancient clematis. Fronds of it tickle the face as you walk in. The trunks twine about each other expressively, like a ballerina's wrists. It is from the garden that the cottage is entered. You would not know that, of course, unless you happened to own it. When we had first arrived to view it, we knocked on the street door. The vendor's head appeared out of the window, and told us she couldn't open it. I thought that maybe she was going to ask us to climb in through the window. Perhaps we shall get a brass plate made, with instructions, or find a means of unlocking the door.

The functioning door gives into a kitchen. It would be the normal size for a kitchen if you were an air stewardess, used to one of those galleys passengers pass on the way to the lavatory in an aeroplane. By other standards, it is a mousehole. The sink has wobbly brass taps, and the woodwork is painted what I believe is called eau-de-Nil – with the emphasis on Nile sediment more than Egyptian romance. There is a little larder whose door, with a heart cut out of it, is opened by a Suffolk latch.

Another latch and another wooden door opens into the dining room. It has a stove. ('We hardly ever use it,' said the vendor. 'It makes the room really too hot.' Which, since there is no such thing as too hot for Naomi, was more of a selling point than she knew.) A door gives into the parlour, which possesses the doorframe, on which people scalp themselves, leading to what was the teenager's bedroom, painted in the pink once associated with schoolgirls' knickers. From the dining room rises the nearly vertical staircase, going up to the two bedrooms upstairs. This floor also boasts a lavatory (more wobbly brass handles) and a shower room, in which we intend to install a bath, since the boys are allergic to showers. The wallpaper of the staircase and corridor is decorated with little sprigs of roses, as though we were inside a sewing box.

If the walls of the cottage were thighs, they would have cellulite. They are bumpy, and mostly painted off-white, so the effect is rather like the inside of a large tub of melting ice cream. This

will provide an interesting challenge when it comes to pictures: only very small ones will lie flat.

When the local council created the conservation area around the cross, they called the cottage seventeenth century, but I suspect that is only a way of saying very old. And it is very old. You can tell that from the sags in the ceilings, the panelled dado that almost certainly hides damp, and the bread ovens in the thickness of the walls (the one in the dining room has been turned into a cupboard, that in the parlour into an alcove for the hi-fi and television that we don't have).

Since it had been the fish pie at the Star that had helped convince us to buy the cottage, it is fitting that, our first rapture of proprietorship being over, we make our way straight there. The Star is on the other side of the square, as I suppose we must call the triangle around the cross: a stone building with tables outside and a faded sign bearing a picture of the Eleanor Cross (somewhat surplus to requirements, since the cross itself towers opposite). As you step over the threshold, the general beeriness and woodiness of the interior, with the sense of the dark, bare gloom of a public bar, with its typical skittles' table, through the door on your right, promises well. But you do not turn right, and the saloon that opens up through the other door is a little disappointing for a country pub. It is simply too big. The main part of the bar is overlooked by a raised dining area in which there are seldom more than a couple of people eating. A void, physically and spiritually, but to some extent filled by the following: a log fire (bright); a large choice of sometimes unheard-of beers; a blackboard menu of extravagant length.

We occupy the table in the window alcove, whose view is taken up with the cross. William wants to know what it is, so we explain. Then, while we are extracting Johnny's wooden ark from the pushchair, trying to prevent the roof coming apart because otherwise there will be sharp screws sticking out (hopeless, given the number of times it has been in the bath), looking for Mrs Noah, and generally rejoicing in parenthood, he asks: 'Why did Queen Eleanor die?' This is meant more in the philosophical than the historical sense. It follows in the tradition of 'Why

did grandma die? Why did Jesus die? Why did the Frenchman kill Nelson? Who chopped King Charles I's head off? What is a king?' But blow me if there isn't a man at one of the tables who can tell him. She died of pneumonia, probably, or pleurisy, the man says. Her memory lives on in the Elephant and Castle in London: a corruption of Eleanor of Castile. Well, I knew that, almost.

The landlord – we are already calling him Peter – sits at one of the circular bar room tables, which also functions as an office, with invoices and a calculator on top and two dictionaries on a shelf underneath. A sort of Old Testament prophet or Neptune figure, with hoary locks and doom-laden manner, he rises from the crossword he has been doing to inveigh against the advertising literature for the new executive homes on the other side of the river, which praises the famous cross erected to the memory of Henry II's queen. It is the wrong Eleanor. The error has been compounded by calling one of the house types the Aquitaine, after Eleanor of Aquitaine. But then the whole development goes by the name of Geddington Chase, whereas the real Geddington Chase lies on the other side of the village. Shaking his head, he pushes his spectacles back on to the top of his hair, and sinks back into the depths of his crossword.

After lunch, we refresh our memories of the cottage that we have not seen for an hour. There is nothing much we can do there, and there are no beds for us to sleep in, but it is still very exciting for the boys. I had feared that they would miss their climbing frame and friends in Warwick Square. But when I ask William what he thinks, he says: 'This is the beautifulest cottage ever.'

Monday October 25

I am back. The cottage is still here. I have not yet got over the novelty of possession which for some reason makes me feel rather guilty, as though I were in the au pair's bedroom. I measure the kitchen to confirm what was obvious anyway: we can have only a very small fridge.

I walk from one historic centre of Geddington to the other, over the bridge. This is another irregular open space, just past a row of old cottages: the largest one, I have been told, was where visiting Plantagenet kings held parliaments in the twelfth century – though it does not look very likely. On the other side of the road is a stone house with a big garden, raised up on a terrace above the street. Perhaps that is the house where the parliaments took place.

The other day I pushed through the glaucous steel door marked Topography and Country Life in the basement of the London Library, clacked along the concrete floor between the book stacks and discovered, between the Revd H. E. Polehampton's *Gawsworth Church and Parish* and Christobel M. Hoare's *The History of an East Anglian Soke*, a volume whose spine bore the single word 'Geddington'. This was *The History and Antiquities of Geddington, Northamptonshire*, by Christopher A. Markham, 1899. 'With the exception of some half-dozen new brick houses at the Kettering end of the village, and one or two elsewhere, the appearance of this little town has not greatly changed for several centuries,' wrote Markham. I suppose the same could be said today – except that there are scores of new houses, not half a dozen. William Pitt didn't think much of the village when he visited in 1806: 'Inferior houses, mud walls and thatch, and a few of the best stone walls and slate. A large brook and stone bridge, with excellent meadows subject to natural irrigation.' No doubt the new houses would have struck him as an improvement, but natural irrigation sounds like a euphemism for flooding. Markham recorded the great floods that prevailed in 1880: 'In July the water flowed past the Cross into the Blacksmith's shop beyond, to a considerable depth. A horse and waggon were swept over the causeway on the south side of the bridge, into the cottage garden adjoining ditchfield, and the horse and driver were with difficulty rescued. Much hay was carried away by the inundation.'

At that time, the school, with its little bell tower, had only recently been built. It is still going, highly regarded by parents despite the ugliness of the modern classrooms. There was an

earlier school, near the church, described as 'lately built' in a book of 1849*, the playground of which has been turned into a garden – though not a very private one, being mostly exposed lawn, so the owners never sit out in it. This was also when the Church of England built a substantial Elizabethan-style vicarage, which is now, almost inevitably, the Old Rectory. Less predictably, Geddington has succeeded in keeping its tally of drinking establishments: four of them, which is an amazing testament to the thirst of local residents, given that village pubs are supposed to be closing at the rate of one a week. The village shop, with its red telephone box, postbox and Post Office sign, is another amenity, and that is where I am going today. It is just past the United Reformed chapel.

There is a big basket of eggs on the counter, and I ask the thin lady behind it, Mrs Chew, if they are from her hens. 'I go out and collect them every morning,' she says wryly. 'No, they are local.' Mr Chew used to work in textiles in Manchester. In 1980, he came to Desborough, a few miles from Geddington, to manage a corset factory. They were still making whalebone corsets in those days. 'This is one of our newer ranges,' he was told when being shown round. 'It was only introduced twenty-seven years ago.' There was another corset factory at Market Harborough, so Northamptonshire must have been the corset capital of Britain. By the time he left the factory, four or five years ago, it was making underwear for Marks and Spencer. When he was made redundant, the Chews came to Geddington to run the village shop.

As I walk back, carrying my jar of Nescafé and carton of milk, two girls paddle across the ford in wellingtons, squealing as a builder's van splashes through. More girls are gathered around

* William Whellan and Co.'s *History, Gazetteer, and Directory of Northamptonshire; Comprising a General Survey of the County, and a History of the Diocese of Peterborough: with Separate Historical, Statistical, and Topographical Descriptions of all the Towns, Parishes, Townships, Hundreds, and Manors, to which Is Subjoined, a List of the Seats of the Nobility, Clergy, and Gentry.*

the cross. 'You tramp,' calls one to another. 'I've never seen a girl wearing a bright red jacket before.' The tramp replies scathingly: 'It's the fashion.'

Tuesday October 26

The day began gloomy in London, but Northamptonshire is a-sparkle, with the trees in the avenue at Boughton looking as though they could be made of gold leaf. The journey from Kettering to Geddington, a little over three miles, is punctuated by no fewer than five roundabouts. At the last of them the way is barred by a row of cones and a police car. 'How can I get to Geddington?' I ask the officer. 'Do you live at Geddington?' he replies. I hesitate, wondering whether I can be strictly said to live there, without a bed on which to sleep, so he asks suspiciously: 'Where in Geddington?' I almost forget that the cottage is next to the cross. The policeman gives me one of those looks of disbelief. 'In that case you can go through,' he says reluctantly. There has been an accident, though I see nothing of it.

Richard, from Acorn Property Services, comes to discuss damp. He is unexpectedly sanguine. The cottage is damp but has been damp for a couple of hundred years, probably. The panelling stands away from the stone wall, so damp does not penetrate. The room that will be the study may be a problem but the cure is so draconian (involves replastering the whole room, practically) that we'll leave it for now. He recommends that we live in it for the winter to see what problems show up. In the meantime, he will send Keith.

In the garden, I find a toad in a flowerbed. That flowerbed, though, must be moved because it is above the interior floor level. I apologise in advance to the toad.

I wait all morning in an empty cottage for the sofa, cooker, fridge and the rest that we have bought from the Kettering Co-Op. I put away those few things that we have here; open all the windows to air the place; read *Memoirs of a Fox-Hunting Man* in the window seat so that I will be able to spot the lorry. It

is surprising how many vehicles in the country sound like lorries. Probably the road block sent the lorry back. Just as I have decided that it will never come, and therefore I might as well go to the Star for lunch, it arrives, wheels steaming from the splash through the ford, driver grinning. I go cheerfully to the Star. While waiting for food, I look closely at the old photographs on the walls. They show various Geddington events, mostly floods. There is one of women in old WRNS-like service uniforms – they might have been my mother – helping children into boats. And in the background the water has reached our cottage. There is a poster put up by the Environment Agency around London – heaven knows why – saying simply 'Floods are not for other people.' I feel these apparently gratuitous posters have been aimed directly at me.

The chef comes into the bar. I had imagined the food being cooked by the wife of the proprietor, rather than a large, bullet-headed man in check trousers. He looks as though he has been in the army, and so he has – the Army Catering Corps. At one point, he had 24 people under him. 'What does he like cooking most?' Not pastries; he hates cooking pastries. And if he hates cooking pastries, I for one, wouldn't ask him to make any. He is a big man. He trained as a saucier, and remains loyal to his Stroganoff. What he really loves, though, is juggling different dishes, different ingredients, so that a table of eight, who might have come in from nowhere, can be served at the same time – olé! The fridge has to be kept very cold, the hob very hot.

It is a long menu – blackboards and blackboards of it – but everything is cooked fresh. As well as steaks, Torbay soles, mushrooms in cream sauce and the famous fish pie, he offers a range of curries, the art of which was taught to him by the mother of an Indian friend. The other day someone came from Georgia, USA, with a recommendation that the only thing to do in England was to eat at the Star, in Geddington. I apologise for having ordered only Cumberland sausage.

In the afternoon, a double-decker bus stops outside our cottage, looking enormous from the casement windows, and returning schoolchildren pour out. It reminds me of visiting a plantation

house in Louisiana. I looked down the elegant alley of live oaks towards the Mississippi, expecting to see a jaunty paddlesteamer go by, when instead the view was blocked by a vast modern oil tanker, which seemed just yards away. The illusion of Tara-like graciousness was shattered.

Wednesday October 27

When I go into the Star, the barmaid's hand automatically moves towards the scrumpy to which I have become partial. I tell her that I am getting the cooker installed this afternoon. 'So we won't be seeing you so much,' she says. But I assure the chef that I shall not be a slave to my stove. 'What is your first name?' he asks, as though he knew my second name terribly well. We are now very much on Clive and Mike terms.

In the afternoon, Keith the builder arrives after an interval just long enough for me to fall asleep on the new sofa. I leap up when I glimpse a shoulder of check shirt passing the window. Then he comes loping in, with an elastic sort of step as though his feet were on springs. Emerging from the neck of his checked shirt is a tattoo of a bird. He is an outdoors man: in the USA he would drive one of those trucks with big wheels and go deer hunting. His alert eyes would help him survive in the wild.

He greets me with: 'Weren't that a terrible accident at Stanion.' A lorry ploughed into a car; the two men in it were killed instantly. They were engineers, Americans, who had been inspecting machinery at the Weetabix works at Burton Latimer and were on the way to another factory. 'They never got there. They were killed instantly. Instantly,' he repeats impressively.

Yesterday, Keith had told me about his move from Kettering, where he had lived on a council estate. There was 'a prostitute at the top, a prostitute at the bottom and a drug dealer in between'. A mad Irishman got into a dispute with a neighbour and threw a brick through all his windows. 'He started coming I-Am-the-Big-Man with me too, and the only thing was to leave. I didn't want bricks through my double-glazing.' So he bought

a house in Geddington, on a council estate where most of the houses have been sold to their occupants. ('Council doors, council windows, council bath,' he said with disgust at the memory of previous ownership.) 'I have never heard a word against Geddington,' he said.

The job of fitting the cooker into the small space available is like a Japanese puzzle. While I make a cup of coffee that turns out to be undrinkable (the milk is off; he would have preferred tea in any case), he tells me about his buzzard. He has kept birds of prey – owls, etc. – since he was young. Now he only has the buzzard, and it is 13 years old. An off-shoot of this hobby was breeding mice, rats and gerbils to feed his birds. Much better than day-old chicks. The surplus he could sell at a pound a time, making sixty odd quid from a three hour drive round Northampton. Some people wanted pinkies – tiny mice – for snakes and reptiles. 'So you can make money from it, if you know what to do.'

This evening, I watch some boys playing Palace Leap opposite our cottage. I call it Palace Leap. They jump on to a table-like noticeboard, off on to the adjacent lamp-post, which they slide down. The noticeboard details the history of the medieval palace. I don't think it was ever really a palace, but a hunting lodge. It served as an outstation for Rockingham Castle, in the centre of Rockingham Forest, one of the great hunting preserves created by William the Conqueror; the lodge at Geddington was somewhere to stay when the king was hunting in Geddington Chase. The existence of the lodge explains how Geddington came into being.

Nothing of it survives, except a house-shaped depression in the churchyard; half of the site now lies beneath old people's flats. The palace is first mentioned in 1130, when William d'Aubigny was paid £17 for 'making the king's house at Geddington'. That does not sound an extravagant amount, but the buildings were sufficiently substantial to be used, later in the century, for what would now be called summits: it was at Geddington that Henry II drew up a treaty with the Welsh princes in 1177, and Richard I brought William, King of Scotland, here one Good Friday. King John was often at Geddington, holding court, which is appropriate, since Rockingham Forest contained a Robin Hood

14

– just possibly the historical figure around whom the legend developed.

To begin with, the palace was timber. Trees from Geddington Chase were often cut down for repairs or extensions to the palace. There was a rush of work in the 1240s, when the walls and the ceilings had to be repaired. Evidently there had been leaks, since the paintings in the king's chamber had become 'darkened by rain'. The dovecote had fallen down. An almonry was built, as well as mews for the king's falcons: hunting was what the whole thing was about. Glass, then a great luxury, was put into the windows. By the time that the Sheriff of Northampton came out in the 1250s to supervise various improvements part of the building was stone. The last reference to repairs is made in 1285; after that the holes in the roof and collapsing walls seem just to have been left. By 1374, everyone had abandoned the manor; the ten cottages were empty; the markets and fairs had no customers; Queen Eleanor's three statues had only themselves for company, staring out on a scene of neglect. I picture the lodge becoming like 'the rejoicing city that dwelt carelessly' in the Book of Zephaniah: 'how is she become a desolation, a place for beasts to lie down in! Every one that passeth by her shall hiss, and wag his hand.'

I suppose it must have been the Black Death which wiped out the village, until new settlers returned to it. Before that, Eleanor herself did not make life any easier. There is some evidence to suggest that she was, in life, a captivating as well as a beautiful woman. Certainly King Edward thought so. Every Easter Sunday, the queen's ladies thought it a great joke to burst into his apartments, and prevent him joining his wife until he had paid them a ransom (quite a hefty one: two pounds apiece). The explanation of this ritual is that the king and queen, like other medieval couples, abstained from sexual relations during Lent. Hence the particular urgency of the king's visit to his wife on Easter Day. Poignantly, he went on paying the tribute to the ladies even after her death had deprived the custom of meaning. Alas, the legal records show a different side to her. They suggest that she was grasping with regard to the estates she acquired; mean in the revenues that she expected her bailiffs to wring

out of them; and vindictive towards the people who, often quite justifiably, opposed her will.

But the folk of Geddington managed to get their own back on their royal landlords, despite the special laws, special courts and special officers which the Normans created to look after their forests. In 1246, Hugh Kydelomb of Geddington was apprehended by some apparently law-abiding persons, who found him to be carrying four shoulders of venison and two heads of deer. At least one of the law-abiding persons was given a shoulder of venison to shut him up, the rest apparently ending up with Ralph, the vicar of Geddington. This time the malefactors got away with it. On another occasion, William the charcoal burner of Geddington, 'Ralph atte Bridge of Geddington and John Aaron of the same town' were convicted of taking home a dead beast, and thrown into the gaol at Rockingham Castle.

I like Charles Kingsley's account of Rockingham Forest in *Hereward the Wake*: 'Broken park-like glades covered the upper freestone where the red deer came out from harbour for their evening graze, and the partridge and plover whirred up, and the hares loped away innumerable; and where hollies and ferns always gave dry lying for the night.' It was a natural cornucopia, teeming with good things to eat. The king could afford to share some of them with the villagers of Geddington.

Thursday October 28

'Are the frog's legs French?' someone asks Mike, the chef in the Star. The mood in the pub is to shun French produce, their beef fed on sewage, in reaction to their illegal ban on British beef.

At the other end of the Ise

Friday October 29

If you were to put on a pair of waders at our cottage, stride halfway through the ford, turn right and make your way far enough upstream – as far as it is possible to go – you would find that our little brook, the River Ise, rises at Naseby. Naseby is a watershed, and full of springs. Three big rivers rise near there. I know for a fact that the Avon does, because if you ride through the village and look over one of the garden walls you can see an ancient metal cone declaring that what appears to be the modest garden pond constitutes the origins of the Avon. That river flows all the way to Tewkesbury where it joins the River Severn. The Nene and the Welland, which also have their beginnings near Naseby, flow the other way, emptying into the North Sea at the Wash. Today I am taking the more conventional route, by road, because it is at Naseby that I keep my horse. I am going to discuss my hunting plans.

Naseby is a village which has grown and grown since the Second World War. There is a village shop, just – the shopkeepers nearly quit in disgust when the Post Office refused to compensate them fully after a burglary. The village school makes a satisfactory volume of noise at break time, and the congregation of the church is sufficient to perpetuate bad feeling with the riding establishment over the road by parking its cars during services so that the horse lorry cannot get out. (Relations have, however, improved since the very low ebb when an electrical fault meant that every time the church central heating was switched on all the metal parts of the stable yard became electrified.) Naseby's

17

older domestic architecture includes some rows of cottages, and a few bigger houses and farms. But most of the homes here have only arrived in Naseby by chance. They could equally well have been built on the edge of Northampton, or Wellingborough, or Corby. They are physically in the village but not part of it, or the countryside. Recently the planners have been trying harder, and the newest development is a clump of cottages, with white walls and thatched roofs. Only they are not cottages in size. It is as though they are cottage-shaped hot air balloons, which have been blown up and blown up until they are jostling each other for space, and any second they will lift up into the sky and float away. If only they would.

Naseby is one of the most stirring words in the English language. Here, King Charles I, leading his army in person, lost the English Civil War. But lost it, as Woody and Buzz Lightyear would say, with style. Charles and his generals were the ones to seek out the Puritan army, and pick the fight, even though they were heavily outnumbered. They made the mistake of laughing at what they called the New Noddle Army, re-formed by Oliver Cromwell and then on its first outing in the field. The king's nephew, Prince Rupert of the Rhine – testosterone in a plumed hat – planned the battle and should have commanded it. Instead, after nights of acrimony and indecision among the Royalist commanders, he worked off his frustrations by leading the cavalry on the Royalist right wing in a furious charge. He was famous for his furious cavalry charges, but at Naseby he overdid it. Rupert's Lifeguards smashed through one end of the enemy line, ignored the distraction provided by the Cromwellian Colonel Okey's dragoons popping out of a hedge, and kept going until they came to the Puritan baggage train. No one can now understand why they thought they had the time to pillage it. To make matters worse, they found it was rather better defended than they had expected.

On the battlefield proper, the bristling 'hedgehogs' of the Royalist infantry – squares of men with their pikes sticking out – had stamped their way into the middle of the enemy line, but the numbers opposing them were just too great for

them to push any further. By the time Prince Rupert found his way back to the main action, it was too late. In his absence, King Charles himself had almost made a last throw. For the little king, whatever his other qualities, was a brave man, and would have put himself at the head of the cavalry reserve – probably made up of the courtiers who surrounded him – for a last Royalist charge, when a Scottish peer called Lord Carnworth, swearing dreadfully, seized the bridle of his horse and told him he would instantly be killed. So the charge never happened, and four years later Charles's head was chopped off.

Well into the twentieth century, the place from which King Charles was supposed to have directed the battle was marked by the King's Oak, which (observed Guy Paget in his *History of the Althorp and Pytchley Hunt 1634–1920*) 'sheltered innumerable litters of foxes beneath its roots'. There are also two monuments to the battle. One of them, an obelisk, is nowhere near anything interesting that took place. Erected by John and Mary Fitzgerald in 1823, it has an orotund and surprising inscription, which manages to give the impression that the Battle of Naseby was really the start of the Civil War, not the end of it. Having 'terminated fatally the Royalist cause', it

> led to the subversion of the Throne, the Altar and the Constitution, and for years plunged the nation into the horrors of anarchy and civil war, leaving a useful lesson to British Kings, never to extend the bounds of their just prerogative, and to British Subjects, never to swerve from the allegiance due to their legitimate monarch.

The other monument is a column with a stone ball on top, put up by the Fitzgeralds's son, Edward, whom Paget wrongly identifies as the translator of Omar Khayyam. This stands more or less where the Puritan army – or rather, the brave little vanguard known as the 'forlorn hope' which occupied a miserable position in advance of the main battle line, to break up the enemy's attack – started the day. Opposite this is the appositely named Dust Hill, where the king ranged his forces. But no one can say exactly where the principal incidents took place. In those days, the landscape

would not yet have been broken up into fields, surrounded with hedges – which is why there was nothing to stop Prince Rupert's Lifeguards, once they got going. There were probably 25,000 men fighting at the Battle of Naseby. Ten thousand of them rode horses. Just to think of that number of horses shows that the battle must have covered a wide area.

I first visited Naseby when the bypass – part of the now famously congested A14 – was being planned. I had been staying with my parents-in-law at Cambridge, and for some reason had left so late that my hosts at Naseby Hall had given up expecting me. Sir Charles Rowley and his wife were leading the campaign against a route for the new road that would cross the battlefield. They wanted it to go on the other side of the village – coincidentally, away from Naseby Hall. We had a wonderful dinner, and the history of the battle was explained to me, using a flower for the king and (appropriately) a mustard pot for Oliver Cromwell. Next day, Sir Charles drove me around the places where the military historian Brigadier Peter Young thought the different parts of the action had happened. The proposed course of the road lay between the oak tree that marked Charles's headquarters and the site of the Cromwellian baggage train, just outside the village of Naseby. When Sir John Betjeman visited the battlefield, he saw the ghosts of Royalist horsemen and heard the thunder of hooves. It was a profound experience for him. The road, it seemed, would dispel such visions for ever. I added my tuppence to the controversy, arguing the Rowleyist cause in both *Country Life* and *The Times*. It didn't do any good. The road was built. A brown tourist sign has been erected to remind drivers that their tyres are now screeching over one of the most precious sites of English history.

And yet, during the construction of the road, not one single seventeenth-century artefact – not so much as a musket ball – was discovered. Prince Rupert and his men might have ridden over this piece of land, but they didn't stop.

Cromwell's baggage train was laagered somewhere near the

bottom of the fields belonging to Shuckburgh House, which stands opposite the church in Naseby. Shuckburgh House is owned by my equine mentor, Sue Muirhead. Sue first came to Northamptonshire as a young married woman, when her husband David was sent there by ICI. It was a bit of luck that their new home was in prime hunting country. When David died, she began breaking and training event horses and hunters for her friends, and now that she herself cannot ride – a bad back that was not helped by the inevitable hunting falls – she takes pleasure in seeing others do it. I think it is pleasure: sometimes my instinct for doing the wrong thing to a horse can be a trial to her, brought up as she was to follow her father round his Snowdonia estate. Since then she has lived her life outdoors, surrounded by animals. She has a contempt for men who wear gloves or scarves; and it is not a good idea to call on a Saturday afternoon when the racing is on television. But the thing that distinguishes her from other country women who have horses is that she thinks about horses and analyses them, bringing on young ones, rescuing ones that have been condemned by insurance companies, training her star performers to put on the Ritz in dressage riding. She also thinks about the people she teaches, and analyses them, and however glaring my faults as a horseman may be, she can at least remember that they used to be an awful lot worse.

The main part of Shuckburgh House is a Georgian square, with a chequerboard façade. But the cottage attached to it is older, and is thought to have housed some of Cromwell's officers on the night before the battle. It is now occupied by Pauline and Debbie, who ride, train and look after the horses. If Sue is the sun in my equestrian sky, Pauline and Debbie are the planets who revolve round her. They have both shared the burden of teaching me. Pauline watched over my early forays, and without her advice, tactfully administered out of earshot of the rest of the field, I cannot think what would have happened. It was a proud if slightly scary day when Sue first let me out on my own.

It is at Shuckburgh House that I keep my horse Storm. That bald statement by no means conveys the emotion behind it. There are two things in life that I have come to rather later than

other people. One is fatherhood, the other is hunting. In order to hunt, you must have a horse, whether yours or somebody else's. Borrowing or hiring horses deprives the rider of some of the intimacy between himself and his animal, as well as exposing himself to the risk of the unknown. Owning a horse, on the other hand, not only opens up a hitherto unimaginable world of expense, it also introduces you to the parallel universe of horse owners of which, ordinarily, you would be entirely unaware. And yet, once you are part of it, there it is, a universe as solid and corporeal as the other one you inhabit, only operating by rules that are completely different from those you are used to. That is the thing with horses. Almost everything is the opposite of what you expect.

Not that I have gone very deep into horse ownership by some standards. A member of the royal family once asked me if I had a house in the country. Not a house, I explained, but a horse. 'What? Only one?' she replied. 'How sweet!' In truth, I have owned only four horses, and even that includes Corky of whom I only owned a leg. But even one horse is a ticket to the platform 9¾ that takes you to the secret other world. Or a ticket, in my case, I should say, to St Pancras station, with its half-hourly train service to Kettering. It was the horse that made us buy the cottage at Geddington.

In theory I should never have bought Storm. Word of him reached me from a friend. She had been entrusted by her brother with selling a ten-year-old gelding, and if by any chance I was looking for a horse, he might suit me. Only I wasn't looking for a horse. I was temporarily off hunting, and quite relieved, with a young family, that one source of expenditure had been closed down. Only Storm had been previously owned by a field master in Shropshire, so he must have known his job. And a horse with a name like that was going to be quite an animal.

I didn't appreciate that he was not really called Storm but Robert. Storm or, to be exact, Mountain Storm was merely the name on his papers; in the stable, people (and presumably other

horses) knew him by the more prosaic alternative. If I had been aware of this sobriquet, I might not have been so predisposed in his favour. But just as one likes to own a good-looking horse (whether or not looks are a guide to performance), so one's horse should also have a good name. A well-chosen name denotes character. It declares the extent of the rider's aspirations for himself and his mount. With Storm – Mountain Storm – I felt I was entering the *Sturm und Drang* world of the early Romantics. It could have been a horse called Storm on which the painter David showed Napoleon crossing the Alps. He is less likely to have been named Robert. A horse called Storm does not come up every day.

And once I had ridden him, that was the end of it. I bought him. Which is strange, in some ways, because he was not a well animal. A very little effort exhausted him. But I thought he was trying, and would try even harder when he was better; and I was right.

I am spending the morning sitting on a stool in Sue Muirhead's kitchen, next to the wire cage for her dog, drinking coffee from a mug which says 'Good Girls Go To Heaven, Bad Girls Go Anywhere', and planning my programme of hunting days. Nothing is quite as straightforward as you would imagine, given my need to balance the only limited tolerance that Naomi has for my hunting on Saturdays with my *Country Life* work during the week; as well as the different demands that are made on Sue's lorry. The week that it would be most convenient for me to hunt she will be away hoping to sell a horse at the Equilibra sale. With Sue goes the lorry. Without the lorry Storm cannot get to the more distant meets. Never mind. I mark down potential days in my gorgeous maroon patent-leather Filofax in red biro – they are red-letter days. The first is tomorrow.

AUTUMN

Saturday October 30

A few weeks ago, as I was walking through the offices of *Horse and Hound*, next to *Country Life*, I noticed a crate of old books being thrown out. On the top lay a copy of G. J. Whyte-Melville's novel *Market Harborough* (republished for the *Horse and Hound* centenary in 1984). I enjoyed reading it more than I expected. It is about John Sawyer, a young blade who abandons hunting in Sussex to have a go at the 'flying countries' of Northamptonshire and Leicestershire. I had always thought that Melton Mowbray was the Mecca of hunting but Whyte-Melville describes Market Harborough as 'perhaps the best headquarters in the world for fox-hunting'. And he knew about hunting. He was killed at the age of 57, hunting with the Vale of the White Horse.

I can sympathise with one of Sawyer's predicaments. He was laughed at for wearing a velvet cap, rather than a top hat. Only a few people wear top hats these days; the majority of the field wear riding hats that fasten under the chin – a sacrifice of elegance for safety that older followers tend to lament. The other day, hunting from Market Harborough I was mortified to find that mine was not in the tack room; it had disappeared. Heaven knows what happened to it; presumably I took it off and left it on a grass verge. I tried one of the girl grooms' hats which didn't fit. Then I investigated a hat smothered in cobwebs at the back of the table in the tack room, which turned out to be my old one. I brushed off the cobwebs and dust. The buckle of the chinstrap had rusted into place, otherwise – if not elegant – it was at least adequate. But it has an unfortunate medicine ball silhouette, and the colour is what the Victorians would have known as rusty bombazine. It sustained a big dent at (I think) the *Country Life* team chase a few years ago, reducing its protective property. In short, the *feng shui* was bad. I looked for another one during the week, only to find that Giddens in Clifford Street – the Harvey Nichols of equestrian outfitting – had gone into liquidation seven years short of its bicentenary. I found a new hat, at extravagant cost: a nearby bootmaker had bought the Giddens stock. But the passing of any

institution which has existed for nearly two centuries ought to be mourned.

I reflect on this as, wearing my new hat, I trot to the meet at Winnick Grange. The weather has changed since the last time I was out. Then, Rosemary Black, a grandmother whom I have heard called – most ungallantly, though she seems quite proud of it herself – the oldest member of the hunt, was saying it was the coldest October day she had ever known. This morning it is misty and threatening to drizzle. I think it will be a good scenting day, and I suggest this to a long-time member of the hunt when Storm brings me alongside him. He demurs. It isn't cold enough, he says; and certainly by the time we reach the field where the meet is being held I feel perceptibly hot.

There are over a hundred other riders circling around, accepting glasses of port and making the strange sort of conversation typical of these occasions – apt to be interrupted suddenly when the horse moves off. Hounds (hunting insiders never use the definite article) sniff energetically around the stationary figures of the huntsman, Peter Jones, and his whippers-in, or whips (the term that was appropriated by the House of Commons for the party managers who organise MPs). 'Have you got all your shoes on, Clive?' asks Jane Brudenell cheerily. 'Last season you always lost a shoe.' While we wait to move off, the sky darkens and I expect to see an angel blowing the last trump; strangely, the downpour that this seems to presage never happens.

Autumn leaves blow into my mouth as we canter. Beneath our feet is old pasture, as soft as corduroy and similarly striated with old ridge and furrow. We are galloping over acres of this glorious bumpy turf, hardly interrupted by roads. 'Strangers, when they first come out with the Pytchley, find the ridge and furrow very disconcerting, especially if their horses also are unaccustomed to it,' comments Guy Paget in his *History of the Althorp and Pytchley Hunt* – a masterpiece of its genre – published in 1937. Most of the ridge and furrow was created by the medieval system of farming, which divided landownership into long thin strips; ridges were needed to drain the heavier land. If you hunt, you love it. But even in Northamptonshire modern agriculture has

destroyed more than three-quarters of what survived after the Second World War, and the twenty-first century will be even more ruthless, probably, unless some Cabinet minister wakes up to what is happening to farming. Unfortunately, none of them farms or hunts.

There are masses of fences today. I would swear at someone who nearly knocks me off as we go over one obstacle, only I used up my reserves of expletives when changing a halogen light last night. At the next fence – quite a stiff one with a hedge concealed behind it – someone refuses in front of us, and Storm won't jump. I am disheartened, but the experience isn't repeated. Storm is on song. I wish I could share my hip flask with him. It is filled with vintage port which some kind person once gave me at Christmas. (Actually it is not so much a hip flask as a blue plastic Milk of Magnesia bottle. The attraction of the Milk of Magnesia bottle, over a silver vessel, is that plastic doesn't bruise you if you happen to fall on it.) For all that, it remains a very poor scenting day.

Scent, the kind excreted from the pads and anal glands of the fox, is one of life's unfathomable mysteries. No one knows what chemical compound it consists of, or which part of the scent (feet or bottom) hounds follow, or why it is that they sometimes fan out across a broad line, while at others they run in almost single file. Yet foxes are the most talked-about of Britain's 70 native species of mammal. In the 1930s, someone called Pollard invented a Scentometer. From readings of air temperature, humidity, wind speed and direction, and the amount of cloud in the sky, Pollard thought it was possible to calculate whether the fox's scent was likely to be strong enough for hounds to follow; if the chances didn't look good, the hunting man could stay in bed. In a mahogany case covered in dials, it looked like the bridge of a steam launch. Quite useless, of course. And I would have been sorry if it had worked. Hunting is like religion: it reminds clever modern people how much they don't know.

I say 'goodnight' (as custom has it) at a quarter past one: William has chickenpox and I do not want to stay out too long. Waiting for the lorry, I discover that Storm has lost a front shoe.

It must have come off in that boggy bit, as I knew it would; or perhaps he knocked it off with his hind shoe. And since Jane Brudenell comes up with coffee and ginger biscuits, my state of shoe loss cannot be concealed.

Kettering, not Concorde, for me

Sunday October 31

We arrive at Geddington just as the vicar is getting into a little red car – a woman! She is folding her surplice, with the care of someone who understands ironing, into the boot. The contents of our boot are somewhat more pagan, including the pumpkin lantern made by Naomi last night and transported in the wrapping in which my new riding hat came.

After lunch, we attempt to give bread to the ducks by the ford, but they aren't having it. They just put their heads back under their wings. Overfed, ungrateful fowl. Then we wander across the bridge to take a look at the terraced cottage that we have affectionately named the Slum. The other day an estate agent called Paul drove up in a silver Toyota to take us around it. The key to the front door doesn't work, so we approach through the back, via the paddock of old cars that passes for a garage. There is a tow truck removing one of the dead vehicles while we do our tour of inspection. I cannot say that there is that much to inspect: two rooms on the ground floor, a staircase, two on the upper floor, a concrete square of yard, one shed that could be knocked down, next to an empty area fenced off for some reason, which should also belong to the cottage. Demolishing the shed and this fence could create a slightly less minuscule area, big enough for a table and chairs.

Having lived through the excitement of one property transaction, Naomi is keen for another. We could buy it with more money we do not have, get in a trendy design friend to do it up, and sell it on, or rent it, she says; buying property makes

you light-headed. The rentals market in Geddington may not be Tri-Be-Ca, New York.

Soon it is dark and time to illuminate the pumpkin, which we do with great ceremony. But our organic pumpkin – somewhat bigger than a cricket ball – has been outgunned by the house next to the pub. Yesterday I noticed a couple of enormous pumpkins, as big as tractor tyres, displayed in a window. Today, I see one of them has been carved with an elaborate willow patterny scene of a bat flying over a churchyard. There is a pumpkin mask beside it and another on top of the bay window of the next-door house. A witch has been hung up on the first house, with a machine for making spooky noises. While we are admiring all this, the owner comes out. She is American and moved in two weeks ago. She produces a skeleton Snoopy who plays a theme tune when you squeeze his paw. 'Happy Hallowe'en everybody,' says William.

While we are sitting in the parlour of the cottage there is a banging on the front door. This is useless, because we cannot open that door. (There is a key but we can't make it turn.) We go outside and see two rather discomposed witches hammering away. They see us and adjust their hats. They are very demure witches, too shy even to say trick or treat. I put £1 into the pillowcase that they are holding. I don't understand the rules of trick or treat. Are we supposed to provide a trick/treat, or are they? It didn't exist when I was small. The pound appears to be the answer to everything. Trick or treat could be called extortion with menaces.

Monday November 1

For some days the car has been full of bin liners and the discarded packaging from the Hoover. Today I lay this sacrifice on the altar of Kettering Recycling Centre, which we have come to know as the Dump. The wonder of the Dump is that it not only receives but sells. There is a kind of permanent stall of chairs, bikes, baths, teapots, electrical goods – all looking as though they have been washed up from the great wreck of life. Men climb on top of

the skips, scavenging through the black plastic bags at their feet: the modern equivalent of gleaners, picking up the stray ears of wheat that the fat harvesters have let drop.

I can hardly believe so much is for sale, but it is. There is a shed where every wall is stacked with chairs, some of which are wired on to display them better. Outside the shed are two perfectly stable Edwardian oak chairs; presumably their location indicates a lack of appreciation. I go into another shed and inquire about prices. 'The pricing mechanism is outside,' announces the proprietor. 'Where is she?' A kindly woman prices the two Edwardian chairs at £2.50 each. I say I'll also have one of the Windsors. 'Six quid the lot,' she pronounces. The sale of the tot pays for the Dump. Rubbish trades on rubbish; a complete life can be constructed from the cast-offs of others.

On our last visit when we deposited a couple of bags full of packaging, we left with a car full of 1. an upholstered chair without a seat; 2. a selection of video tapes; 3. a wooden tray (wormy); 4. various plastic vehicles with which to clutter up the garden. Then we went to Comet for a washing machine, freezer and tumble-dryer, to generate more quantities of expanded poly-styrene for us to take to the Dump. You could write a whole opera about it, really. I am reminded of the dust mountains in Dickens's *Our Mutual Friend*, symbolising the whole capitalist system.

I read in the papers today that a couple of trick-or-treaters in Coventry had kicked to death the kitten of a householder who had failed to deliver. One of the boys had booted it into the air with his foot, the other had hacked at it with the plastic sword that was part of his Hallowe'en outfit.

Wednesday November 3

Work takes me to Northumberland today. Derry Moore is photographing lots of different people from the hunting com-munity, and I am there to see if I can make any of them smile. Derry considers too much cheerfulness in a photograph to be

vulgar. We stay with his friends, Sarah and Duncan Davidson. In 1972 Duncan founded what is now one of Britain's largest house builders, Persimmon plc, which currently has a land bank of 50,000 building plots waiting to be developed. As a result, the Davidsons themselves are in a position to live on an estate far from any neighbour, in one of the least developed counties in England.

Most of the trees in Northumberland have now lost their leaves, but not in the park here, so beautiful in its streamers of gold and red. The house itself is not absolutely beautiful, more indestructible. But it has been made, against all the odds, extremely comfortable, with the air of having been a family home for generations. There is a view out towards a circular tower that has just been built of stone, to the design of the bookseller Henry Potts.

A butler wearing a jumper emblazoned with HMY *Britannia* takes our bags. Then we eat some sandwiches, and go out into the stable yard to photograph the girl groom Dawn. She leans on a broom, in different poses, for an unconscionable time, given that even to me, wearing a Barbour, the wind feels pretty sharp.

Off we go in the car to meet a former farm worker called Arthur Smith. By dint of borrowing a field, he is able to keep a horse and, at the age of 68, hunt every day that he can.

Back at the house, Duncan erupts into the room. 'Gather you like our tower. The reason it is good is that it wasn't designed by an architect. We sell 7,000 houses a year, and never use an architect. From that you can gather that I don't have a high opinion of architects. You're not an architect, are you?' We go off for our baths, and when Duncan reappears he is wearing a bottle-green velvet smoking suit which looks like pyjamas. The guests are marched into the dining room double quick, because of a soufflé. Afterwards Duncan, who is very generous with Château-Giscours and cigars, expounds on the housing conundrum. He simply provides houses for people who want to buy. They cannot all go on to reclaimed industrial wasteland, and two-fifths of them occupy green field sites. He persuades me that I should go to the estate village at Deene; the houses are all rebuilt

by Persimmon for sale. I describe the whereabouts of Geddington. 'You shouldn't see the houses we built on Buccleuch land near Kettering.' Obviously they are not Persimmon's showpiece. But where are all the new houses to go? He doesn't know any more than the government.

When dancing with Dawn, he had asked how old she was. 'I wish I was twenty-two again,' he had then said. 'So do I,' she had replied. He is rather proud of that.

Thursday November 4

I wake at 5 a.m. to have a pee. Then not until 7.50 – for me, an incredible feat of somnolence. Derry's assistant Gavin had been banging on my door several times, and even ringing. I didn't hear a thing. A big bed with an eiderdown, and heavy curtains that shut out all the light – these, and general tiredness, were what did it. The alcohol, though prodigious, was more a hindrance than a help.

Everyone is at breakfast by the time I descend. All the papers are laid out on a table. Duncan roars at me, because I have failed to notice *Country Life*. On the sideboard are poached eggs, sausages, bacon and black pudding. Duncan storms through his plateful as though it were something not so much to eat, as defeat.

We have a quite wonderful drive over the Scottish border to St Boswells. There we meet Dot Hogarth, who is now in her eighties, and first hunted in 1919. She only stopped when she found she was less good at seeing barbed wire. Since her cataract operation, she can now see wire again, and regrets having stopped. The point-to-point has been held on her farm for 51 years.

Thinking of the end of hunting in Scotland she says, 'I could weep for my pensioners.' For them, following the hunt is free. There isn't much else by way of amusement.

We catch the 2.30 p.m. train from Newcastle. Outside Doncaster we pass an enormous billboard for Persimmon Homes.

I phone Sue Muirhead on my mobile and I am upbraided for

Storm's feet. 'The farrier thought Debbie had been riding him and gave her an earful. The reason you kept losing shoes last season was that the hoof had worn right down. There wasn't enough of it for the nails to grip on. After six months, the hoof was just beginning to get right, and he remarked on it when he was shoeing Storm, in an emergency, on Tuesday night. By his visit on Wednesday, it was broken right down again. He was furious.' Oh dear, I said. 'We have to hope for the best. At least you weren't killed,' she says, more matter-of-factly than I might have wished. 'It was a front shoe. They think that the loss of a front shoe caused the fall which broke Peter Jones's collarbone (by the grace of God, not his neck) last season. A horse can tread on a stone, and then he goes down like a stone, because there is no shoe to protect the soft part of his foot.'

I shall run away to sea and become a sailor.

Friday November 5

Last night I did not reach Geddington until half past midnight. It was just as well I was tired, given that I had to sleep in a sleeping bag on the floor. Today, I go to Kettering in search of a bed.

The Kettering Bed Centre is found in Regent Street, which is not so grand as some other Regent Streets: a real red-brick Midlands street, humdrum and squat. But there are beds and beds and beds: so many that my spirit quails before them. A salesman overwhelms me with hand-tufting and pocket-springing, and the number of springs there are to a mattress. I choose a bed with a wooden frame, as suitable to the cottage, and a mattress made by Staple's because it has a royal warrant. Her Majesty must know a thing or two about beds, with the number of palaces she has. They say they can deliver today. When they do the cottage will become more than a number of walls enclosing a void: almost a habitation.

We have been assembling furniture from a number of sources apart from the invaluable Dump. The jumble sale in Warkton village hall – not a lot bigger than a garden shed – provided

two apricot-coloured kitchen chairs, a Parker Knoll wing chair, quantities of books, old plates, and some poignant little objects, which we discovered when we unpacked the boxes at home; they must have meant something to the people who owned them, but now only speak of old age. 'The chairs are 50p. If you give me a pound I'll throw in the cot.' So we took all the above, including the cot and various partly complete toys. Everything else from the jumble sale was being packed away into bin liners when we arrived at three o'clock. The organiser was the only person left in the hall. Jumble sales work on the following principle: doors open at 2.30 p.m.; there is an immediate stampede of pensioners looking for bargains; 2.40 p.m. proceedings finish. We pulled a tartan dressing gown out of a bin liner but there are limits.

A postcard in the village shop window led us to one of the suburban excrescences on the Kettering road, where a man with a moustache was selling some of the 1930s oak furniture that his late father had owned. We crunch over the tidy gravel to the equally tidy garage, and the cloth that covers the gateleg table is swept away with exaggerated pride of possession. I buy the table along with a couple of carver chairs, resisting the hat-cum-umbrella stand. I put down the seats at the back of the car. This means moving the children's seats, to reveal a mouldy apple core, biscuit fragments, empty bottles, etc. The back of the car contains a plastic policeman's helmet, my wellingtons, fragments of a warning triangle deconstructed by children, bags of rubbish destined for the Dump. I spread out blankets and the man, with a final flick of his hand to brush away specks from the table top, helps lift the table into the car. Then he jigsaws oak chairs into the back. The man is regretful that I have not taken his hatstand, assuring me that it really isn't that big, and if I could find a space for it, I should let him know. I could make him an offer, he says.

Today I go to John Reed, the upholsterers. Women stitch lengths of black tape on very old sewing machines. The proprietor, Mr Reed I suppose, is showing a lady customer a variety of foam fillings for three piece suites. Mr Reed junior appears, and we go downstairs to the car. I stand my priceless heirlooms

– one from the jumble sale, one from the Dump – on the pavement, while we look at them in the rain. The Parker Knoll is regarded as an aristocrat among chairs: 'always worth upholstering, they last for ever'. Even the tub chair from the Dump is not condemned as irredeemably verminous, and I leave both exquisite pieces with Mr Reed, though he probably cannot do anything to them before Christmas.

Lunch at the Star sees everyone looking out of the window in case the bed arrives. Peter gets on to the council to remove the rubbish bin. Last night the tables outside the pub were piled one on top of another, with the bin as garnish.

It is still raining, which doesn't augur well for Guy Fawkes night. There are now very few private fireworks. What people do is to go to the boating lake at Corby, where fireworks are laid on by the council. Last night, there were fireworks at Wicksteed Park, the adventure playground at Kettering, which cost £5 a car to get in.

When the bed does arrive, towards the end of the afternoon, it is quite clear that it won't get up the stairs. The stairs are steep, narrow and have an awkward bend. The wooden bedstead is too tall. First man shakes his head. Second man glowers at me, 'Are you sure there is no other way upstairs?', as though I was deliberately concealing the existence of the imperial staircase at the back of the cottage. The three of us manage to snake up the mattress, though, so I suppose one mustn't say die. They will come back tomorrow with another frame. I must shop before hunting.

I cannot reach Naomi because she is at a fireworks party. I cannot go to Corby boating lake because it's too late and, besides, a very damp night. At a low ebb, I think about supper, only to realise that most of the options are invalid because of the absence of 1. a saucepan, 2. a tin-opener, 3. a corkscrew. I am too tired to borrow the last item from the pub. I eat toast and smoked mackerel, and apple, washed down by a cup of tea. It sounds as though World War Three has broken out over Corby. I sit in my own private nuclear winter.

Saturday November 6

I still sleep in the sleeping bag, but on top of a mattress, which is an improvement.

It is my first day's hunting from Geddington. But first I must go to the Bed Centre where I arrive ten minutes before nine. I try to conceal hunting kit beneath my Barbour, unsuccessfully. I choose a bed with metal frame and legs which detach. This must get up the stairs.

As I hack to Sibbertoft, red rosehips and berries shine in the bushes, and at the meet I attach my own dot of scarlet to my coat, in the form of a poppy.

On the hill above Hothorpe Hall, with its view of house and woods, I talk to Richard Spencer, the field master, about the scene before us. We are photographing his daughter Polly as a frontispiece for *Country Life*. We then set off towards a post-and-rail fence, and I feel so much part of the inner circle, as well as confident after the successes of last Saturday, that I follow immediately behind him. Second in the field. But there is a dip in front of the fence making it considerably more difficult than it looks, and the impossible happens. Storm stops. A woman has to pull up behind me, saying 'Bloody hell.' I get over second time round but what a humiliation. Pride comes before a stop, as well as a fall. At least not many people are out today. David Miles, a local farmer who used to keep his horses with Sue Muirhead, offers to sell me Patrick 'if I ever need a decent horse'. It is his comment on my riding.

I talk to a farmer who is hunting for his 42nd season with the Pytchley. He remembers the era of 'Colonel Lowther and the majors, when it seemed that everyone was in the services, and they spoke to you as though they were sending their men into the Somme'. The world, not just the Pytchley, has changed. Now it is a friendly pack; but whatever the faults of the majors, my farmer has an affection for the old days, when people wore 'pink tops' to their brown boots when they were cubbing. (I'm sure he said pink tops. Sue says he can't have done, but they are a nice thought all the same.)

We come to another stout post and rails, perfectly easy to the horse but less so to the rider, because of a big drop on the other side. Storm refuses. 'I didn't think he was going to go over,' comments Joan Tice (the most senior of our four masters) to nobody in particular as she sails past. We get over this one at the second attempt, but altogether the success rate is only about 50 per cent. We set ourselves at a big hedge with a post and rails in front of it, but try as I may we do not get over. So I nip round the side with half the rest of the field, then back again, and someone says: 'This is a good place to watch them coming over the hedge.' First over is Richard Spencer, of course, but his horse does not see the post and rails – it looks like only a hedge from the other side – and catches his hooves in it. He comes crashing over, and so does Richard. Richard lands on his head and shoulder, and sits by the hedge holding his lip, while Dallas, who is a doctor, tends to him. But he gets back on after a while.

At Geddington, the bed arrives. I construct the cot, bought from the jumble sale, with more difficulty than expected. It must be pine but can I get the screws for the brackets to go all the way in? I cannot. It is also missing a bolt. Naomi and the children arrive. William says he has a good name for this cottage: Everything's Fine Every Day.

I remove a bolt from the cot to take with me to buy another, and put the screwdrivers out of the children's reach in a cupboard. We rush to the Dump (we buy table, tray, plates, tape of steam engine noises – half of which we leave behind), then to Argos for Johnny's sheets, bumper set, some glasses and saucepans. At Do-It-All I find I did not take the bolt after all. I buy garden wire. We buy a telly from Comet. Naomi gets food shopping from Lidl. We return home for a meal of frankfurters, toast, beans and fried eggs, eaten around the oak table.

I wire the cot together, but my efforts at changing the jack on the telly are not rewarded by obtaining a picture. The atmosphere is too fractious to start on the bed. But remember: Everything's Fine Every Day.

AUTUMN

Johnny cries in the night, but the cot does not collapse.

His best friend Patrick arrives by train with his mother, Clare Brown, and after a couple of hours of failing to meet them, because Naomi's mobile phone had run down, we extract them from the McDonald's where they have been soaking up the sights and sounds of Kettering, and have lunch in the Star. The children climb everywhere in their excitement. 'You must not play with things on the bar but go back to your parents,' says Anne, Peter's partner, between gritted teeth. 'Sit down at the table,' booms Peter, looking more Old Testament than ever. We arrange to carry the rest of our meal back to the cottage which suits all parties. On Sundays, though, the Star serves only traditional Sunday lunch. I'm sorry to say this, Mike the chef being my new friend, but it is the sort of thing which gives English food a bad name.

I am let off driving to London and we all go back on the train together. The paraphernalia is mountainous. Three cases for me, the pushchair, several bags, plastic and otherwise, hanging off Naomi, coats, Sunday papers, etc. 'You go to the platform while I buy the tickets,' I command. But after I have bought the tickets, they are still on platform one, when the train leaves, in approximately fifteen seconds, from platform three. So we hurl ourselves down steps and through the tunnel, and up steps at the other side. The adults bundle possessions, children and themselves on to the train. Second class is full up, so I march down to the first class carriages – only a pound extra at weekends – looking for space. I step literally over Sally O'Sullivan's two dogs. Sally O'Sullivan is the terrifying queen of magazine publishing. She looks up from the letter she is writing in a big girlish hand. It is not a moment for making small talk to a magazine doyenne, so I step over the dogs again and slump down in another carriage. Throughout the journey, the boys enchant somnolent passengers by running up and down pretending to be helicopters.

Monday November 8

Kettering is not a town that is forward about its charms. Walking up the hill from the station you pass the Kettering Centre for the Unemployed, the Driving Standards Agency, the Health and Mobility Centre and, finally – in case your spirits have not been adequately depressed – a shop selling garish remnants of old carpet at bargain prices. It is not a swanky town, or a bijou town, or anything much of a town. If you arrive by car, from the Northampton direction, your first sight of Kettering is a horrible clutter of pink-walled and orange-roofed housing estates straight ahead; immediately to the left, a dump of used cars. 'Kettering is a dump town,' says one of my neighbours, who does not admit to going there now. But I find that the ordinariness of the dump town is oddly touching. And it has a reasonably efficient – quick, when on time – train service to London. And thank heavens for the Dump itself.

We go there today, inevitably. We have to because of the quantity of cardboard and transparent plastic sloughed off by the bed and TV. Just as people who live in cottages (except us) are very tidy, neat and unburdened with possessions, so they must also generate little rubbish. How does the council expect families to survive on only one rubbish collection a week? This collection takes place on Friday mornings. I forgot too late that this was one reason why I was intending to come on Thursday evening – to put out the wheelie bin on to the pavement. But the capacity of a wheelie bin isn't infinite, and our one certainly isn't equal to the expanded polystyrene tide flowing out of our cottage.

It reminds me of the huge jawbone, presumably from a whale, that is kept in the church at Stanion, near Corby. It is supposed to come from an enormous cow, whose boast it was to fill any vessel that was presented beneath her with milk. A witch came along, and milked the poor animal into a sieve. The cow heroically produced more and more milk until it died. For milk read white moulded packing. For vessel read wheelie bin. For sieve read the Dump.

When we arrive at the Dump we have to give it the once over, somewhat against my inclination, and we leave with a Lloyd Loom chair, a bedside table, a trolley (Edwardian I should think, though with sodden baize on top), a coffee table from the 1950s, some glass dishes, a beaten-up brass umbrella stand with elaborate coat-of-arms (the sort of thing that usually goes with horse brasses) and sundries, all for £12. I can't see the beauty of these purchases at first, and I am not, if I am absolutely frank, in the best of tempers as I try to cram this collection of old junk into the car.

Wednesday November 10

I discuss address cards with Naomi. We decide on the name Midway Cottage and unconventional sized cards to fit the same envelopes as our letter paper. We found the name on a letter that had arrived for someone who has moved away from the cottage. It sounds nicer than 2, Grafton Road. We shall have to get some means of identifying the cottage on the front door. This way we can also direct visitors to the garden entrance, to stop them banging on the (apparent) front door.

I tell my assistant Pollyanne to reject the offer, put to me by a travel PR, of a weekend flying Concorde to Barbados, to stay in luxury, eat fine food, be taken sailing on a catamaran, and the like. I would rather be in Geddington. It is Kettering, not Concorde, for me.

Did you. See. Anything.

Thursday November 11

There has been more carnage, and this time on the doorstep of the village. Keith the builder brings the news. In the early hours, a BMW was smashed into by a lorry just by the entrance to Geddington from the A43. The men in front were killed instantly – 'write-off, not a chance,' says Keith – and the other passengers are in intensive care. The lorry veered off the road and hit the old wreck of a camper van that is parked on the grass verge.

I go to the Star for lunch. One of the regulars, a generally friendly young woman, ask me what I think about hunting. 'Hooray Henries on horseback,' she replies, after I have said I am for it. 'But then I don't really know anything about it. And as you said, the world has to change.' Except that I hadn't said the world has to change. I am usually quite pleased when it doesn't.

A man called George asks if *Country Life* would cover the Geddington Volunteer Fire Brigade's sponsored paddle. What is he talking about? The idea is that the Brigade will paddle from Geddington to the Wash, a distance of about 70 miles. Only he does not tell me what a Volunteer Fire Brigade is.

When I get back, Keith is still at work. He has reorganised the kitchen so that the oven door opens. Childproof window locks have been added to all the windows except that which William most often opens, the one to his room; it has a metal frame. The washing machine has been plumbed in. The bathroom wall is now graced with the Do-It-All bathroom cabinet – fantastically extravagant at £20 – which I now find will not shut.

AUTUMN

Friday November 12

Today I am standing in the ford, with the chill seeping first through my wellingtons into my feet, and from there through my entire frame. A newspaper wants a photograph of me in Geddington, with family. Only Naomi has missed the train after Johnny's best friend Patrick fell off the trampoline at Tachbrook Street and was momentarily concussed. At Kettering station, she could not find a taxi. So, with the light failing, I stride out into the Ise on my own.

Finally a taxi rumbles into view, and the photographer is delighted by the contrast to myself in Barbour and cap that is formed by Naomi in Selina Blow tailored coat and enormous dark glasses. The children are not on top form. Johnny still has chickenpox and William is unprovided with boots (which I had left outside his bedroom at Tachbrook Street). Consequently he rolls up school uniform bottoms to the knee and does his best to wade in anyway.

Keith has gone by the time we get back. Shortly afterwards, though, another player steps on to the domestic stage in the shape of George, the aerial engineer. He is very anxious to explain the process of mending an aerial. Ours provides a real challenge. A device called the masthead booster – or something like that – has been incorrectly wired, with freakish results. And the sort of aerial plug that has been supplied by Comet is unlike anything George has seen before. I think he will never leave. There is a limit to how much any one person can hear about aerials.

Naomi has established that it would not cost very much to do up the Slum, if we are careful. We have discovered, however, that the space on the other side of the fence which would have formed a sitting-out area does not belong to the Slum; and furthermore, it contains the lavatories for the garage. The noises might detract from the stylish design effect we have in mind. Naomi, however, is undeterred.

I actually feel quite feeble at this point of the day. After a cup of coffee, though, I begin on the bed. This makes a significant

demand on the intellect, but is quite straightforward really, once the geometry has been mastered, except that the very last bolt refuses to go in. I try it every way I can. I loosen the other bolts to give it a chance. But no, I can't get the thing home. I can't take the bed back to the shop: it would mean disassembling the whole thing, which is unthinkable, and erecting another bed, which is too frightful to contemplate, quite apart from the tedium of not having a bed in the interim. The bed I have made is good, but it falls short of perfection. It makes me feel that I have fallen short of perfection.

So the bed is up, the children are asleep. There is a pronounced chill, due to the fact that Johnny turned off the night storage heaters in the kitchen and dining room last time he was here. But an air of playing at housekeeping – rather than housekeeping as chore – pervades the set-up. It is still only Friday night and it feels pleasurably like Sunday.

Saturday November 13

By rights, it should have been lucky, since Pete the sweep came this morning. (There is something about sweeps being lucky, isn't there?) Pete lives at a cottage called Mole End, and came with a big vacuum cleaner and an assistant. Together they struggled to get his brushes up the narrow necks of our fireplaces. There were sheets down everywhere, but thanks to the vacuum system, no mess. I went outside to see the brush poking out of the chimney top, a sight I have not witnessed for thirty years. Pete is a man of few words, but there is nothing wrong with his reactions to judge from the speed with which he dropped the transformer thing beside the fireplace. I was asking him what it was; he plugged it in; I then drew attention to the oddity of a detached wire.

This is Pete's busy time of year. 'It's been mad,' he said disapprovingly.

We make the second of the day's trips to Sainsbury's, so that Naomi can search for two red buses that Johnny had left at the

43

bottom of the trolley on the previous visit. While this happens I go to buy a casserole from Wilkinsons. Wilkinsons could loosely be interpreted as the Peter Jones of Kettering. But it sells mugs – rather attractive hand-painted ones – for 29p each. This is a pretty good price for mugs, though not quite as good as the sets of three ballpoint pens in a little plastic case which Naomi found on the last outing: they cost a penny each. She ought to have bought the whole box.

There are now bunches of flowers attached to trees where the accident took place. The police have erected three enormous billboards asking DID YOU. SEE. ANYTHING.

Sunday November 14

I drive to the Co-Op beyond Weekley to buy onions, forgotten yesterday. I buy (from the village shop in Geddington, which does not sell onions) the *Sunday Times* and *Sunday Telegraph*. As I arrive back, formations of cubs and the British Legion are assembling for their procession to the war memorial, wherever that is.

At the cottage, Naomi is unhappy at lack of the *Observer*, which carries a feature on the first book of her company Naomi Roth Publishing. So I go back to the village shop. By the time I return, the cubs and veterans have drawn up, on this drizzly morning, in the churchyard, revealing the war memorial, a tipsy stone cross, on one of the hummocks. I am the last to tag along as they troop into the church.

St Mary Magdalene, Geddington, is not one of those intensely atmospheric churches which immediately fill your nostrils with the polish-and-dust (enriched with incense if you're lucky) smell of ancestors having worshipped in this place for centuries. The plaster has been stripped from the walls to expose the bare, grim stone. (Doctrinally as well as aesthetically unsound: 'And flocks shall lie down in the midst of her, all the beasts of the nations . . . desolation [shall be] in the thresholds; for he shall uncover the cedar work' (Zephaniah 2:14). Zephaniah would

have presumably have added 'and stonework' if there had been any around.)

High up on the inside wall of one aisle is a run of Saxon windows; when they were built, the church consisted of only the nave. Then the Normans extended it, putting a row of arches into the lower part of this wall – without, amazingly, disturbing the upper part. The other curious thing about these arches is that they number two and a half. Presumably they planned to complete the third one, but didn't. Every succeeding century has left some mark on the church. The Tresham family, one of whose members played an inglorious role in the Gunpowder Plot, gave the screen, which used to stand in the chancel arch but was moved to a side aisle when the Victorians made the arch higher. There, in the middle of the screen, is the date, 1618: notable because of what would then have seemed the horribly old-fashioned Gothic style. But the Treshams were crypto-Catholics, and the old ways must have had special meaning for them.

Country churches are supposed to be dying but not this one. The congregation's loyalty is remarkable, given that the parish (joined with Weekley and Grafton Underwood) has not had a vicar for two years. The bishop has reorganised the priest's role so that the new incumbent will not only have two parishes but will be the ecumenical officer as well. No one wants the job. Meanwhile, the congregation makes do with one retired priest, who last time preached a somewhat literalist sermon on the second coming, and the lady vicar (if that is the right designation) whom I saw the other day; she has wound down her commitments due to ME. Today the church is so full that I can only take a seat at the back.

At the opening of the service, a couple of old men, medals on chest, carry a banner to the altar, knocking the top on the screen, followed by one of the cubs. The roll call from the First World War is, as everywhere, astonishing. The man at the lectern must have read 25 names; Saxon names, like Brains, Crick, White, etc. The number seems huge in relation to the size of the village then. I suppose all of them worked on the land, or came from families who did so. The hymn 'O Valiant Hearts . . .', with its lilting

melody, I did not know, but I found my eyes watering. At one moment during the service, a ray of bright sunshine pierced a stained-glass window and lit up a square of pew, just where two old ladies were sitting. They giggled to each other about it.

We are all ready to go out after lunch when Naomi realises she does not have her blue ring. I have seen the ring by the fire. It was previously by the sink but one of the children (William as it turns out) must have moved it. I then moved it somewhere – the table I think – for safe-keeping but it has disappeared again. We spend forty minutes looking through wastepaper baskets and bin liners, to no avail. By then, it is dark, and so is our mood. Still, we make the best of it and go to the antiques fair that we saw advertised yesterday. We drive there through the modern flotsam that has washed up against the town. Large sign boards advertise Persimmon Homes. Eventually we find the enormous aircraft hangar of a leisure centre where the antiques fair takes place. Or took place, because a steady stream of people is wheeling trolleys of goods out of the building to pack in their vans. The fair is nearly dismantled by the time we go in, but that does not stop us from buying plates, egg cups and a frame full of Victorian Christmas cards and découpage, arranged, unpromisingly, by someone who is blind, or nearly. I spend rather more than intended.

While these purchases are being made, William races around the aisles propelling Johnny in the pushchair, to the latter's only partial delight. The stallholders remain by and large cheerful (at least stoical) in the face of the regular collisions with bags waiting to be loaded into cars.

I am pleased to have acquired a plate printed with a hunting scene, even though it only dates from 1956. It could be viewed as reasonably pretty, if you like the subject. Most hunting art, fine and applied, is terrible. If I am in a good mood with hunting, I love those tea towels printed with foxes, bad watercolours and even the humour (Sue once gave me some aftershave called Huntsman's Breeches). At other times, I can't help finding it narrow and elephantine. I am an art historian, after all.

Tuesday November 16

It is a brilliant, sunny morning as I walk to the village shop. They are talking about the carnage as I come in, though it happened a week ago. 'There were pieces everywhere,' I hear Mrs Chew say to a customer. 'It was a real nasty one.'

At home, I contemplate the wormy wreck of an old wooden tray bought from the Dump and try to convince myself it is Georgian.

I am getting to love this cottage.

Wednesday November 17

The first thing I do when I switch on the computer this morning, when my brain is not yet in gear, is to search for Kettering on the Internet. Just Kettering. On a whim. There can't be another Kettering, so it isn't necessary to put Kettering, Northamptonshire. How narrowly parochial can you get. Of the 97,300 web pages which my search produced the top one was all about Kettering, Ohio. I felt like that time that I looked up my name in the phone book – to check I was ex-directory – and found not just another, unknown Aslet, but another C. W. Aslet, living in Plaistow. We are meant to be the only one-t Aslets in existence, for heaven's sake. Now I suppose that if I do an Altavista search for C. W. Aslet tens of thousands of web pages displaying Indonesian C. W. Aslets, Belorussian C. W. Aslets, Lapp C. W. Aslets will appear. I try to imagine some nineteenth-century pioneer wagon-training through the empty wastes of Midwestern America, reaching his apportionment of land, looking around and thinking, ah yes, this reminds me of dear old Kettering.

If we were in Kettering, Ohio, we could enjoy *Peter Pan*, showing on Fridays, Saturdays and Sundays in the second half of November, one performance accompanied by a sign language interpreter. Happily, the construction of a new restroom at the Fraze Pavilion is expected 'to have little impact on city's

treelighting ceremony'. The *Kettering-Oakwood Times*'s list of top local news stories is headed by 'Sugar Plum Event Benefits Children's Medical Center'. Second, a long-running planning battle over a pharmacy. 'Hot Air Balloon Makes Crash Landing Near WSU.' '35 Housing Units Approved by Kettering Council' (sounds familiar). 'Man Faces Indecent Exposure Charges in Oakwood.' The coyote population is exploding, says Rick Jasper, assistant wildlife management supervisor for Wildlife Division 5. Coyotes have attacked humans on 53 occasions over the last decade. According to Jasper: 'That seems like a small number but any attack is unusual.'

I then tap in Kettering, Northamptonshire. Four of the first ten websites are estate agents, but then we settle down to the real business of life. A quilting group meets once a month. Golfers are encouraged to swop experiences. The Kettering Bridge Club offers an alternative distraction.

A search for Geddington reveals that there is no other in the (virtual) world except ours. I find details of the parish council, the address of the vicarless vicarage and a website on the Eleanor Cross. Damn cheek. 'Eleanor was the wife of Edward I . . . footnote: He's the one played by Patrick McGoohan in the film *Braveheart*.' Bah!

Friday November 19

There has been an anxiety at the back of my mind that I shall forget to pick up my hunting boots. The cloth loops that you pull them on by had worn through, and they needed mending. So it is a relief to hurry off to Ravensthorpe, and look for the sign of the boot – painted so that it is not visible when you first approach it, only when you drive back through the village having missed it. Beneath the sign is a gateway, and through the gateway, opposite a brick house, is the long, leather-smelling workshop of Horace Batten, now an old man but still hard at work as a boot-maker, much to the satisfaction of his grateful, discriminating and sometimes grand clientele. Mr Batten's prices

are much lower than those in London. To own a pair of his boots shows discernment at every level.

Mr Batten's shop is a temple to the individuality of the human foot. The boots awaiting collection on the shelves – mostly, like mine, after repairs – speak eloquently of the legs they have been crafted to encase. Legs, on the evidence of the boots, that can be as slender as hand-rolled cigarettes or as stumpy as buckets. I commented on this, on my first visit, exclaiming over a pair whose calves ballooned out like hams, above surprisingly dainty feet. 'Guess who they belong to?' he said, and then named a royal personage who is usually seen in long skirts.

Gordon Winter, my old colleague, was once nearly killed when he fell while out hunting and caught his leg in the stirrup. He was dragged across a field and would have been killed, except that, providentially, his boot came off. I now realise that the correct response to this story should have been: 'It can't have been a very good boot.'

I had bought my first pair of boots, before I had met Mr Batten, second-hand. They were quite fine in their way, with patent tops, though with the oddity of laces at the front which caused some discussion among colleagues. Far more imposing were the wooden boot-trees, magnificently stamped Maxwell of Dover Street. They have to be assembled like a jigsaw puzzle every time they are inserted into the boots, and their presence makes the boots enormously heavy to carry. But Maxwell was Maxwell, the Supreme Being of hunting boot cosmology, and I felt very lucky to have picked up, for only a few pounds, trees whose original cost might have approached that of a small Henry Moore. The boots, made – since I can see you're interested – by Poulsen Skone of Jermyn Street, were discarded after a while; the laces formed ridges which caught in the stirrups, and I was worried that the jolly-seeming eccentricity would kill me if I was dragged along after a fall. The Maxwell trees were rewhittled by Mr Batten when he made the new boots. Only he whittled off the Maxwell stamp and replaced it with his own, which I now realise to be far more distinguished, though I may have gone through a

short period of mourning before this insight dawned.

According to Mr Batten, boot orders have taken a dip this season, because of people's concerns about the future of hunting. But fortunately he is not dependent on hunting orders, since he makes boots for racing as well. Only the jockeys never pay.

Today I am surprised to find a tall girl working on the bench, because, now I come to think about it, I have never seen a female cobbler before. Mr Batten presents me with my boots, looking uncommonly clean and polished. He says that they have done quite a bit of work on them because of a rough place on one. I hadn't noticed that it was on only one boot – a sort of scaly look. I have seen it on other people's boots before: I thought it just happened. The girl at the bench suggested that it was just a result of chaffing on the horse. 'Burn,' Mr Batten said, conclusively, inspecting it. I suppose I must have left it next to to a radiator or the tumble-dryer. My beautiful boots! However, he has rubbed the patch with neat's-foot oil, and if I do similar with oil, dubbin or household lard (except our household doesn't see much lard these days), they should last a long time.

Saturday November 20

It is a drizzly afternoon, and the boys make straight for the videos bought when they had chickenpox last week. Our walk to the village shop – closed, of course – is undertaken with reluctance.

On our return, I light a fire. The saying 'no smoke without fire' is untrue. I go outside and I am embarrassed to see smoke rolling heavily down the roof like some form of industrial pollution – I imagine for one hysterical moment that the roof is on fire. And yet the logs in the hearth emit no warming blaze. Towards the end of the evening I hit one of them with the hammer I have been using for putting up pictures – we have no tongs – and I am amazed to see, a few minutes later, flames dancing in the grate. There must be a science to fires that I have not learnt. I even have some difficulty getting newspaper to light.

I realise that, without a watch, I have started the stew and

baked potatoes at three rather than five o'clock, so we are in a position to eat early. Not that this does not prevent the boys going to bed at what Naomi proclaims is a dreadfully late hour – though perfectly usual, unfortunately. The whole process is accompanied by mutterings from Naomi about the impracticality of it all, and repeated assurances that she won't be coming here next weekend.

Sunday November 21

I have been catching up with the *Kettering Evening Telegraph* whose daily rate of production sometimes exceeds the news around here. Tuesday's front page shows a photo of a mother of four who died after the terrible car smash at Geddington. 'Tragedy of a Devoted Mum' reads the headline. The report names the dead woman as Miss Hess and her mother as Mrs Clarke. Mrs Clarke is quoted as saying: 'Terri was not an angel and made some mistakes but she tried to move on. She just seemed to be getting there when the accident happened.' Rather more moving, this hint at complexity, than the Devoted Mum headline, though let us hope she was that too.

Hunting tomorrow. On Mondays the meet is not till twelve o'clock, so there will be time for me to do my boots and stock tomorrow. I hope.

WINTER

I wonder if I was there

Monday November 22

I wake without (unusually) any great desire to face the world, or not that part of it which is not contained beneath a duvet. Last night I filled the hot-water bottle left by our predecessors (after appropriate detoxing). I feel I need spoiling because of my cough. Why do I have to go hunting today?

I crawl around the house, making breakfast, brushing out grates and generally putting off the least attractive job of the day: emptying last week's bin liners in search of Naomi's ring. They have been kept in the garden, now submerged beneath sections of expanded polystyrene packing and sheets of polythene from the fridge and tumble-dryer. It has been drizzling, is drizzling now and looks as though it will drizzle for evermore. I tear open the black plastic and turn out the contents on to newspaper. My past life (that part of it which took place about ten days ago) swims before my eyes: vegetable peelings, milk cartons, tea leaves, a bottle of Jacob's Creek, remnants of the boys' meals, nicely matured now, pungent on the nose. I lift out each item and place it in a new bin liner. And there, in a candy-striped plastic bag that I open, is the ring.

On the way to the meet, purring along in Sue Muirhead's new lorry, we pass Lamport Hall, where, ages ago, I bought the self-same ring at an antiques fair. I have never told Naomi that it is not aquamarine but a man-made stone from the 1940s. It fools everyone.

The meet is at Isham Farm, near Holcot. Storm has been clipped out and is unbelievably smart. Pretty girls offer cake and port:

more port is consumed than cake. The old gang is out, and I realise why it is that I love Mondays: there are just friends present. There are, I should think, between 50 and 60 just friends even so. And I don't know that I am entitled yet to call them my friends, but Mondays do impart warmth.

The drizzle has turned to mist. Still, it is warmer than it has been. We set off towards the reservoir, where we stop in a track. A fox crosses the fields above us, running in an unhurried sort of way. Then another races up, through the hedge and over the main road. We pursue that one. Storm just wants his life to be one long, heedless gallop. We race along the edge of a seeded field, in single file, mud flying up from hooves of the horses in front. It will not be a good week for the brushing of hunting coats. The point takes us over three good jumps, one with a slithery sort of a dip in front of it, and Storm sails over. Television producers cut from a shot of a fox to one of the hunting field jumping hedges, to give the impression that a lone animal is being chased by dozens of riders. It is not like that at all. The huntsmen and hounds are away in the distance, while the rest of us merely follow more or less the route they took several minutes – if not longer – previously.

I have the satisfaction of jumping a fence which Joan Tice, the senior Master, has just refused – sweet, after last time out. And then, as we walk along a muddy track, I wonder if Storm hasn't lost a shoe. A rider looks down, and confirms the presence of the shoe on the near side. Another rider is appealed to for assistance. The shoe on the off side has gone. Everyone says that it won't matter with the going so soft. We are now in a field, and I watch almost undecided as the field pops over a post and rails. They are going in the direction that I need to go, and there is no other way of getting there. But no, after the admonition received from Sue last time, I cannot risk it. It could leave Storm lame for the rest of the season, or worse if he fell at a fence. So I turn and trudge up to the gate. Needless to say, it is a stiff gate, and I cannot open it from on top. So I climb down, wallowing around in the mud. Fortunately there is a stile for me to remount, but I seem to have half Northamptonshire attached to my feet. Then, wearily, I walk back along the track to Scaldwell.

Scaldwell is a lovely village. We pass the church on its mound, and some houses that seem to quietly give one the eye and say, what about it, come on, possess me (the advertisement pages of *Country Life* are often called property pornography but this is, so to speak, eye contact with a stranger). We wait on the less lovely side of the village, towards Old, opposite some new houses with large cars parked outside. I throw my coat over Storm's rump and rub my nose into his hay-smelling neck as he munches grass.

After stabling Storm, I leave Naseby, to return a pair of breeches, which I had borrowed, to David Miles. His farm is just next to the A14 at Welford; in fact, the road was made through part of it, bringing in some useful compensation and the chance to create a truck stop; that is the sort of farming that pays these days. I discover him sweeping up leaves beside the house. Perhaps that is part of being a farmer, just as fiddling round Northamptonshire is part of being editor of a country magazine. We discuss firewood; he has some that is two years old. But I can't think what to do with a pick-up truck's worth. I see the turkeys pecking round the compost heap in preparation for Christmas.

Thursday November 25

I spend the evening unsuccessfully attempting to fit some bone knobs, bought from Joss Graham in Eccleston Street, on to our latest purchase from the Dump – an oakish-looking chest. I saw them in the window, left a message on an answering machine and Joss dropped them round in a Jiffy bag. Had I actually spoken to him, I could have used the killer line, 'I am desperate to get my hands on your knobs.'

Friday November 26

I may have made a mistake at the Dump today. I went there first thing, to deposit a kitchen unit that has been replaced by

one marginally smaller, to allow the cooker to squeeze in. Now I find I have an enormous oak Thing in the dining room, a great big square object like a wooden walk-in fridge. We have been in need of a chest of drawers. This is similar, though recently in use as a garage object for storing paint tins, etc. Now I realise that the paint which seemed easy to scrape off from the shelves is set to the hardness of a fossil. The knobs are wonky or missing. The doors of the cupboard part do not shut properly. Never mind. I keep reminding myself that the wretched object is solid oak, and you don't get that at Ikea.

Afterwards I pick up the Parker Knoll chair from the upholsterers. Cost of chair £2; cost of upholstery £117.50, excluding fabric. It looks very David Hicks in its blue check.

I go on to Northampton, to meet the head of the Highways Department. Appropriately, I cannot find my way to the council offices and have to phone from an immense roundabout, known by the splendidly Saxon name of Lumbertubs. Other people have similar difficulty, since the offices lie in a wasteland outside town. They are in the International Ranch style of modern architecture: all roof and horizontal lines, a bit of Frank Lloyd Wright here, a hint of Japan there. You see it everywhere. It could be a supermarket, a hospital, a corporate headquarters or a motel.

The man I want to see is Brian Welsh. Brian Walsh's secretary comes down. It cannot be easy when there is a Brian Walsh and a Brian Welsh in the same building. After a moment's confusion, Mr Welsh appears and I ask about accidents on the A43. But the A43 is a trunk road, and trunk roads come under the Highways Agency, not the county council. Even so, he comments that the bypass for Geddington is not very likely to materialise. Of course, the A43 itself was originally a bypass (it is called the New Road), but now quite a bit has been built on the other side of it. Mr Welsh's preserve is the green transport policies being developed for Northamptonshire, bringing more services to villages (to reduce the need for vehicle journeys), encouraging cycling, reducing the number of cars in town centres. Every day he walks two miles along the river to work in these offices, located so unsustainably out of town.

Afterwards, I add my mite to the global catastrophe by jumping into my car and making the dispiriting journey to Cambridge through a dismal landscape, colourless as the froth on a cappuccino, with new houses scattered like chocolate powder. I have lunch with Constance, my mother-in-law, and leave with a variety of bags containing, among other things, jam jars, sundry tinned provisions (past their sell-by date; probably perfectly all right but I won't give them to the boys), candles, a small copper and brass jug from Gretna Green (bought at Trinity College jumble sale: 'I wondered which fellow it came from'), Spontexes, adhesive coat hooks, an oil painting given to Constance and Martin, my father-in-law, by Air Canada, a photograph of sunrise over a lake by a friend ('you can always use the frame'), children's bowls, logs from the garden, more storage jars, a spice rack and other useful items that have involved much rearranging of cupboards. 'This is a Viyella tie – for some reason Martin has never taken to it. It'll do as a country tie.'

At Do-It-All I succumb to the inevitable and purchase a drill. I passed a Cuprinol lorry earlier in the day and this reminded me to buy some woodworm poison. At home, I drill holes into the drawers of the oakish-looking chest and slide in the bone knobs.

About half past seven, I skulk across the wet road to the pub. There is a minibus outside, and Peter is inspecting it. 'Never seen them before in my life,' he says of the occupants. 'There they are, parked on a double yellow line, in the most dangerous spot in the village!' To think of the road system around the cross as being in any way hazardous stretches the imagination. Everyone, though, is out of sorts. Mike is in a corner, nursing a very large, empty vodka bottle. He and Peter are bemoaning the lack of custom for Mike's excellent food. In Market Harborough they would charge two pounds more for each dish. 'The Three Swans does a roaring trade,' volunteered another drinker.

'What do you make of Market Harborough?' I ask Mike. 'Never been there,' he replies morosely.

Wednesday December 1

I have not kept my diary for the last few days. The cough that hunting should have blown away is worse.

That, however, is not why Keith and I fail to move Big Bertha, the horrible oak cabinet in the dining room, upstairs today. The trouble with our stairs is that they go up steeply and then turn. As a result you must lift the object – Big Bertha – while attempting to rotate it. It gets stuck on top of the door, as well as the dado rail at the back. We try it without drawers. We discuss removing the dado rail. But, basically, it is not going to get up. So this oak monstrosity is now lying on its side, like an enormous dead body, and you have to step around it every time you go into the dining room.

We don't yet have any fire extinguishers; part of the point of today's appointment was to tell Keith where to mount them, before the boys succeed in letting them off. However, the electrician has been. 'I don't suppose he found much,' I say cheerily to Keith. He blows out his cheeks and gives me a look as though to say, 'If only you knew the half of it.' Something needs doing? 'It was bad. You've got some old rubber cable, goes back to the 1940s that does. And it's a big job, rewiring is. The only good part was the cooker socket.' I think that tuberculosis sufferers get light-headed towards the end. With my cough, that is how I feel. If I am heading for a sanatorium in the Alps, why should a little rewiring worry me?

I am more concerned about the morality of chopping up Big Bertha for firewood, but it seems to be the only way to dispose of the corpse.

Last weekend we went to Wicksteed Park. A blisteringly cold day, but the children played on the climbing frames, of which there is a very creditable selection, whooshing down, falling on top of each other and wearing themselves out. Half the rides, for instance a giant gondola that swings backwards and forwards, were shut. So the atmosphere was that of a seaside pier during winter. But

Wicksteed Park is clearly a phenomenon. It was founded – so an exhibition reveals – by the inventor Charles Wicksteed. The son of a Unitarian minister from Leeds, Wicksteed made a fortune in *fin-de-siècle* Kettering, first from Gaiety Cycles, then his patented gearbox for cars. Wicksteed Park was supposed to have been the site of a model village, but the First World War put a stop to it; when hostilities were over, Wicksteed developed it as a sort of high-minded fun fair. Some of the early rides are still going, or rather, they are still going in summer.

Red-cheeked, the boys were then hauled around an antiques fair (so called, though most of the stuff there was a higher order of junk) in one of the Wicksteed Park buildings. No, hauled is wrong. They would have roared around if they could. Stallholders winced as Johnny picked up china horses and painted cups. A woman by the entrance doorway was selling oak furniture that, unlike Big Bertha, was actually attractive. Granny's Attic was the name of the stand. On an increasingly precipitate dash around the rest of the show, we bought three framed plates of decorated cakes from a 1940s cookery book (£4.50 each; less surely than the cost of the frame) and half a dozen 1940s plates decorated with village scenes (£1.50 each).

Back at the cottage, the boys settled to *Barney* and *Teletubbies* videos, and I to the lighting of fires. Seventy-five years ago, someone like me might have smoked a pipe, and fires have the same therapeutic value; there is always some reason for fiddling with them. I am forever having to poke around embers with a piece of kindling wood, or roll up pages of newspaper into a knot. The stove in the dining room has little levers that you can pull across, or in and out, to regulate the oxygen. This does not prevent me from also opening doors on a regular basis, letting clouds of smoke into the room. These days, my clothes and hands are generally blackened. In terms of heat generation, the fires do work, though you would only know it by contrast with the perishing temperatures upstairs.

Thursday December 2

My sole outing is to nip into the Star for a whisky mac. Peter, doing crossword and Mike, reading *The Times*, are there. There are a table of others and a log fire. It is a beguiling scene.

Friday December 3

It is 11.10 p.m. and it seems like the middle of the night. I arrived an hour ago. I have been off work for the last two days, convulsed by coughing. Each morning this week I thought: if I take it easy today, I'll be quite able to face life tomorrow. I was wrong. Every day I have felt as bad as the one before. So this morning I cancelled hunting tomorrow. Now I am furious with myself for chickening out. I am not as bad as that and I'll have to wait another week. It is just awful.

I came up this evening with pork loin, chicken drumsticks, etc. from Swaddles Green Farm in my bag. The reason: our Pimlico fridge has finally been defrosted after the door refused to close, and the organic meat – approximately equivalent, in money value, to caviare – must not be wasted. Hence also my transport of some ageing leeks and onions, which have lent a light perfume to my clothes.

To travel by public transport you have to develop the arms of a gorilla. I was also carrying, naturally, my laptop, as well as Simon Schama's *Rembrandt's Eyes*. Schama is pitiless to the reader who does not have a porter or private staff to help him reach platform four.

The dining room is still dominated by the unlovely recumbent form of the oak wardrobe.

Saturday December 4

I was on the point of going to bed last night when I thought I would shove some tea towels in our new washing machine. I opened the door and a cascade of water flooded on to the kitchen floor. I momentarily thought the whole kitchen would be flooded, as though below decks on a convoy ship that had just been torpedoed by a U-boat. I suppose only a jugful of water escaped, really. Still, it was enough to penetrate my shoes and scotch fond imaginings of an early night with *Rembrandt's Eyes*. I couldn't get the machine to empty itself of water. Eventually I saw that Johnny had pressed in all the buttons, including High Water and Rinse Hold. I coughed so much in bed that I had to hold my hot-water bottle to chest to subdue it. I rejected *Rembrandt's Eyes* in favour of Sir Humphrey F. de Trafford's *The Fox-Hounds of Great Britain and Ireland*, 1906, as a compensation for no hunting tomorrow. It was given to me by a friend, and I wallow in its musty smell and red half-morocco binding, with its picture of a horseshoe and hounds stamped on the front in gold. ('Admittedly the best four-days-a-week country in England,' is what Sir Humphrey writes of the Pytchley.)

This morning I come down to discover that the washing machine, which I left washing, has vibrated itself out of its cubbyhole by the sink right the way to the kitchen door. I wonder if some prankster has broken in during the night – not difficult, I had forgotten to lock the door – but, of course, it must just have been the effect of the spinning. It is a bit eerie. Unshaven and uncombed, I set off to the village shop for matches to light the fires. I disguise the state of my hair with a cap. I forget that it will be necessary to remove the cap once inside the shop, but there it is. It is now mid morning, Naomi is on her way to St Pancras in a taxi and I resemble a jacket potato as the warmth of the dining-room stove slowly cooks me.

* * *

Naomi and the boys arrive. In the afternoon, I think of going for a walk around Boughton Park, and for that purpose follow the sign on the road to the man selling Christmas trees. Call me a snob, but a Boughton Christmas tree does sound, somehow, grand. For several Christmases, *Country Life* tried to photograph a representative sample of ducal Christmas trees, on the grounds that at least one of the dukes would have a particularly swanky tree, in a handsome setting. They were a disappointment. Nobody had hereditary baubles or flunkeys in livery standing by with fire extinguishers to put out the candles. We were informed that the Duke of Buccleuch's would be quite impossible to photograph – something to do with him spending Christmas in one house and immediately decamping to another for the New Year.

The man in the bobble hat who sells us the tree isn't much use on walks. He says the park is closed until the house reopens, and suggests a picnic area in Grafton Underwood. If you are local, I suppose you don't go for walks. Anyway, with the sky louring, we go to Grafton Underwood, to torment ourselves by looking at the house we didn't take. I picture Grafton Underwood as Geddington's lily-in-the-field sister, which neither spins nor weaves.

We walk about 50 yards along a stream, pursued by a whole flotilla of ducks – first they swim towards us, then mount the bank – until William protests that it is too freezing and he wants to listen (for perhaps the 600th time) to his *Brambly Hedge* tape. *Brambly Hedge* is about a colony of mice who live in a hedgerow. The reality of the countryside defeated by the idyll. I notice that the barn conversion is now inhabited. Perhaps the idyll persists for some.

We have excellent organic pork for dinner. But the triumph of the evening is in making *The Tales of Aesop* video (bought from the Dump) work. Not much to that: we only have to put it in the machine. But the other tapes from this purchase all turn out to be different from the boxes they are in (fortunately none is pornographic).

Sunday December 5

This morning, after wrestling the washing machine back into its housing, we go to the playground, which is deserted. Perhaps children round here all have gardens. Even in our tiny space, William has been 'busy working' at collecting leaves. We watch the cars on the A43 glint as they flash behind the distant line of naked trees.

After lunch, we pile into the car to seek out a couple of entries in Simon Jenkins's *1,000 Best Churches*. The sky is oily – the sun giving it a kind of iridescence, like a light bulb shining behind one of those lamps in which shapes bubble up and down. The church at Warkton is closed; never mind, we shall try Higham Ferrers. Higham Ferrers is an onion of a town, with some mind-searingly banal executive housing as the outer skin, followed by a ring or two of old council houses (more respectably designed), and then the inner core which is delectable. Admittedly it has a busy road running through it, and two girls are sitting on a bench beside it, enjoying the traditional country pursuit of shouting abuse at strangers. But jolly Christmas lanterns and lights lend festive enchantment, and the church, the old school and the bede house are a wonder. The key to the church is kept at a shop called Chinatown which Naomi has already cased; something pretty may just have been allowed to slip in beneath the garishly coloured silks and mass-produced carving. Inside the church, we look at the old choir stalls, carved animals rubbed to the smoothness of marbles, and the splendid brasses, both boys helping to move carpets. William takes Johnny on a tour of religious art.

'Look, Johnny, that's Jesus on the Cross.'

'Ah. That's Jesus on the Cross, is it? Daddy, Jesus came back from dead, did he?'

The old school building mysteriously contains a supermarket trolley; perhaps it is from a harvest festival of our times.

I am pleased to discover that when Simon Jenkins visited Cottesbrooke for his great book the church was invested by the 'local hunt'. I wonder if I was there.

Tuesday December 7

In the Star, we are discussing markets. Peter says that, as a boy, he would be sent to Northampton market just before it closed, to return with armfuls of vegetables which cost next to nothing. Someone, by a stretch of logic that I cannot quite follow, says something about Adam and Eve, and Mike goes on about Cain and Abel. 'They had a third son,' says Peter. 'Name will come to me in a minute. I think it was Seth.' How does he know? 'It's in the Bible.' Yes, yes, but how does he come to know so much about the Bible? 'Anyone would do if their father had sent them to church three times every Sunday as mine did.'

Mike, on the other hand, grew up in Battersea. He doesn't think much of Peter's style of mine hosting. 'I always say there's no such thing as a bad pub,' he says darkly, 'only a bad publican.'

Friday December 10

I leave London early, but not early enough to beat all the traffic. As I arrive, a schoolgirl gets out of a car and then runs up the path to the church. Soon, one bell rings out rather overenergetically. This is followed by a peal. For some reason, they only seem to ring peals in short bursts, even on Sundays. Do people object? To me it is one of the most glorious sounds in the world and I could listen to it for ever.

In the Star, I relax over a pint of Three Kings, a beer that is brewed more or less locally, in Oakham. The Millennium is less than a month away but Peter and Anne do not seem to have plans. There is only one formal Geddington celebration on offer but it has sold out. It is at the village hall and you have to take your own food and eat it in a marquee, which could be cold. Anne intends to keep the Star open until eight, but if customers want it, they will remain open longer.

* * *

R. S. Surtees wrote in *The Analysis of the Hunting Field*, 1845: 'It is the duty of every man to get as much hunting before Christmas as he can.' Surtees, the creator of Jorrocks, was right, of course; in January a freeze can set in, and that means the ground is too hard to hunt. Later, the lambs come, fields are sown and farmers are less keen for the hunt to come on to their land because the ground does not recover so easily from the horses' hooves. So the best of the year's hunting is before Christmas; and we must make the most of it.

Saturday December 11

It must have rained all through the night. The ford doesn't seem deeper than usual as I whoosh through it, late for Naseby; but on the way to the meet at Holdenby North Lodge – Dick and Pam Saunders's farm – see water lying in fields and overflowing the ditches. The rain does not get any better during the meet; if anything it gets worse.

We stop the lorry at what has become known as Bra Corner (after the bra that Mr Saunders once found hanging on a gate there) and I make the familiar hack up the hill to North Lodge, the scene of many disasters and triumphs, of snow, fog and – today – rain.

Today it is triumphs, because when I say 'Good morning, Master' to Richard Spencer at the meet, he utters the delicious words: 'We would like you to wear the hunt buttons.' It is the prerogative of the Master to award the buttons of a hunt, which the recipient then wears proudly on his hunting coat. They are a sign of belonging. Just as I am digesting this piece of good news, Richard tells me that his daughter Polly will be photographed in a jacuzzi, the idea being to reflect the summer she spent in Iceland. The jacuzzi is meant to evoke hot springs. 'Oh yes,' I say nervously, this being the first I have heard of this location idea. 'We don't mind as long as

it's not pornographic,' says Richard. I shall be interested to see the results myself.

Rain has made the turf squelchy and turned the field margins into a sort of red fondue. I have never seen people get so muddy. My own coat comes to resemble a piece of avant-garde knitting, thanks to the tufts of grass that become attached to it. Water pours off the brim of my hat. But I rather agree with Paul Hopwell – a yeoman farmer to look at, who is actually an antique dealer, specialising in the best type of old oak – when he says that he has never had a bad day's hunting. The days are different, that's all. This one is wet.

Shortly before those people who have more than one horse, as well as the stamina to continue, change on to second horses, the rain stops. There is a palpable risk that the sun will come out. 'We don't want it,' says Paul when I brightly draw his attention to what I deem a climatic improvement. 'We want it to get cold again. The best scenting days are cold, wintry days, when everything is still and the hedges look black and horrible.'

The antis are out. I feel sorry for them. They blow their horn so badly that no hound is going to mistake it for Peter Jones, the huntsman. The rain falls on them just as much as on us, only they are on foot. The reserves have a white van to drive around in. At one point, Richard Spencer, perhaps spotting that the protesters are away from the van, leads a sudden diversion. It is the only alarming part of the day, since it involves hurrying down the wide verge of a road. The horse in front disturbs a plastic bag, which flies up from under its feet like a pheasant. Storm shies, and I nearly come off. I lose my stirrup and only regain it after a struggle. Then I find myself having to canter down the road in pursuit of the rest of the field, just in front of the antis' van. I think they might try to frighten Storm – idiots do sometimes – but the antis are gentlemen.

I leave at second horses. When I get out my mobile phone, I find that it is wet from the glove I had put into my pocket. Adhering to it are pieces of a KitKat that has otherwise completely dissolved.

When I arrive back in Naseby, I tell Sue Muirhead about the buttons. 'I should think it was that photo of Polly that did it,' she says, with less positive reinforcement than I expected from the woman who has been, after all, my hunting mentor. I do not say she is wrong, but I won't rub the gloss off my own glory. I am very pleased to have the buttons.

Sunday December 12

Before lunch, I drive along Grafton Road, past Boughton House, turning in at the next entrance, which has a wooden gate and a Victorian lodge. It is a rustic entrance for such a grand house. The drive swings around the rise of a hill and deposits me in the second courtyard, where Valerie Finnis lives. She faxed me at *Country Life* the other day, welcoming me to Geddington: our chief sub is her god-daughter, which is how she knew we had come. To gardeners – the really serious kind – she is famous as a photographer, plantswoman and founder of the Merlin Trust, which helps young horticulturalists travel. The fax says that she will give me details of doctors and tradesmen, to help us settle in.

She has left a red traffic cone out to tell me which part of the establishment is hers. There is another notice on the letterbox saying welcome, and drawing attention to the enormous size of the letterbox, an inspiration of the local postman, Trevor. She says it is because of the need to deliver *Country Life*.

The wing is really a complete house, though she says she only uses three rooms. There is an area for children, with a bear wearing a military cap, as well as lead soldiers and other delights. Valerie is very keen on children.

We drink sherry in front of an enormous fireplace. Her quarters used to be the laundry. Originally it would have been filled with great big coppers, etc., for washing. The fireplace tiles, though, date from 1850. They used to be painted red, to hide the bold colours, but I think they are splendid. The other half of the room – the part that isn't sofas – is devoted to the running of

the Merlin Trust. At present, Valerie has 350 Christmas cards to send out.

Geddington is a great worry to her. The vicar had to leave because of the noise of traffic on the A43. They built the new vicarage on the road. He was a Devon man and he is now happily returned to Barnstaple. Just where they have built the new houses, bang on the road, there was a dreadful accident with a fire engine a few years ago, she says. Miss Finnis, or Lady Scott as her married name is, remembers the time when David, her husband, used to go over Geddington bridge at the start of his journey to Scotland. The road past our cottage was then the main road.

I have not had the village newsletter she said she would arrange for me. The reason is that the organiser has been burgled. This is awful news. Geddington had seemed to be a sort of crime-free Eden, from what Keith had said. The burglars apparently hit a couple of other houses in another village on the same day, so they must be professional, which is a consolation. No self-respecting burglar would consider our cottage, there is nothing in it.

Then comes more shocking news. The Star was closed down, for a time, by the hygiene police. My comment in my leader in *Country Life* mentioning Geddington ('excellent food at the Star') caused a certain amount of hilarity among locals who had suffered food poisoning. Well, I don't believe it. It must have been a long time ago, before Mike.

Valerie gives me the address of the doctor, and I sign the visitors' book. She walks me to my car, gesturing towards a large skip. It is full of asbestos, taken out from the basement of Boughton by men in protective suits. It will be dumped at Weldon where there is a facility for the disposal of such things. Children at Corby have been born without hands – thought to be a consequence, or that is what is said in the village. She hears all these things when she goes to Geddington to collect her pension or have her hair done. The hairdresser is another unlikely Geddington amenity, occupying what used to be the cobbler's shop.

As I leave, she peers into the back of my untidy car, delighting in the child seat and toys.

In the afternoon, we go to the Dump. It is simply amazing the amount of rubbish we have to dispose of: two bin liners and a box. I feel like one of those ships from New York that was condemned to roam the seas looking for somewhere that would accept its cargo of refuse. We buy a rocking horse for Johnny (£3, back of seat missing but the seat doesn't need a back). He loves it.

I brush my hunting coat by the light of our Santa's grotto-style garden lamp, whose lumps of coloured glass make it look as though it has been constructed of winegums. The coat is so plastered with mud that it is more a case of washing it, using a water-soaked brush. I hang it up to dry in the kitchen, the surface still mottled with marks that I'll need to get off next time. Seeing it later, Naomi says it looks Hardyesque. She means that it looks like some garment from a primitive age before dry cleaning. I explain that dry cleaning is not considered the thing, partly being seen as an unpardonable extravagance, partly as bad for waterproofing. But it is Hardyesque – that is the whole point about hunting. Like Hardy's novels, it drops you straight back into a timeless rural world where the weather, the physical geography of streams, woods and hills, the animals you are riding and chasing, your own physical capabilities and quickness of eye are what counts, and the ability to e-mail Mars or shop in Voyage doesn't mean anything.

I go out to the car, in an attempt to rationalise the accretions of junk that Valerie Finnis admired, to be confronted by some large youths requesting their football back. They say that it has come into our garden. I can't see it. I get a chair to examine the roof, it is not there either. I take a chair outside the garden and discover an area of roof that is otherwise invisible. There is the ball. Clearly they have already been looking since the clematis is knocked down at this point. I provide a broom to retrieve the ball. 'You ought to get your hedge cut,' says one boy as he leans over the clematis. Perhaps it is a joke. They return to playing football in front of the cross, strikingly close to the parked cars, one of which is mine. It's not that I care about the dents, but Geddington is not a *favela* in Rio.

Blow *now*!

Monday December 13

I phone Dick Payne, the hunt secretary, expecting to get the answering machine; instead, he answers on his mobile. 'Are you hunting?' I ask. 'Yes, in the snow.' I ask about the buttons. 'You buy them from Frank Hall in Market Harborough. Stay still, Weazle.' And does the collar go with them? 'The collar is a different entity entirely.' So there are yet more glories to aim for.

We are now in two minds about the Slum. Property speculation may be a luxury.

Wednesday December 15

Polly's photo shoot has come into the office. It is absolutely true, she is in a jacuzzi, or at least a large bath, looking lovely and covered only with bubbles. To replicate the steaminess of the hot springs the photographer Guy Hills used a smoke machine, but the effect just makes most of the transparencies look washed out and soft. We have chosen the clearest picture, but it will need a few more bubbles to preserve modesty. I am dying to hear Polly's account of it.

The tape of *The First Christmas*, bought from the Dump, is enchanting. We still don't know what we ourselves are doing for Christmas. We have offered to do it, but ritual dictates going to Colchester. There would be much to be said for staying at Geddington. Against this, I keep remembering William's rapt

expression last year, when he just sat in his chair and watched, not eating anything because of the large volume of smoked salmon sandwiches already consumed. I must not lose sight of that memory; it could be the beacon by which I steer through the Dardanelles of another family Christmas. Still, no doubt a similarly warm experience can be created at home, without the battles of a long car journey. I vote for Geddington.

Friday December 17

In Market Harborough, the window display of Frank Hall's shop consists entirely of the tops of riding breeches. Awaiting collection, they have been thrown over the screen that shields the shop itself from the window. I comment on the number of scarlet coats that are still being commissioned, despite the threat of a ban. A hunting coat costs £900. When I raise an eyebrow, he takes me upstairs to where the coats are made. Everything is done in the same style as when he joined the firm in 1961. But then he was paid eleven guineas a year, and came from Hull to take the job. The cloth that he uses, though good, is not as good as it was. 'My hands always used to ache from cutting it.' No one makes such thick cloth as they used to any more – though you would think that hunting coats were one area of tailoring where requirements had not changed; there is no central heating in Sywell Wood.

The tailor looks out the buttons, black buttons, not brass: brass would imply a red coat. Do my buttons entitle me to wear a red coat? 'Oh no, sir. Bugger me, no, sir.' He shows me a photo of coats made for Prince and Princess Michael of Kent; they are Beaufort coats. They happened to say that they had been hunting with the Cotswold. He didn't feel he could query whether they were entitled to wear the Beaufort Hunt coat or not, but mentioned it to the Crown equerry, whom he knew. A letter came back from the Kents, with a cheque, saying: 'We enclose payment for the coats. Please store them until we are entitled to wear them.' The old Duke of Beaufort then kept them waiting two seasons.

A pair of Frank Hall breeches would be £350. He recommends the nylons. Everyone wears them now, except a few ultra-traditionalists. The old woollen ones need brushing. 'Gone are the days when you can hand them to someone and say get these ready for Monday. With the nylons, you can come back from hunting, have a bath, rinse them in the bath water, hang them up and they'll be ready to wear the next day.' He bemoans the passing of tweed jackets and spongebag trousers for solicitors.

On the way back, at Pugh the saddler's, I buy new garter straps, also saddle soap and another pair of gloves. 'The string ones do hold the water but you can always ring them out,' advises the lady behind the counter. 'Keep a second pair under the girth strap, they will be nice and warm when you need a change.' I should think on Saturday a nice warm second pair of gloves will be just the thing. It has got cold.

Saturday December 18

It is a bright day. The sun is shining on fields that have a green dusting of young seeds. The ground is still soft from yesterday's rain. I am late for the meet and only arrive in time to join the stream of horsemen who are leaving the Old Rectory at Haselbeach. As we rattle off down the lane, I find myself next to Polly Spencer, very demure and neat in her riding jacket.

'It was very brave of you to allow an Icelandic photograph of yourself,' I say. 'Wasn't the artificial smoke rather uncomfortable?' 'Oh no,' she replies, 'the worst part was the cold.' The apartment with the jacuzzi was in a half-finished building, and did not have any hot water. They managed to raise the temperature to lukewarm but it did not last long. Then the jacuzzi itself had not been wired up.

'But there were bubbles,' I remind her. 'I saw them.'

'Yes, we were lucky. There was a builder working down the corridor, and Guy had the brilliant idea that we could get him to blow down a tube. Fortunately he didn't seem to mind.' I

don't suppose he did. There was Polly with nothing on. He must have thought all his Christmases had come at once. 'Blow *now*!' Guy would shout, and an uprush of bubbles would create an instant geyser.

We get on to the Cottesbrooke Estate, a species of English heaven with its unfolding Gainsborough of copses, hedges and fields. I am lucky enough to be able to hack around it from Naseby. The house itself sits as warm and delicate among trees as an egg in a bird's nest, and is owned by a keen hunting family, which explains the tapestry-like beauty of the landscape. But today we aren't meant to draw there because of the shooting; hunting would disturb the pheasants. We manage to go over a few jumps, however; three to be precise. At the third, there is the usual mêlée, with the field crowding closer and closer to the jump, which allows little room to get up speed. Just as I set off, a member of the heavy brigade – a big man on a big horse – cannons sideways into me. He heaves over the fence, and although Storm has lost his momentum, I still give it a go. Too late! He cannot get up enough speed in time, and goes over the fence – a standing-up post and rails – at not much more than a walk, catching his back feet on the rails.

Whatever happens happens so quickly that the details fly past unrecorded. The essence of it is that I go over Storm's neck. Storm probably also comes down. Somehow I land on the inside of my elbow, bending it back. Once I pick myself and my elbow up, I have to sit down for a couple of minutes to nurse it. Cheerful faces flying by ask politely, 'Are you all right?' Storm disappears from view. Hugging my elbow, I make my way back as best I can to the other side of the big field, thinking it it pretty heroic to be on my feet. And then I hear someone bellowing, 'Clive, run.' It is Louise Bates, former Master of the Cottesmore, who comes trotting up with someone else, each one side of Storm with a hand on his reins. I stagger along. 'Come on, hounds are running,' commands Louise.

I clamber one-handedly aboard, and set off. Storm seems OK, perhaps all the better for the excitement. We gallop up one very long hill, with a jump at the top of it. Storm hesitates. I send him

forward but we don't make it. I wait, eyeing the obstacle for a minute, which is the worst thing to do. Charlie, our favourite policeman, then crashes over it, breaking two rails. But I go through the gate, and then have a long hack home. The bright morning has given way to a grey afternoon.

Sue Muirhead's verdict is that I should have trotted Storm after the fall to make sure he was sound. I should not have tried to jump after the bump. We must just hope Storm is all right.

I collect Naomi and the boys from the station, shielding from them, as best I can, the state of my elbow. But it is impossible to pick the boys up, or get them out of the supermarket trolley once they are seated, or to fold the pushchair and put it in the boot.

It is the night of the Bletsoe-Browns's party. The drive of the house is lined with four-wheel-drive vehicles, with a Rolls-Royce at the end of them. Naomi is plunged into the world of the Pytchley Hunt. She must be the only person not a member of it. She talks to Jane Brudenell who hunts three days a week. 'I think it's attractive round here,' hazards Naomi.

'After London, I should think you do,' comes the reply.

These people hardly ever go to London, and never willingly. Naomi survives, but I could do without Charlie coming up and asking, in a loud and jocular voice: 'How are you after that fall this morning? Oh, that was a horrendous fall.'

We phone the Star and we are just in time to eat there. (Might as well make the best use of the babysitter. William is still up, being read to.) As we finish, Mike goes past saying that they had a shooting party at lunchtime and he has just worked a thirteen-hour day. Our late arrival is not, perhaps, much appreciated.

As we leave Peter urges us to attend the Boxing Day Squirt, between the Geddington Volunteer Fire Brigade and the real fire brigade from Kettering. He describes it as a tug-of-war in reverse. 'Wrap up in waterproofs. They'll probably try to soak you if they realise you're new to the village.' But I still want to know: what is a Volunteer Fire Brigade?

Sunday December 19

'I'm fed up with those hunting people, they're all criminally dangerous lunatics, chasing poor innocent foxes. I'm going to tell that Master, and I don't mind doing it myself, just where he can put his buttons.' So says Naomi at breakfast. The realisation of my fall dawned when I asked her to unscrew the marmalade jar. I feel fortunate that detection was postponed till after the party. Surprising, since yesterday I could not pick up the children by the conventional method and reverted to lifting Johnny by the equivalent of the scruff of the neck – the back of his collar – which proved remarkably effective.

I phone Sue only to find that Storm is lame and it is all my fault.

Monday December 20

I have been to a party at Brooks's, followed by dinner at the Caprice. On coming home, I find my elbow feels strangely improved. I can scratch my nose.

Wednesday December 22

There is a log crisis, people must be stockpiling. The Duke of Buccleuch has sold out of Christmas trees, so his log operation is in abeyance. The village shop is closed. The only firewood I can find is kindling at a garage. Naturally I buy a sackful more than I need. But then I cannot allow my family to be logless at the Millennium.

I leave my freshly brushed hunting coat (still pretty muddy) at Frank Hall's shop in Market Harborough and I buy what is apparently called a 'companion set' of tongs, shovel and brush for the fire. It comes from the next-door shop, which sells coal. 'Much warmer than it was,' says the chatty lady who serves me,

without any regard for promoting trade. 'Last Monday was the coldest day I can remember.'

Later Rupert Golby arrives at the cottage, and we assess the garden. Rupert is one of the most talented gardeners alive, and has the very best clients, limitlessly rich and gardening on the grand scale. Our garden, which is not much larger than a tea towel, represents the other end of the size range. Even so, he gives it his undivided attention: the more he thinks the less he talks. Eventually he pronounces: some plants can be allowed to live. They must be espaliered back against the walls, for which we will need a new trellis. The clematis that is the principal feature of the garden, spilling over the wall, cannot stay. Seventy per cent of it will be dead wood. I am not absolutely sorry because it is a very ordinary one; still, it is rather nice to have it, or something, tumbling into the street. Rupert concedes that it could perhaps be reprieved for one year, but a better thing to see from outside would be a tree.

I return to Market Harborough to collect the now button-sewn coat. I find myself in the front of the shop, and while different people walk upstairs and look at parcels, nobody attends to me. So I cannot very well fail to overhear the conversation about a hunting coat in the next room. Someone is saying that she has different sized arms, due apparently to thrombosis in one of them. It turns out to be one of my Pytchley friends accompanied by her mother. I explain, proudly, that I am collecting my coat with its hunt buttons. My friend says that she is having a white collar applied. I ask if she is ordering a new coat with the collar. Her mother says, 'What do you think I am here for? Paying for it, of course.' Mr Hall tells the story of Prince and Princess Michael of Kent and their Beaufort coats again.

Sunday December 26

We arrived here last night at 9.15 p.m., having driven from Layer Breton in a trance. The A14 was empty, and the radio broadcast *The Marriage of Figaro* from the Met. The boys were asleep.

They woke up when we arrived, and the whole family went to bed together about midnight. Among the presents is the wastepaper basket that was the focus of William's letter to Father Christmas. He looked somewhat perplexed to find one in the pillowcase that served as his stocking.

It is not until 10.00 a.m. that I wake up. Incredible! Just time to light the fire before Johnny comes down, asking for egg. Putting on the candy-striped, now balding towelling robe I found among the other useful house-making impedimenta donated from Cambridge, I repatriate the turkey from the outhouse. The egg is cooked and the turkey somehow squeezed into the oven, in a baking tray several sizes too small for it. When I open the larder door to find olive oil, I think I see a mouse disappearing into the hole where the wire is. William appears and we eat toast and croissants, Johnny, of course, not touching his egg. When Naomi appears, we set about our various tasks (self: stoking fire; boys: playing with Christmas presents; Naomi: reading about Audrey Hepburn) when the street outside fills with ranks of firemen. Two of them are wearing ancient brass helmets. Evidently this is the Squirt and we are missing it. I rush upstairs to get dressed, while Naomi (already dressed) gets the boys ready. To my surprise, William will not put on his coat to go out. 'I'm not even going to see so many firemen.' I suppose he does not know why they are there.

I go outside in time to hear this crew sing, somewhat raggedly, the 'Song of the Geddington Volunteers'. They are crowded on to the steps of the cross. People are keen to tell me about them. The Volunteers could be described as a drinking club that turns out to help in the village when needed. It is very useful that they have a fire engine when there are floods, because it can pump out houses. They perform other services, such as clearing the churchyard, giving meals to the elderly and raising money for charity.

The Geddington fire engine is a beauty. They call it the Queen Eleanor. It is the equivalent of a classic car, built in the 1950s and beautifully maintained, all gleaming red paint with an elegantly rounded front. The fire engine has even taken them to Castile,

following the Eleanor connection. Apparently they were treated royally, with police escorts wherever they went, and 'never had to stop for a red light once'.

The two chaps in the brass helmets are the Harker brothers. It was their father who founded the Volunteers. 'The vicar had a brass helmet, too,' I am told. So it is now in the West Country, I say casually, and they looked shocked. It is a relic that can never leave Geddington.

While I had been dressing, they had marched off to pay their respects to the grave of the first and only chief, Jim Harker. So great is his memory that the head of the Volunteer Fire Brigade is now called the commanding officer. There could only be one chief.

There is quite a crowd around the cross. I am told we must get tickets, if we can, to the Twelfth Night dinner, which is for everyone in the village. 'As much as you can eat and drink for £7.50.'

I manage to cajole William out of the house. I look down to see him waving, and it is to Peter, in the doorway of the pub. The crowd has by now arrived at the bridge. We wouldn't be able to see anything from the bridge, because there are too many people on it. Besides, I have been told that it would be a strategic mistake because of the high probability of being soaked. So we stand a little back, on the cross side of the river, behind the Kettering fire engine. The Geddington Volunteers have the advantage. The bore of the hoses was smaller in the days when their engine was built, so it has a more powerful pump. A few years ago, when the Kettering brigade had to renew their hoses, they gave the Geddington Volunteers their old ones. So they now have the same width of hose, and the pump tells.

A tractor stands behind the fire engine. From its uplifted blade a rope is suspended. On the other side of the river it is tied to a tree. In the middle, hanging from a loop of rope, is a barrel. There is some delay as the barrel is positioned, pumps are switched on and the firemen stand in the river, hoses pointed downwards. Then the opposing hoses are directed at the barrel and the world dissolves

in an explosion of spray. The barrel is lost from view. The crowd on the bridge cowers as water showers over them. And then the water is turned off, and the barrel can be seen dangling over the opposite bank. One–nil to Kettering.

This is the best of five, so the tractor blade is lowered, the barrel replaced at the centre and the process repeated. Only this time the Volunteers have got their eye in. After a furious battle of jets, during which the spray rises like a cathedral, the Geddington hose pushes the barrel towards us; and as it does so, its trajectory necessarily lowers, and spray falls on us like a high-pressure shower. William runs away. I hurry back to the cottage to find Naomi's coat. Geddington win the next two bouts. By the end of it, William is dancing in the spray. Older children are running towards the river and back. Everyone is wet, to a greater or lesser degree. Everyone is laughing at the absurdity of it. And the good-humoured crowd troops back for a drink at the pub, or hot soup at home, according to choice. I don't know who won.

We are invited to tea by the Griffins. So as soon as we have finished our turkey, our sausages, our bread sauce, our two types of stuffing, our roast potatoes, our parsnips, our onions, our beans and our etceteras – in other words, a complete re-run of yesterday's feast – we cross the road to their cottage. They have just had Anthony Griffin's grandchildren staying, so they are used to children. Before long, Johnny is running his car up and down Anthony's leg.

Anthony has something of a proprietary interest in Geddington, since an ancestor of his owned the manor; that was in the Middle Ages. Latterly, the family lived in the big house at Dingley, of which he talks so fondly that I imagine they have only just left. 'Oh no, we sold it in about 1870,' he says.

The Griffins have a low opinion of Peter and his pub. The Star used to be the place where everyone in the village met, but Peter enlarged it, turned on the music and installed a TV. It didn't attract the extra custom he had foreseen, and it has lost some of that which it had. He parks his car across the entrance to the car park to prevent people watching the Squirt from using it. The teams used to go back to the Star for a drink

but now they go to Burwells, in the old working men's club. 'There are always rumours that he will sell up and move on but he never does.'

It is now 1.03 a.m. Naomi is watching *La Dolce Vita* on TV. I am smoking a Davidoff cigar, from a Christmas present of last year; I have been keeping them in the fridge. They have developed a slight mould but it has not impaired the experience.

Tuesday December 28

My arm is still not right. I can bend it, but any tiny twist – as in doing up a button, looking at my watch – causes a sharp pain. Now my wrist hurts when I type.

By a miracle of sleep, we are waking after 10 a.m. It is almost indecent. This morning, Naomi hurries off to London to feed Mrs Biggs, the oldest cat in the world, and attend Harvey Nichols's sale. I get the boys ready, and coax them as far as the playground. They run around for a bit, and then, just as I am responding to their entreaties to go back, two other boys appear from the bridge. One scales the little wall. William rushes up to him to tell him it's not allowed, because he might hurt himself, but he is brushed aside with the reasonable comment that they are older than him. They are country children, about six years old, but trying hard to look as though they are street-hardened tough guys from an American ghetto. One wears a back-to-front baseball cap, the other an oversized padded jacket that keeps falling off his shoulders. William, in his little red hat and windcheater zipped up to the chin, could almost have strayed from the pages of *The Secret Garden* which we were reading last night.

'If you tried to get on to my pirate ship, I'd make you walk the plank,' says William. To which Jack (the other one's Hank) replies: 'I would kick your head in, then smash your face.' They ignore his overtures as they play football; then encourage him to chase them. Since they are bigger, they can always run away, or kick the ball past him, or at him. Johnny is on the climbing frame, from where I watch – wanting to intervene but believing I must let

William learn about life. 'Come on, chumpy trousers. I called him chumpy trousers, Hank,' jeers Jack. William eventually finds a stick, and so does Hank, at which point I march over. William runs off, and busies himself poking the stick into a molehill, oblivious to the taunts of the boys, which is a relief. We go home, William rather wet from the falls incurred while playing. We tread mud all over the cottage.

I am listening to the sound of a mouse cracking pieces of dried pasta. Earlier, I uncovered the remains of a mince pie at the back of the larder. I thought for one moment that I should replace it, laced with mustard powder. A mousetrap was on the list for today but somehow neglected.

Scanning the larder to see what constitutes a rodent risk, I pick up the little-used Quaker Oats packet, the tab opened at the top. Staring out at me from on top of the oats is the mouse. I wonder what a Thomas Hardy character would have done. I am so surprised I drop the packet, and the mouse dodges away towards the boiler.

My father once took off his shoe, threw it at a mouse running across the other side of the room, and hit it. It became something of a family legend. I am not living up to it.

Wednesday December 29

Last night, before I went to bed, the frost on the car was as thick as a pie crust. There are sheets of ice everywhere today, but it is sunny. So I prise the boys away from their Christmas videos – I curse the godparents – and we slither down the road to feed the ducks. On the way back I am hailed by Angie Cooksley, white-haired and rosy-cheeked. Angie is a friend of Anona Hawkins, secretary to the parish council, nurse and former graphic designer. She deserves a footnote in the history of brand images as the designer of the first Penguin biscuit wrapper in 1955. Born in Kettering, she arrived here, from somewhere local, about ten years ago, expecting that she wouldn't be accepted for another thirty years. On the contrary. The day after she moved in

a neighbour appeared on her doorstep offering a basket of plums. 'If I ever wrote an autobiography I think *A Basket of Plums* would be the title.'

After lunch, we make the short drive to Valerie Finnis, from the cosy shambles of our tiny cottage to her handsome, freezing apartments at Boughton. She takes the boys to her children's corner. They sit on a little cane chair that she had when she was five, whose seat activates a musical box. They play with another, bigger musical box. They admire the pug, with its Scottish regimental hat; Valerie has hidden a jar of biscuits behind him. They pick up the telescope that belonged to her father-in-law, an admiral. They are taken to the back stair where stands an immense, old-fashioned fire extinguisher. They play with lead soldiers (largely headless). Only one room has any heating, and that is her sitting room, with the immense log fire. She tells us about Mr Ireson who is the Kettering historian. Valerie remembers Kettering when it was a market town, full of useful shops. Now it is a centre for the manufacture of Jiffy bags but the little shops have gone. The best butcher in these parts is at Twywell.

Before we go, we have to draw something in the visitors' book – rather large, because this is the last page left before 2000. Naomi draws a book. My contribution is a figure of Old Father Time, with a cherub, representing 2000, carrying a banner saying Merlin Trust.

We go into Kettering where I make such stupendous purchases as an ironing board, storage containers (more of them), a lunch box for William and mouse killer. The last is made by Zeneca, and takes the form of a little mouse puzzle. Mousey has to nip in at one end, nibble the poisoned bait in the middle, then exit at the other end, before going off to die in another part of the house – it removes the necessity of handling poisoned bait. I had wanted a mousetrap as being more humane: as in fox hunting, a sudden death, although in the case of the mousetrap not so assured. The bait promises freedom from rodents in four to five days. I don't know how long it takes for death to occur but it does not sound very quick. Horrible, yet this is what the people in Boots recommend.

Thursday December 30

Rain, rain, rain.

Naomi packs our food into storage containers. Even with reinforcements from Wilkinsons, we still have too few. When I first saw the plethora of storage jars on sale in Kettering, I thought, oh what fussy, old-fashioned people these must be. Now I know it was mice.

After lunch we drive to Uppingham. The road fringes Corby. Geddington is in what our old friend Christopher A. Markham describes as the ancient hundred of Corby. These days, applying the word 'ancient' to Corby is a bit of a joke, since it was mostly built after the Stewart and Lloyd steelworks came in the 1930s.

We have never been to Corby before. It is the right day to see it, perhaps: wintry, raining, without hope. We pass enormous sheds and then an electricity sub-station, the whole place forming a hell of gloom from which, with signposts pointing only to Deliveries, Industrial Estates, Shopping Centre – nowhere beyond Corby itself – it is impossible to escape. So we get lost, and find ourselves heading hopelessly for Corby centre, if it can be exactly described as having one. The buildings get taller. There is a shopping centre which a glance suggests is even cheaper than Kettering. We head out in the direction I assume to be correct – and there is the sub-station again.

The steelworks, absorbed into British Steel, was closed under Mrs Thatcher, leaving the town, floating like an oil spillage on the pond of Northamptonshire, without purpose. But now it has succeeded in transforming itself economically, if not visually. 'Corby,' says a man in the Star who has an engineering business, and therefore knows about these things, 'is home to the biggest sandwich manufacturer in Europe: Solway's.' They butter the bread by machine, which is as it should be, because 'the first bread-buttering machine in the world was made in Kettering' (this said with a touch of local pride). Orchard orange juice in Corby uses a million oranges a day. The area of Corby is home to Golden Wonder crisps, Aquascutum clothes and Weetabix breakfast

cereal. There is almost full employment in Corby, and yet the place is a civic disaster.

Eventually we emerge down the steep hill into Rockingham, on the edge of Corby, and there a miracle happens. Suddenly you are in a delightful, tawny stone village, the doors of the thatched cottages all painted in what must be the estate green; and then, from the top of a hill, a broad view of fields and hedges opens out before you like an immense embroidery, worked in threads of green and brown. We are back in the English countryside as most people conceive it, and away from the urban blob that has dropped on it, as though from some enormous industrial gannet. After a few miles we reach Uppingham: the perfect market town, with old-fashioned coloured lights festooned across the streets, a delicatessen, two ironmongers in one street selling baskets (rather a feature of these parts), logs (the ones I purchase regrettably sodden) and enormous saucepans. We have reached safety in the cosy protective world of the rural dream, middle class or aspiring to be so. Not that the pub into which I take William when he wants to go to the loo is the perfect tea shop; it doesn't seem middle class at all. But I'm sure we would find the ideal if we were to look.

Friday December 31

The last day of the century, and we are in London for the funfair in the Mall and fireworks. By the evening, the never-before-experienced absence of traffic has given London an eerie quality, which feels halfway between a celebration and a nuclear disaster. We wander towards dinner with friends at Morpeth Terrace along the white lines in the middle of the roads.

The children come with us because there is no possibility of getting babysitting tonight. Besides, it is a night that we would all like to spend with the children, particularly in the hope that they will remember enough of the events to bore people about them when they are old. Altogether there are six boys, running in and out of the rooms in a variety of disguises. The sound of the

television is turned up at eleven o'clock. As the announcer says this is the European Millennium – Britain, of course, not being Europe – we see the Eiffel Tower turned into a space rocket with fireworks fizzing around the base and shooting out of the sides. The Pope appears for about twenty seconds before the producer decides he will lose the audience. At 11.20 (dead time for the television schedulers), the Archbishop of Canterbury is allowed an embarrassing spiritual moment, with a politically correct mix of children, until the programme reverts to pop singers again. We are still eating trifle at half past eleven. Johnny is sleepy, William fixedly plays with Lego and shows no appetite for venturing outside. Andrew sacrifices himself to look after them and the other stay-behind children. Naomi, Clare and I leave about twenty minutes to midnight, pushing five-year-old Alex in our pushchair.

We had thought that the dire police warnings would have put off the crowds, but there is an endless stream of people along Victoria Street heading for the river. In Great Peter Street we can only make the junction with Millbank before being stopped by crowds. By this time Alex is practically asleep, with a bottle and shawl. Naomi becomes alarmed by the crowds as we wait out the few remaining minutes of the century. I notice that we are next to a tree: if there is a surge from the crowd we could protect Alex behind it, perhaps. I point out, though, that it is more likely that the surge will be towards the river, to see the much-heralded River of Fire. We wait for the chimes of Big Ben – but even though we are at the corner of the Houses of Parliament we do not hear them, or any of the twelve bongs, because the rockets have started to go off, and the crowd is roaring, gasping, kissing, squirting champagne over each other as though it has just won a motor race, and the fireworks are accompanied by such a barrage of detonations that one feels quite brave to be standing there.

Never were there such fireworks. They are going off all along the Thames, making the sky one giant Butler and Wilson window of seductive glitter. They are the colours of boiled sweets – red ones, white ones, blue ones, violet ones – and drip from the

sky like jam. The display lasts longer than you would have thought possible, reaching a kind of frenzy at the end, with every imaginable sort of whoosh, fizz and aah! going off at once. When it is finished, we kiss each other Happy New Year, and begin the quite alarming walk back to the Browns's flat, pushing Alex through the files of people – as tightly packed as a rush hour tube train – marching towards Victoria station. When we arrive back, we are greeted from the bottom of the staircase with shouts of children on the fourth floor. William and even Johnny have been restored to life. They rush about saying they have seen the fireworks from the window. 'I'm still so excited,' says William. We watch the video replay, with David Dimbleby dignifying the moment with gravitas but failing to capture the public mood.

We leave about one o'clock. Now it is drizzling and this has caused more people to go home. William has to stand on the back of the pushchair, lamenting piteously. Eventually I carry him. We go to bed about 2.30, with the sounds of revellers still audible from outside. We are already in 2000 AD.

Not the coloured sort, just bangs

Saturday January 1

Up at 6.30 to look at the clock – it seems to be already light but it must be just street lights. Another hour's sleep, then I leave for Naseby at 8.30. The drive is quite spooky. There are no cars in Belgrave Road. In Park Lane, the ice sculpture saying HAPPY NEW MILLENNIUM outside the Dorchester has not yet melted away. There is hardly any traffic in London at all; and then the motorway – it is like photographs of the M1 from 1959 when it opened, with one car every half mile or so. By the time I get to Junction 15 I realise what is also missing: lorries. I see just one throughout the entire journey. To begin with, the landscape is completely grey, and I think: can this be the new Millennium? Dull, dull, dull. Then the skies brighten as I reach Northamptonshire, and by the time of the meet at West Haddon it is a perfect morning, but useless for hunting.

Where has everyone spent Millennium Eve? Pauline, Sue Muirhead's head girl, passed most of it quieting the horses. The Fitzgerald Arms, next to Sue's yard, had live music and fireworks. The fireworks went on until 6.30. When Sue phoned up to inquire about them beforehand, she was assured that they weren't the coloured sort, just bangs. She was not reassured. So Pauline had to abandon the dinner party she was giving, and Sue, when she got back from friends, joined her.

Everyone seems to have marked the occasion in some way. People on high ground looked out across a panorama of different fireworks displays, one for each village and town of the plain. And they were moved to find everyone doing the same thing, thinking

the same thoughts, filled with the hope of the New Year, at the same moment. Even the hunt has recognised the special character of the day, the meet, at noon, being an hour later than usual. Millennium bells ring out from the church as we leave. I only stay out an hour, on account of my injured arm.

Over lunch in Sue's kitchen, she tells me the terrible story of her sister, Trish. She went into Northampton hospital for exploratory surgery on her stomach, and while there caught flu from the old bird in the next-door bed. The doctors pressed ahead with surgery. Trish developed pneumonia. She needed intensive care but no bed was available for her at Northampton. There were only two free beds in the whole of the country south of Manchester – one in Telford, one in Swindon – and the family had to decide quickly which one to take before it went to someone else. So Trish was stabilised – which means being completely knocked out and put on a ventilator. The ambulance woman arrived loudly complaining of having to drive to Swindon on Christmas Eve, which was hardly tactful. The consultant had to come too – imagine the inefficiency of it. By the time Trish reached Swindon, her condition had deteriorated and she died at 1.00 a.m. on Christmas Day. The body has still not been released because of the shutdown of administration over Christmas, and the fact that a death certificate cannot be issued without a post-mortem, since the doctors at Swindon had not known the patient for 14 days.

I return to Geddington and collect Naomi and the boys from Kettering station at six o'clock. Sainsbury's is closed, so we go straight to the cottage, only to discover there is no milk. I spend 45 minutes trying to find a garage that is open. We return to the cottage and behold, no butter. Naomi buys a packet from the Star for 50p.

I spot two mice in the pantry. The second one is moving slowly and I could probably catch it with my foot, but I hesitate and it is too late. Besides, think of the mess. I fear that poisoned bait will result in an awful smell from mouse corpses under the eaves.

We eat the foie gras that my incomparable assistant, Pollyanne, a genius at presents, gave us for Christmas.

Sunday January 2

Valerie Finnis phones. Her Millennium Eve was spent under torture of booming music until two o'clock. The duke had lent the big room over the old stables to a daughter of one of the staff for a party.

Monday January 3

We were going to go to London last night, but we didn't. Never mind, because Mrs Biggs, our cat, is well cared for. On the other hand, I wondered, earlier today, whether the departure of those other furry creatures close to us would leave a hole in our lives, and felt a twinge of nostalgia. I did see one mouse creep into the box containing new crockery but thought he might be on his way out. The mouser seems to have done its business. All the same, I searched through the larder to see if I could spot security hazards that should be eliminated for the future. I noticed that a jumbo pack of crisps – the sort containing lots of smaller packets – had been badly nibbled. I took it out to investigate the contents. I could not see inside properly. Then, peering through the nibbled aperture, did I see a shadow move? I put the bag down on the floor, and out hopped a dark little mouse. Off it tripped behind the cooker. Immediately my thoughts turned to getting another mouser. What if the present one has been used up, or overwhelmed by the scale of the mouse invasion? It is amazing how quickly one's warmer feelings towards rodents go out of the window.

There is a condom on the street beside my car today. If this reflects recreational activity on the cross, I take my hat off to Geddington's youth for their hardiness. They should qualify for the SAS.

Tuesday January 4

I am back at work, and it seems an age since I was last here.

At 11.00 p.m., I take the M1 to Geddington – 1 hour 40 minutes. In the back of the car I take one enormous tin that used to hold an Italian cake, an old biscuit tin (empty), two new tins of biscuits (half price after Christmas – and the tins will come in useful) and two glass storage jars. My deputy, Michael Hall, says that he remembers a holiday in a Cotswolds cottage when he emptied milk on to his cornflakes one morning, to find a dead mouse coming out of the bottle. It had got in somehow and drowned. However, not much rodent activity detectable at Geddington so far. It is eerie.

Wednesday January 5

I arrived so late last night that I didn't feel I could go to bed straight after the motorway; as a result I am not off to a brisk start today. But I bundle myself off to Naseby for a riding lesson from Pauline, as well as sympathy from a fellow elbow sufferer. Her injury was much worse than mine, and I am sorry to say that the cause of it was my own horse, Bing. He stumbled and fell, rolling on Pauline whose elbow was dislocated, and we all worried that it would never come right. That would have ended her riding career. But it did come right, to my everlasting relief. Today she is only suffering from the cold; the sand of the riding school has frozen hard.

Although I cannot hunt on Saturday with my arm as it is, I thought I would still run over and pick up the things that did not arrive through the post from Mr Batten. These were a big tin of black polish and some garter straps. The garter straps I have already replaced but only Mr Batten sells such satisfyingly large tins of polish. I phoned him yesterday, a little late, but no reply. So today I just turn up. I find him in his workshop in, I think, pyjamas with an outdoors coat over them. It is freezing there, so I hope he doesn't stay long. He says he's had the flu, and

so has most of his workforce; as a result they are reopening on Thursday rather than Tuesday. It is a mystery why the package, sent to work, never appeared; if somebody pinched it, expecting to find valuables, they must have been disappointed. A chap from the Warwickshire Hunt arrives in the workshop, also to buy boot polish. We discuss the New Year's Day hunting and basset hounds (remarkable for the amount of noise that they make).

I return to Geddington, where I fish a number of stimulating periodicals – *The Economist*'s *World in 2000*, for example – out of my case to read in the Star. Anne, Peter's partner, is there. They didn't have much of a Millennium, closing at 10.00 p.m. and watching the telly. They both had colds, she says. Sitting in a corner is Norman, in charge of corn drying for Geddington Farms – 3,500 acres. We all discuss logs. The logs Anne has are ash. Norman says ash is the best you can get; other sorts of wood spit.

Before I leave, I order lunch for Tuesday, when my *Country Life* colleagues will come for our Think Day. Mike appears from the kitchen. We decide not to offer them a choice, so I ask for fish pie. His army background has trained him to resist customers who know what they want. He tries to distract me with thoughts of chicken chasseur and cod in parsley sauce. Fish pie, he observes gloomily, is served in individual dishes. Anne points out that it could, for once, be made in a single big dish, and with much shaking of his head he agrees. For afterwards: bread and butter pudding with custard. And what could be nicer?

I strip the Christmas tree of William's Tellytubby and Mr Men decorations (which have been cut out of comics) and Naomi's expensive, tasteful ones, which only went up at the weekend. I drag the tree out of the house and haul it off to the Dump. I am now going back on the 6.01 train, my hair decorated with pine needles. There are pine needles down my neck, everywhere. Quite a lot of needles had already been shed, thanks to attacks by William in order to give him something to put into his wastepaper basket, but there were still plenty left.

Thursday January 6

I went to the doctor this morning. This evening, I visited the physiotherapist, who probed my arm, bent it, poked it, rubbed it – and generally treated me with less ceremony than the Christmas turkey whose remains we have just thrown away. It seems to have worked though. Or rather, it worked at the time. It hurts again now, but that may be due to the poking and probing.

We have now reached Twelfth Night, and I haven't really made any resolutions, except those concerning the extermination of mice in our larder and (though I know I won't keep this up) drinking five and a half pints of water a day, as they say in the papers men should. But I have been thinking about change. The year 2000 only means something because 2,000 is a very large round number. Equally arbitrary, as an epoch-marking event in people's lives, was the year 1900, only a century away from the Millennium and much closer to us than the years 1800, 1500 or 1000. But Geddington 1900 was nothing like Geddington 2000. Only the stones of the cross, the bridge, the church and some of the houses are the same, providing the stage scenery for what seem two quite different sorts of drama – which yet are similar enough to suggest that the playwrights who created them were friends.

In 1900, there was no running water, that didn't arrive until ten years after the Second World War. For most people (those not lucky enough to have a private pump), water was carried by bucket from the well against the chapel, or the spring that bubbles up under the cross. Children would help old James Dainty, the baker, taking pairs of buckets on a yoke – time after time – up to the bakehouse. They got a bun in return. On Sundays, they would carefully convey their family's little joint of meat, swimming in a protoplasm of Yorkshire pudding, to be cooked. The use of the bakehouse for this purpose continued into the 1950s.

These days, the high point of village activity is the school

run, when cars double park all the way along the road outside our cottage. After that, there is silence for the rest of the day. Geddington 1900 was far from quiet; there must always have been the banging of carts, the shouting of men and the ring of hammers, as well as more mud and smoke, for Dainty was only one of many people who both lived and worked in Geddington. Court Farm, next door to our cottage, was occupied by my friend Paul Hopkins's grandfather, a working farmer. And there were four other farmyards in the village.

The Militia Lists of 1777 show that Geddington contained eighteen weavers. I suppose they used wool from the descendants of sheep run by the Tresham family on their enclosures. In a similar line of business were the six tailors, four woolcombers, two cordwinders and the serge-maker. By 1900, though, this industry had disappeared, and nearly all the work was provided, directly or indirectly, by farming and the Boughton Estate. There were thatchers, wood dealers, furniture-makers, coal merchants, drapers, smiths, turners who made rakes and ladders, butchers who might also be farmers, and wheelwrights who doubled as undertakers. The greengrocer provided the coconut-shy next to the church at the Geddington Feast, and on winter evenings the saddler and harness-maker could be seen in his shop, doing repairs by candlelight. A woman made money – it can't have been much – from gathering blackberries and mushrooms. In addition, the Boughton Estate ran its own brickyard. Everyone knew when limestone was being burnt at the kiln; the choking smoke made the Kettering road almost impassable, villagers rushing through it with their scarves pressed close to their noses.

On windy nights the oil lamps that lit the streets would blow out. Even scarier, for some children, was the prospect of going to a lavatory that was nothing more than a deep hole in the ground, over which a board had been placed. 'Some of the cottages,' declaimed the vicar, the Revd Turton, in 1914, 'are not fit for animals to live in.' If cows had been put in such cramped, insanitary conditions, the duke's agent would have been 'down upon the owners imperatively demanding improvement, but as

they were only human beings who lived in them nothing was done'. The duke must have seemed a creature as remote and awesome as one of the gods in his own painted ceilings. The villagers could not even afford for the doctor to call unless *in extremis*; when they fell ill, a grandmother in a starched apron would stay up with them.

The floods in those days were much more frequent than today, and more serious. The children, needless to say, loved them. It was fun to watch the baker delivering bread with a hay fork to the bedroom windows of the flooded cottages; they were too young to sympathise with the mouldy wallpaper, or the gaps in the stonework, and the dampness of the walls, which were the general condition of cottages then, but made worse by the floods.

There was not much in the way of amusements to distract people from these discomforts. Generally, the village encountered what might be called the entertainment industry only when the dancing bear came around, led on a chain by its owner. When a circus called, which it might sometimes, a string of elephants would create quite a spectacle trundling down a country lane. These entertainments stood out in the memory of Geddington's old folk because they were rare. Teenagers then were very much like teenagers now: prone to boredom and misbehaviour. They used go bird's-nesting, blowing out the eggs they stole on to the palms of their hands and swallowing them whole, like an oyster. They raced each other and played football. Sport, according to one of them, took preference over their other main concerns, work and love. Less innocently, they kept a lookout in case the village policeman, or slop, came round the corner when they were playing their gambling games round the cross. Every Guy Fawkes night, they would somehow manage to get a barrel of straw soaked in oil on to the steps of the cross, and set it alight. Poaching might involve taking the duke's pheasants, which were game for anyone, literally, after eating whisky-soaked raisins. In 1901, a poacher eluded the police who were pursuing him by taking refuge in the chimney of a house, then climbing out on to the roof. As the local paper reported: 'All threats to

forcibly dislodge him were met by counter threats to hurl his boots at anyone's head who dared to put their face above the ridge.' He would have done it, too. 'Those were happy times,' remembered Andrew Kyle. But his father had been a gamekeeper, and sometimes took a beating from the gangs of navvies, working on the railways, for whom poaching was not just a lark.

Mr Kyle senior gave up gamekeeping to run a pub called the Royal George in Geddington (now, even in this village of pubs, disappeared). A Scotsman, he had the canny idea of papering the walls of the taproom with old copies of the *Illustrated London News*, cut up throughout the year. The pictures of the Zulu Wars gave the drinkers something to look at. Young Andrew inherited his father's love for nature, experienced through the medium of field sports. He was one of the villagers encouraged to record their reminiscences of Geddington in 1900, whose manuscripts are in Northamptonshire Record Office:

Up before dawn and up to Geddington Chase for cubbing. I have often been in the woods before dawn waiting for the hounds to come, while the owls were still sounding their distinctive 'Twoo-Twoo' through the still darkened woods . . . The sun is gradually illuminating the woods. There is a heavy dew which hangs on the bracken and gorses, grasses glistening like a million jewels. The background of ethereal mists rolling gradually away as the sun rose. Then the voice of the 'whips' at the far end of the wood to the hounds – a sound utterly unlike any other sound of the human voice – a sound I can faithfully imitate now after 50 years, but which is quite impossible for me to describe in words . . . My silence is broken only by whimpers of the young hounds as a rabbit or pheasant darted or whirred up from under a bush. Then a deep toned 'tongue' from several older hounds who are schooling the young dogs, and 'they've found'. Intently we watch the 'Riding' to see the cub strike across . . .

'Seem to have lost him,' says old Tom, the village cobbler, after a silence of 15. 'Let's see if there are any nuts, boy,' so

we jump over the ditch into the 'covert' and collect pockets full of hazel nuts. It is now 7.30 a.m. and the distant sound of a boot factory whistle from the town six miles away, brings us back to the fact that we must soon be starting on that six mile walk to work.'

Perhaps Andrew Kyle was nostalgic, remembering vividly the sound of the inn sign swinging outside his bedroom window when he was a boy 50 years before. In the interim, he had spent more than 40 years working in a shoe factory that employed 2,000 people. 'Would to God we were back in those times,' he wrote. 'You can have your modern improvements! What have they given us?' His memoir is dated 3 May 1940.

'Would to God we were back in those times.' But the modern world was soon to arrive, with a bang. In 1911, a Napier motorcar, all brass lamps and radiator, came poop-pooping down the road from Stamford, only to miss the sharp turn into what was then a continuation of the main road, into West Street. It smashed through the garden wall of the old vicarage. It was a solid wall. Even so, there was only one casualty: a passenger who broke his shoulder. That car heralded a century that would weaken local bonds, close shops and bring people like me to the village, because everyone can jump into a car. Since then Geddington has seen more, and worse, road accidents. The copy of the *Kettering Evening Telegraph* on the table next to me bears the headlines 'Death Crash Truck Ploughs Into Ditch' (on the A43, just south of the crossroads with the A47 at Duddington) and 'Appeal For Help After Boy Aged 10 Is Killed' (on the A45 near Rushden). They could have appeared on any day.

People live in drier houses; the river floods less often, though the effect when it does flood is in some ways more devastating, because houses have televisions, freezers and wall-to-wall carpets to lose. Would some ruffian sitting round the cross have told Pete Spence, gardener and raconteur, to 'Fuck off, you grey-haired old fart,' as he told me one did? I should think he would. But villagers would not have been surprised, because it was a rougher

world; and perhaps Geddington had fewer aspirations to gentility than today. 'The obscene language I was compelled to hear was anything but pleasant,' observed a po-faced correspondent to the *Kettering News* in 1889, commenting on the large number of people walking from Kettering to Geddington on Sundays. 'Seven out of every ten were smoking, and a large proportion of them seemed to be unwashed and unkempt.' That comes from a history of Geddington compiled by Paul Hopkins's mother. In the village newsletter, edited by Paul's partner Pam, I notice that in 1924 a drover called Moke (otherwise George Edward Gray), from Weekley Terrace in Geddington, was summonsed for using obscene language on the public highway.

'Gentlemen, I'm innocent this time,' he told the bench. 'I've been before you gentlemen a good many times, but I'm innocent this time.' It was his 33rd appearance before them.

These days, youngsters who disturb my neighbours round the cross seem magically to disappear when they reach seventeen: they learn to drive. In 1900 there was no such escape. Geddington was full of families who had lived here for generations, the only members to move away being daughters who married outside the village, or sons who went into the army, or (in the case of the eighteenth-century Turkey merchant whose monument is on the wall of the church) hoped to make their fortune overseas. What can the Turkey merchant have thought when he came back to Geddington, where his school friends were following the same trades as their fathers? That claustrophobic world was shattered when Geddington's menfolk marched off to 'answer Kitchener's call' in 1914.

For a few months, local people hardly noticed the war. The parish council continued to debate the poor state of village roads. The cancellation of the church choir's excursion train to Hunstanton was hardly an adequate harbinger of what was to come. Reports of the wounded had begun to arrive by the time the enlarged village school was reopened in November 1914. Altogether 170 men from Geddington served in the Great War, and 43 of them died as a result. Not all their names are recorded on the war memorial. Soldiers were still dying from their wounds

in the 1920s. One hanged himself, tying his scarf to his bedstead, one cut his own throat.

That was the end of Geddington as an island. There was probably an attempt to recreate it; and some of the older residents still fight a rearguard action on behalf of the old intimacy. But they know that the age is against them. Too many families, like us, blow in from outside, and blow out again when changing circumstances and the property market make a wind. Farmers, the few that are left, work the same land that their grandfathers and great-grandfathers did; but they more than anyone know what it is like for Geddington to find itself part of a larger world that goes beyond Northamptonshire, beyond England, beyond even Europe, as their livelihoods disappear before the onslaught of world prices.

They were perfect savages

Friday January 7

Two pages from the *Sun* have been photocopied and stuck on the wall at the end of a corridor at work. On the left, is a large picture of Polly Spencer. The rest of the spread is occupied by other examples of what they call Top Toff Totty. Oh dear.

I have to admit that the captions are quite witty, for the *Sun*. But we have heard the joke about Sophie Burrell, whom we photographed on the half-shell as the prime figure in 'The Birth of Venus', 'bearing her Botticelli' before.

Sunday January 9

I go to church. By the time I return, Valerie Finnis has arranged with Naomi to look in at 12.15, which she does at 12.00 – waiting outside the front door which doesn't open. The children are not dressed, the floor is littered with toast fragments, etc. So we spend as much time as I can reasonably expect examining the garden. 'This is a relation of the crab apple. You know you can make lovely jelly from this fruit. I wonder if this is an elegant rose or not. You won't keep the cotoneaster, will you?' The yellow corydalis grows like a weed. But isn't that very difficult to grow from seed, I say, and she says that's the blue one.

Inside, it is impossible to persuade the boys to switch off the *Winnie-the-Pooh* video. But it doesn't matter because Valerie went to school with Christopher Robin's wife, so she is interested to see what Disney have made of him.

Monday January 10

Polly Spencer has now appeared in the *Daily Sport*. Apparently the family could smile at the *Sun* but the context provided by the *Sport* – sex ads – is too much. They are out when I phone.

Tuesday January 11

I came to Geddington at 12.30 last night. Today is the Think Day. My colleagues arrive at 10.45. In the garden, Shufti, the Jack Russell belonging to our assistant editor Rupert Uloth, finds a dead rat, which he buries in a corner. Anne Wright, the chief sub, looks round the garden, identifying roses by the ingenious method of reading labels, which I had not noticed before.

We have lunch at a long table in the Star. Peter presides over lunch like a Satanist performing a black mass.

Wednesday January 12

I drive to Kettering and park in Sainsbury's car park and walk across the street into Tanners Lane. It runs beside the Newlands Shopping Centre, in which you can find Boots, Kwik-Save, a lot of bargain shops and some shops that are empty. Architecturally the shopping centre is a horror, nothing but ugliness. And there opposite it, in Tanners Lane, stands Beech Cottage, built of ironstone with moss green paint, cheeky little stone heads poking out of the walls and a beech hedge. I arrive just at eleven, the appointed hour. But a nurse appears at the door, and there has been a confusion.

So I trudge away to Wilkinsons, buying some 29p boxes of firelighters, and then drive to the Dump (today's bin liners ought to contain the rat but Shufti buried it behind a climbing rose, making it unrecoverable).

When I return to Beech Cottage, a cheery-looking head pops out of an upstairs window and promises to be down in a minute. It is a raw day and I freeze on the pavement for a chastening time; then the door opens to reveal Tony Ireson, 85, arthritic, but chipper. A photograph shows that he was very good-looking when he was younger. Now, in the parlour, he lowers himself on to an electrically-operated chair, that rises almost vertically when he gets in and then reclines to the near-horizontal. The room is lined with his father's sun-filled watercolours of Mediterranean scenes, painted from sketches made during the First World War, when he was sent as a soldier to Greece.

We talk about old Kettering. It was a shoe-making town, leather-aproned, boisterous, civic-minded, industrial, ordinary and decently proud of itself. Even now 2,000 little sheds survive from the days when cottagers used to make shoes in their gardens. They didn't like the factories when they came. Kettering people used to drink all weekend, then recover on Saint Monday as it was called. Shoe-making has disappeared, and so has the engineering that used to make some of the presses for printing postage stamps. As a result, 'nobody quite knows how Kettering lives'. Someone makes padded envelopes but that cannot be the only thing that keeps the town going.

Parts of the town in which Mr Ireson grew up survive: the church, the market, the railway station, the library-cum-art-gallery-cum-war-memorial. Standing rather pompously to attention in its livery of red brick, old Kettering still radiates a sense of Edwardian civic pride. But comprehensive redevelopment destroyed the pattern of old, tree-lined lanes, gardens, leather warehouses, stables, smithies, printers' offices and bakehouses that swarmed up the hill, in what had been Victorian Kettering's most bustling district. With everything else went Beech House and its garden, which used to provide the view from Mr Ireson's parlour window. Now he looks out on the bleak walls of the Newlands Centre and its multi-storey car park. But the developers did not get their hands on Beech Cottage.

'I am now going to leap to my feet,' he says, as he begins the laborious business of levitating the chair. He gives me a copy of

Old Kettering and Its Defenders, which tells the story of the epic battle to save his cottage. It is one of six books that he has had printed at his own expense. 'I don't take exotic holidays,' he says to explain it. It is a moot point whether the Newlands Centre is actually the ugliest building in Kettering. The Telecom fortress, a grey concrete tower which looms over the low streets like a Norman keep, is arguably worse. New technology has made it largely redundant. But it remains on the skyline, a very large, useless monstrosity, dominating the town like the hated barracks of an occupying colonial power. That power is ugliness. We need Mr Ireson, and more like him, to chase it out.

Thursday January 13

I opened a breezy note from the Duke of Buccleuch today, welcoming us to Geddington and asking if we had been told about the risk of flooding. He hoped we had taken precautions.

Jane Spencer phones. Yesterday some creep actually called at their house, wanting to see Polly. The *Sport* had printed the name of their village, so it wasn't difficult to find. He was 55 or so, and had driven all the way from Hertfordshire. How dreadful, but there is nothing I can say or do.

We have got to the point of exchanging contracts on the Slum. Naomi produces her file on the property, which is a large Jiffy bag stuffed with faxes. It may not be advisable but we will probably buy it.

'If a foreigner were brought here on his first visit to an English town to form his estimate of the English character, I am quite satisfied he would return forthwith and never set foot in England again.' That's what Charles Dickens thought about Kettering. I learnt this from the Millennium edition of the *Kettering Evening Telegraph*, which came poking through our letterbox on 1 January. Considering the unflattering picture he gives of the town, it was brave of them to print it. The reason for Dickens's

visit was a by-election, which he was covering as a young reporter.

From his room in what is now the Royal Hotel on the market place, where he stayed from 14 to 19 December 1835, he wrote to his future wife: 'The noise and confusion here this morning – the first day of polling – is so great that my head is actually splitting. The voters themselves are drinking and guzzling, howling and roaring in every house of entertainment there is. Our house is so full and the blue swine [Conservatives] are such beasts that we have retired into my bedroom.' There was a riot, and then the sort of behaviour which we now associate with young English males in Ibiza. 'In their convivial moments after the business of the day was over, they were perfect savages.' I have not seen much of this rowdiness in modern Kettering; but then I have not stayed at the Royal Hotel during an election.

I visit the Alfred East Art Gallery in Kettering today. It is quite something for a small Midlands town to have an art gallery, even if it is really part of the library, and it has just been done up. The last time I visited, a few months ago, the pictures were squeezed into a corridor; now there are two big rooms as well. East was born in Kettering in 1844, and went to Kettering Grammar School. There, according to one of the labels, his artistic talent was 'recognised but not encouraged', so he joined the family shoe business and got posted to Glasgow. He took night classes, and that was it. East himself appears in a self-portrait: a gloomy Edwardian figure in a gloomy green landscape, with a Roy Strong moustache, gold-rimmed glasses and a big hat. This was painted in 1912 the year before his death, so perhaps he had reason to be gloomy.

The other artists include T. C. Gotch, from another boot and shoe family. He favoured unsavoury images like 'Death the Bride' and 'The Exile', subtitled 'Heavy is the Price I Paid for Love'. But nothing gives me the creeps so much as Frank O. Salisbury's 'The Wonders of the Sea', showing two girls on a rock. One has her

back towards us and the light just catches and sculpts the cheeks of her bottom, practically paedophiliac.

Afterwards, I walk to the market, only the stalls have been moved to another place. It is undergoing a process of council improvement which will probably kill it. 'Three parn a parn, bur-NARN-ahs!' barks one of the vegetable men. I wonder what Dickens would have thought of him.

Friday January 14

I get up late. The man to fix the washing machine arrives while I am still in my pyjamas. He puts one hand inside the drum and asks where I got it, who installed it. The transit bolts have not been removed. He has the look on his face that I remember from the AA man who came to mend my old Volkswagen Beetle on the eve of our wedding; when he started the engine, after a problem of oil spillage, it went round with a clunk. I had thought the clunk was a hopeful noise. I tentatively hurrahed. The clunk was as far as it got before the engine seized up. We had to make other plans for the honeymoon.

Nothing is so bad with the Bosch. But we have to wait while the washing machine heats up so that he can check the thermostat and element, because anything could have been shaken loose. So I have plenty of time to discover that he is Catholic, the father of four, sending his children to a church school of which he is on the PTA or equivalent, and acted as Father Christmas (the part would suit him). Apropos a TV programme on snobs, he says that his wife's grandfather had been a lord but lost all his money. Since the owner of the big house at Geddington, called the Priory, has a plumbing business, I tell him he is in the right game.

Saturday January 15

Sometime in the last century there was a brave sporting lady called Dorothy. She rode her horse at a five-bar gate, sprang over

it on to a bridge, then straight out over another gate on the other side. That was Dorothy's leap, and it is commemorated in one of the field names at Cottesbrooke: Dorothy's Leap Field. This is where we unbox Storm today. The meet, in front of Cottesbrooke House, is like an enchantment. There are a 114 horses there. I joke with Ellie Bletsoe-Brown about the difficulty of identifying people to Sue Muirhead after hunting. I only know people by their Christian names – at best. And then there is the inevitable question as to what they are riding. A horse? Recently both Sue and Pauline, her assistant, have described Jane Brudenell to me, as though categorically, by saying: 'You remember, she used to come to Leatherlands with a Strawberry Roan.'

The cavalcade moves off briskly through the park and beyond. We spend all day hunting round and through the park. There are four fences that Storm jumps, the last, after a long run, on the second go. Afterwards I decline a stiff-looking fence which drops steeply downhill. A man in a red coat careers through another fence, and both horse and rider land on their faces. He has broken the top rail of the fence. I don't wait to jump that – there isn't much point; and besides, by the time it is my turn, the ground, if it wasn't boggy before, is now a quagmire. My rule has been to jump what is offered. I am sorry, Storm, but I want to make all your experiences today good ones.

There should be plenty of scent. It is a dull morning, listless, the air colder than the ground. At one point, hounds are flying. I watch a fox disappear into a covert with a hound, detached from the pack, only a couple of feet from his tail. 'Doesn't mean anything,' Paul Hopwell, the antique dealer, cautioned. And it doesn't. The rest of the pack arrive eventually, and we never see or hear any more of him. Later, the sun comes out and threatens to turn it into a beautiful day. It shines on that strange urn on top of the column by Cottesbrooke village that doesn't belong to anything. My arm is still not better and I rather lose interest.

Cantering along a track, more or less liquid in places, I come upon a couple of riders standing beside a dismounted girl. When she turns round, it looks as though someone has rubbed a mud pie in her face. Two unhappy eyes swim in a disc of mud. I lean

over and give her my handkerchief, though she can't remove all the mud pack. Everyone she sees from then on jokes about how it would have cost a fortune in a health spa. She takes it in good part. When the group turns towards Brixworth, I head back along the gated road towards Naseby. It is a quarter past one. The first part of the hack home is almost as pleasurable as the hunt. I am alone in the landscape, with just a red dot in the distance where someone is hurrying to change horses.

The other day I went looking for Seville oranges. Kettering market was entirely full of stalls selling junk but I did buy some from a greengrocer – yes, a greengrocer! (How does it survive almost next to Sainsbury's?) Seville oranges are not so easy to find; last year I didn't come across any. So my blessings on you, greengrocer. I am resolved to make quantities of marmalade.

This evening, we begin marmalade operations. We slice up the fruit, simmer it, put the pulp in muslin and squeeze out the pectin. The last is torture if you do not leave it to cool, which we don't. In any case twisting the muslin causes twinges to my wrist. But we persevere, stroking, pushing, massaging, prodding, strangling this increasingly slimy sleeve of material, scorching our fingernails as we do so.

Here are two delicious stories from Tony Ireson's *Old Kettering and Its Defenders*. (I paraphrase.)

For thirty years the Revd James Hogg, Rector of Geddington, divided his time between his ecclesiastical duties, serving as a magistrate, local government work, and running the grammar school. His bizarre punishments have assured his place in history. He sent incorrigible boys home without their trousers, while those offenders for whom there was some hope were made to go about wearing ancient and ridiculous wigs.

Every male member of the Draper family was known as Ducky Draper. Queen Victoria and Prince Albert visited the White Hart in 1844, en route by coach to Burghley House, from Weedon, the nearest railway station; they needed a comfort break. Only 15 minutes were allowed for the halt

at Kettering. But Henry Draper, landlord of White Hart, performed Sir Walter Raleigh-type stunt with a cloak, and immediately afterwards pulled down the White Hart sign, renaming the inn The Royal. When asked for his impression of Queen, he said she was a 'real little ducky' – a sobriquet which burdened his successors through generations. He was said to preserve a phial of amber liquid, which he called the Queen's water.

Sunday January 16

Yesterday saw stage one of marmalade-making completed. This morning we begin boiling. The boiling goes on until 2.30, 3.00, then 3.30. Finally we have to suspend it to go into Kettering because, among other things, I haven't bought enough jars. The boiling resumes. The contents of the saucepans bubble to darker and darker shades of mahogany, while some spills over and bonds like superglue to the surface of the stove. Every so often, we remove a drop of the liquor, tip it on to a chilled plate and observe the effect after a minute's cooling in the fridge. It puts me in mind of the Queen's water. We prod the amber syrup with a finger but it shows no inclination to crinkle. About half past six, after the sort of sustained boiling that would have impressed Macbeth's witches, I think I detect signs of glutinousness having developed. So I spoon it out into an array of enormous jars, and I shall find out after I return from America next week whether we have marmalade soup or the real thing. One thing's for certain: this marmalade won't be for wimps.

Saturday January 22

I returned from New York yesterday. When I arrived there, I thought I would collapse, literally, it was so cold. My dinner companion said we must hang back when waiting for the Walk light on the avenues because the wind was coming from the north. Next morning, the temperature fell to 4°F.

Driving past the park at Boughton, the 300-year-old limes, with their hairy armpits and knees, look like mad old trolls, their limbs making frenzied, contorted gestures of ambiguous interpretation – perhaps welcome, perhaps warning. It is now Saturday, or rather Sunday, 2.20 a.m. The first thing that William notices as he comes into the cottage is that the sticky bud in the pint beer glass has started to burst into a pinkish pre-spring sort of leaf. The marmalade, to our horror, is still liquid.

Sunday January 23

No church today because Naomi's parents, sisters and families are coming. We wake late, following yesterday's late arrival. Naomi dresses the boys in cherry-coloured trousers that I have brought back from Gap in New York, with zips at the bottoms and Velcro pockets. We squeeze two chickens into one smallish baking tray, to suit our smallish oven, but realise that the preparation of the crumble has left no baking tray for vegetables. We go to Sainsbury's and, incredibly, spend nearly £50 on things such as cinnamon and oven cleaner, and return just as the Cambridge contingent is standing on the pavement wondering whether this is the right house or not. It is the right house, Anthony Griffin has just told them.

David thinks he might disappear into the Star until the anxieties of the journey have worn off. Martin and Constance are still in the car; Martin emerges saying, 'We have been all around the houses trying to get here, a terrible journey.'

Then the whole party gets wedged in the cubbyhole of a kitchen which also serves, I now see, as a corridor to the rest of the house. As a result it is well past one before the unpacking of the baking trays makes it possible to cook the vegetables. So we all go to the playground, taking a leisurely tour of historic Geddington – that is to say, the cross and the bridge, the church by now being closed. We return and eat smoked salmon for an hour or two, while the vegetables refuse to cook. At last the chickens and accompaniments are ready and we eat them, sitting on every available chair

in the cottage. Cheese and crumble take us to five o'clock, by which time David is prone on the parlour floor, asleep.

Once everyone has gone it is a big task to clear up, because of the tiny sink and absence of a dishwasher. We have just laid the table again for the children's supper, and I am telling Johnny not to scribble on the walls, when Lisa Wilkinson from over the road appears at the back door. This is one of the disadvantages of having no bell. The boys, by this time, look like Murillo urchins. Johnny's new fawn-coloured top from Gap is not only streaked with mud and chocolate but has a half-chewed Percy pig stuck to the breast like a brooch. The Hoover is out, pyjamas dry on the log stove, all Raffi's cast-off toys, carefully preserved in their completeness by Ilona, have been emptied on to the floor, most of them you can't see because of the additional layer of Sunday newspapers – it is like the set of a kitchen sink drama, in which two small children have to be rescued from parental neglect. Lisa assures us that it is just like this at her house (she has young children) but I'm not convinced. We have a glass of wine. The object of the visit is to stir me up about the threatened closure of the wildlife centre in the old church at Newton, half a mile on the other side of the A43. I had read about this in the Geddington newsletter. The problem is that the council wants to withdraw the £35,000 p.a. grant, in order to fund a PR person for their education services. If their education was any good, it wouldn't need the skills of a PR person to present it, I'd have thought. But that is perhaps prejudging the issue. I agree to see the centre on Friday.

The Levellers of Newton

Friday January 28

There used to be a village at Newton-in-the-Willows, while another Newton, Newton-in-the-Something-Else, with its own church, stood barely 200 yards away. Medieval Northamptonshire was pretty densely populated, to judge from the bumps – I always imagine them to be deserted villages – that we ride by when hunting. In the ancient of days, Newton was bigger than Geddington. But no dwellings cluster around Newton church now. It is alone by itself, a little thirteenth-century delight, in the middle of fields.

The church has been converted into the Newton Field Centre. Lisa and I are a little early when we arrive so we trudge off, against a lacerating wind, towards the dovecot that lies on the other side of a field. Dovecot is hardly an adequate word for the structure; it is almost the size of an ocean liner. It was attached to the great house that used to stand here, of which just the foundations can now sometimes be seen. But the thousands of pigeons it could have accommodated would surely have been too much for one family, however greedy. They must have been sold, I should think. There are still a few doves, but the stone nest boxes are also used by owls. There are owls, too, in Geddington churchyard, according to Lisa; you can see them on the cross, pecking at it.

The house and dovecot belonged to a branch of the Tresham family, distant cousins of the Francis Tresham of the Gunpowder Plot (he was the inadequate plotter who gave it away). The Treshams were not model landlords, or even terribly nice

people. In 1607, Sir Thomas Tresham, who had bought part of Rockingham Forest from James I, started to drive out the peasants who were living in it. Strictly speaking, the peasants should not have been there, but some of them had made it their home for generations – presumably because the Crown had become too inefficient to stop them. Tresham wanted to fell the woods, enclose the common land and run sheep. The peasants, giving themselves the name of Levellers, tore down the hedges and fences he put up. They had a fire-and-brimstone leader who called himself Captain Pouch; he carried a leather pouch on his belt that was supposed to contain a magic charm against the Levellers' enemies. His real name was Reynolds. Tresham got the king, from whom he was purchasing the land, to expel the Levellers; a militia was formed; as many as a thousand Levellers assembled to oppose it. But since the Levellers were only armed with staves and bows, whereas the militia had muskets and cavalry, it is hardly a surprise that the forces of progressive agriculture should have won. Sir Anthony Mildmay and Sir Edward Montagu (of Boughton) led the charge, and 40 or 50 Levellers were killed. Their leaders were strung up, and their remains displayed, in the fashion of the times, around Northamptonshire.

By the time all this has been explained to me, the woman who farms this land has joined us. Another extraordinary thing is that all this area used to be ironstone workings. They have landscaped over the quarries, so that you would not know they had ever been there. The footprint of the Tresham house used to have a spoil dump on top of it.

The little church has been very well converted to a field centre, where schoolchildren can be taken down to the Ise to look for waterlife, wildflowers and molluscs. In the afternoon, they study under microscopes what they have collected. There are courses for adults, too. The whole thing is exemplary, so naturally the local education authority want to stop their grant. If they did so, the church would close, have no obvious future use, and I suppose the land would have to be deconsecrated: people still have relatives buried in the churchyard.

The Duke of Buccleuch's agent, Alan Wordie, turns up, being a trustee. He used to fly helicopters for the army in Hong Kong, and damaged his leg, perhaps lost it, in a helicopter accident, where people say that he showed heroism. Thinking of tomorrow's *Today* programme, I ask everyone whether they believe that life in the countryside has got better over the last three years or worse. They all say worse. Or at least the farmer and the agent do, so vocally that it seems as though everyone says it. Bureaucracy, uncertainty, demoralisation, no hope of things improving, a way of life under threat. I have heard it all before, of course, but I'll quote them on the radio tomorrow.

I nearly forgot to mention – this was the first night I had sampled one of Mike's eye-watering curries.

Saturday January 29

I somehow manage to get up. The night was spent cuddling a hot-water bottle to stop getting the shivers. I drive into Northampton, then back to Geddington again, to change into hunting things, and on to Naseby. Before I set off towards Thornby, Leanne, one of Sue Muirhead's girl grooms, with tears in her eyes, apologises for not having taken up my offer to let her compete on Storm, but her parents are moving house. It is to do with a change in her father Trevor's job; he is a keeper for the Duke of Buccleuch. They have been in that house in the woods for sixteen and a half years. To Leanne, that is practically all her life. They are moving to Newton, which, though a very small village, won't be the same as the openness and solitude that they have known until now.

It is very blustery as I hack to the meet. In fact, I miss the meet and join the hunt in a field. I am selective about jumps. I might not have done any at all, I am being so careful, but Sarah Knight (in her new hunting coat) says, 'Don't worry about the style. You just have to roust him up and do it.' So I do it. Three fences but two stops. Damn.

My greatest excitement is to lose balance and kick the stirrup leathers off the saddle. I am dangling around Storm's neck, like one of those cowboy stuntmen, with my feet out behind and a stirrup leather hanging by a thread. Unfortunately David Miles, the farmer, is just behind so the performance does not go unnoticed, even if, for today, unremarked. At one gateway, a little voice is heard: 'Oh help me! Oh please, *please* stop . . .' and a pony bearing a little boy shoots past us all and through the gate.

It is so blustery that we can't hear any conversation. We can't hear the hounds, and they can't smell anything. After a gloomy start the sun comes out, and we look over a bumpy valley, with the hounds scampering up the opposite hill. Fine, very fine, but I don't stay out long. The cold, you see, and there isn't really much doing. My arm is still not back to normal and I don't want to risk any more stops. Damn.

Tuesday February 1

There is something almost medieval about the National Farmers' Union dinners, even though they take place in the Hilton Hotel. A red-coated barker commands the proceedings. The president and guests troop on to the top table, which is raised up above the multitude and – in the manner of Leonardo's 'Last Supper' – allows people only to sit along one side. So they eat literally as though on a stage. A band plays all through dinner, ending up with the music from which the *Archers* theme tune is taken – rather clever.

I sit beside a pig farmer who has made a success through traditional Wiltshire cures of bacon. Most pig farmers are going to the wall. On the other side is a lady who is a farmer's wife but also a teacher and who has started a nursery school, and a riding establishment on her husband's farm at Madresfield in Worcestershire. The farm doesn't make any money but the school is a runaway hit.

Afterwards, the head of Mars (as in bars) gives a speech. His video image is projected on to huge screens behind him. The camera catches not only him but the person immediately behind

him on the top table. So while the speaker is addressing the need for change in a demoralised industry, we watch a rubicund Tim Yeo (there as Shadow agriculture spokesman) bite the end off a rocket-sized cigar, and then luxuriate in smoking it.

The speech is followed by the awards. And then songs – 'Bladon Races', 'To Be a Farmer's Boy', etc. John Gummer tells me that Tony Blair's speech that afternoon showed him at his worst. It took four meetings for the NFU to persuade him, or his people, to remove a section about hunting, on the grounds he would have been shouted down. Pity he didn't leave it in, I'd say.

Thursday February 3

They are threatening to put down yellow lines to stop people – us in particular – parking outside the cottage. I get hold of Mr A'Ness on the phone. He is the traffic co-ordination officer, or something, for the parish council. In other words it is his job to busybody around and interfere everywhere. He says that the junction outside our cottage could be dangerous if you had to pull out into Grafton Road to avoid an enormous Landcruiser (such as owned by departed neighbours), particularly on a winter's day when the sun's in your eyes. But the road by our cottage, I tell him, is about as wide as the River Thames. Then there is the problem – you wouldn't be aware of it, not being here during the week, he says, with perhaps a trace of moral superiority – of the mothers dropping off children to school. They sometimes park for as long as half an hour. The police say that it is in any case illegal to park within 15 metres of a junction – in which case, I'd have thought, the yellow lines wouldn't be necessary. There will be a parish council meeting on Monday week at which I can make representations.

Just as we're closing he says that the chances of being allowed to put down yellow lines in a village conservation area are practically zero. An odd admission, because it makes the whole effort seem completely pointless.

Friday February 4

Over lunch in the Star, Norman, of Geddington Farms, gives me a detailed account of the corn-drying operation. It is vital to the farmer. Corn is stored with a moisture content of 14 per cent. This is also the optimum for milling. There is a skill, though, in getting it to 14 per cent rather than 13 per cent. At 13 per cent the farmer is losing weight. Geddington wheat goes all over the world. There is a shipload now sailing for Russia. American wheat is better for bread but doesn't come in such volume. That is why American machines can be so big (operated with TV cameras at either end); they can cope with the proportionately smaller throughput. Not that the Geddington machines aren't big enough. They cannot move the combine on roads without a police escort. It takes up the whole width of a Geddington street.

Saturday February 5

Last weekend the sticky bud looked like the umbrella on top of a cocktail stick, only more complex – a sort of fernery, in tiny, tiny miniature. Now the leaves, or some of them, are real leaves, quite big ones. And another part is opening into a flower. *Miracolo!*

Sunday February 6

The garden is sprouting, and I just don't see how I can fit in my neat little beds, edged with box or, more daringly, hedge germander, because the available grass is a sort of banana shape. It is not exactly Versailles. I phone Rupert Golby, gardening genius, about these worries. He has the good suggestion that we could move some of the plants not wanted in Pimlico to Geddington, principally, for symbolic value, the roses that came from *Country Life*'s garden at the Chelsea Flower Show three

years ago. There are some other plants that would be much better suited to the sunshine of Geddington. I could then restrict Pimlico to plants that grow in the shade of a dank basement and make a gloom garden.

We eat steak followed by syrup pudding with custard for lunch. William won't eat custard. We are puzzled; then we realise it is because he has never been given it before. He is coaxed to eat a tiny morsel from the end of a spoon – tongue protruding like a lizard – and then he is off. A lifetime of custard-eating before him. We now know he is a true English-man.

Valerie Finnis says we must see the snowdrops in the woods at Boughton. Snowdrops are the plant of the moment, and she herself is a galanthophile, as snowdrop enthusiasts are sometimes known, having 45 different snowdrop varieties in her garden. So yesterday we set off, past the big house towards the wood that goes up the hill. We found a few snowdrops and aconites – round-headed yellow flowers that look like the curls of butter that you used to get in fancy restaurants – but not many. In a hut, some white overalls suspended from a peg seemed like a man who had hanged himself – a gardener in despair at the low snowdrop count.

Today, we go back on the hunt, but not until I have brought back the *Mail on Sunday* for Naomi, for whom the competition (sure to make our fortune) has become a fetish. It takes me four shops to buy one. So I am not in the best of moods on returning. Then Naomi believes that the jacket she was going to return to B-Wise has been stolen from the car – 'Oh, you're so trusting – lovely country people, I don't think.' She finds it upstairs. This causes a mature exchange of views (otherwise screaming match) on the way to the snowdrops, for which we have new co-ordinates from Valerie. We were almost there yesterday, just a few yards short. We turn into the wood and there they are, pools of snowdrops alternating with aconites. They are mesmerising, a bit reminiscent of fried eggs – but quite wonderful, too.

In Geddington, I am just settled in front of my laptop when

there is a knocking on the kitchen door. That is the only way people can make themselves known here; still, it is always a bit spooky. It turns out to be Jane, the former mounted policewoman who now runs Granny's Attic, returning Big Bertha. We have had it restored; it is oak after all.

Monday February 7

I have just posted a cheque for £423.77 to Sue Muirhead. But why does anyone keep horses? I spend the morning in the middle of a field at Leatherlands, with Debbie and Leanne from Sue's yard, wearing Debbie's waxed jacket, with sleet beating on my ears. Leanne looks like a picture of misery, arms straight down by her side like a doll, trying to make herself as tiny as possible. I watch Storm perform for Debbie, but he doesn't do very well. The idea is that I will ride, she will roust him up, and then I will ride again to feel the difference. But Storm will only jump reluctantly for Debbie. When it is my turn, I feel he will go better if I get off and push. Sue wants to have his back checked; perhaps I have ruined him. It may be that he is still stiff in some way after that fall; I am.

To console myself, I have one of Mike's less ferocious curries for lunch at the Star. There is a chap there complaining about the way the government is going to close thousands of sub-post offices. Think what that will mean to village shops. Peter comes over.

'It isn't the government that's closing village shops, it's the people in the villages who don't shop in them,' says Peter.

'They're trying to make us all live in towns,' replies the chap.

'Who are?' asks Peter.

'The government,' says the chap. 'They should give us a reduction in the community charge. They have all those facilities in Kettering, and we can't reach them, except by car.'

'Where do you do your shopping?' inquires Peter.

'Tesco's or Sainsbury's,' replies the chap.

'There you are, then,' says Peter. 'There used to be a little centre of shops around here – a working farrier, a butcher with an abattoir, a general store, etc., etc. They've all closed because nobody used them. Mind you, it wasn't just that. The bloke who ran the Co-Op was a cretin.'

'People have to shop in the towns because of the price,' counters the chap.

'It isn't just price. I bet someone could find shops that were cheaper than Tesco's and Sainsbury's if you didn't mind shopping at half a dozen places,' says Peter.

At this point Peter is called upon to pour a pint of Guinness and the chap goes on grumbling about being forced to live in towns.

Friday February 11

I visit Northamptonshire Record Office, in somewhere called Wootton Hall Park outside Northampton. I assume a country-house setting, and there must have been once, but now it is a wilderness of sheds and huts, containing the police headquarters, fire brigade and less glamorous public services. The record office is a red-brick building, with a drinks dispenser that would work if I had a 20p piece, which I don't, and no cafeteria. So I stay, locked in and nun-like, until closing time, missing lunch.

Twenty-three buildings were constructed at Geddington in the early seventeenth century; perhaps Midway Cottage was one of them. In which case it may have been occupied by one of Geddington's 16 able-bodied men, listed in 1638 as being 'fitt for His Majestys Service in the Wars'. They were drawn, so the archivist tells me, from the Posse Comitatus, the body that the sheriff could draw upon in case of military need. They included husbandmen, labourers, a smith, a carpenter and a tailor. That ought to be more or less everyone except for clergymen, cripples and ancients. Why only 16, though? By the end of the century the figure had risen to 21. Yet in 1719 the population was 540.

Either the village underwent a growth spurt about 1700, or some residents managed to dodge the sheriff's eye.

Saturday February 12

Once I think that the racing on television is over, I phone Sue. The vet says that the reason Storm is not jumping is that his back is hurting him. He must have pulled something when he caught his back legs on a fence. Apparently, these things can go undetected at first, but then seize up. I am somewhat relieved at this verdict, because it means that his failure to perform cannot be (entirely) put down to my riding. But I won't be able to hunt next weekend, maybe the weekend after.

When I go out to collect logs from the car, I find a man looking anxiously at acrid, coal-smelling smoke pouring from his chimney. 'I think I have set the chimney on fire.' It is Graham, our new neighbour in the Tea Shop.

Sunday February 13

I attend church. The previous vicar is there, sitting in, so to speak. He now lives in Devon, where he comes from. He tells me afterwards that he was exhausted and so felt he needed to go home. Not much respite there, though; he is now in charge of five parishes, covering an area about the size of Wales. Farming is now such a disaster people are on suicide watch.

Monday February 14

Headline *Kettering Evening Telegraph*: 'Dumped and Left to Die'.

Three puppies were found dead after being callously dumped in a plastic bag. A fourth animal from the same litter was

121

trapped inside the bag, which had been knotted and thrown into a Corby street.

Corby: it would be.

The parish council meets in the village hall in a white-painted room with asymmetrically placed prints of the Eleanor Cross on the walls and a horseshoe of tables for the councillors. I arrive and an elderly man is addressing the meeting about street lights on the A43. His house is on the A43, and he wants a light outside it. It was so dark that some burglars from Corby had dumped their loot outside his house, without its being seen; by the time the police arrived three hours later it had gone again. He has been trying to get this light for 24 years. He has written to the electricity board, the county council, the highways engineers, the local MP, and now he is back with the parish council. He has letters and notes to back his argument. In the meantime he objects to the traffic calming proposals, because he cannot get his light. At one point he shines a torch around the room, in each parish councillor's eyes (I'm not sure why, my attention had wandered). Three parish councillors have visited the site, and found the lighting level adequate.

Words become heated when a councillor asks if he will take responsibility for accidents that might happen while the traffic calming is not in place. But generally the councillors, in the face of this massive boredom, are patient, reasoned, as accommodating as they can be, polite.

On the question of yellow lines, Mr A'Ness reads out a letter from the county council which more or less answers it. The exact extent of yellow lines will have to be marked on the enclosed map, map returned, deliberations made, objections considered, and if in their wisdom the county council is minded to grant permission, the cost of the exercise will be £800–£1,000, which it doesn't have. Since, according to a previous speaker, the light on the A43 would cost the parish council £250 which the parish

council cannot afford, it is unlikely that the yellow lines will come within budget.

Our community policeman, PC Ambrose, explains the objections to parking. Particular mention is made of a large four-wheel drive outside the Tea Shop. It is noted that this is now parked somewhere in Brigstock (the owners having moved). On Sunday there was the problem of a large BMW parked on the pavement – accusing looks towards me, but I could plead not guilty. The BMW is identified as belonging to a member of the church congregation, who comes from Kettering. 'In that case,' says PC Ambrose, 'I'll be along next Sunday.'

I think we can put our faith in British common sense.

Friday February 18

I go to Kettering, on what starts as a joyfully sunny morning. Driving towards Sainsbury's, I notice an antique shop, with pots and an old print in the window. It is the only antique shop in Kettering and I stop. There are lots of odd things like transfer mugs, bone-handled knives and a statuette of Napoleon, but I am looking for big prints in old frames, so the owner brings down from upstairs an etching of a Scottish game lodge. It has officers contemplating a stag that is being weighed by a ghillie, while all around slaughtered birds and animals are displayed in profusion. Just right for Jonathan Young, editor of *The Field*, but not me. He has a really big print, the owner tells me, of the death of Nelson. The death of Nelson, I ask you! It is almost too appropriate; the only danger is that it could lead to Nelson fixation in William. The print is too big for him to keep in the shop so he will bring it in from home tomorrow. I cannot afford it and yet I feel already that I may have to buy it.

I hurry back to the cottage, change and then drive to Naseby. Sue is gloomy because of her sister who was buried in Wales yesterday. It meant revisiting her old family home – a country estate in Snowdonia – which is now owned by a pork pie manufacturer, who made disagreeable remarks about her family

after the funeral. She feels nostalgic after seeing childhood friends and former tenants. A young man in a suit comes into the yard and talks to Leanne. This is not tactful. It turns out that he is someone she met in the pub last night, an insurance salesman, who is hoping to sell her life assurance, as well as generally chatting her up. He is seen off; Leanne is in a strop, then tears.

We are trying Storm at Leatherlands to see whether he is now better. The weather has changed; there is a cruel wind and a very mean kind of rain is trying to partner it. Storm is rather less enthusiastic at finding himself in open country, with jumps, than I might have imagined. I warm him up, then Debbie puts him over some jumps. It takes some riding. He is better physically; it is the mind we must worry about.

Before I leave, Sue and I talk about dogs. She says that terriers of any description are too snappy for children, but what about a dachshund, or even a poodle. A poodle could quite suit Naomi.

Saturday February 19

I take rubbish to the Dump and buy a red metal-framed chair. A man is staring out of the stable door with the patience of a philosopher. When I ask him how much he wants for the chair, he replies, with economy of effort, 'Two.'

I drive on to Dragon Antiques where the death of Nelson is produced. It is after the Daniel Maclise that hangs (if murals can be said to hang; this one just decomposes, having been painted in an experimental technique) in the House of Lords. It is very long, and in both its original frame and mount. There is any number of figures, gesturing, hauling on ropes, shooting carbines, kneeling by Nelson, firing cannon, clambering up rigging, expiring in any number of decorous poses; it is the sort of picture you are supposed to read like a book, but heaven knows what they are all doing. And, of course, Nelson didn't actually die on deck: *C'est magnifique mais ce n'est pas la guerre*, as one of

124

the other team would have said. I cannot escape destiny by not buying it. For one thing, it is a miracle of engraving – so many people, admittedly most dead – and it *is* Nelson.

I go then to Kettering where I join the library and pick up Naomi and the boys from the station. We did not buy the Slum but whenever we come into the village we have to slow down, as though someone had just died in it. 'The For Sale sign is still there,' says Naomi, not wanting to let go. We put the print up over the dining table and at various times after we get back William can be found sitting opposite the print, rapt in concentration. We consume stew for dinner. William is excited to sit facing the print. The conversation during the second half of dinner consists of: 'Why did the Frenchman kill Nelson? Were any Frenchmen killed? Why was there a battle? What is a battle? Why were the sailors sad to lose their great leader?'

Sunday February 20

In the evening, I look at one of the books I have taken out of Kettering library; *Geddington a Village at War*. I glanced at it yesterday, noticing a photograph of a cottage under the heading (from local paper) 'Dwelling House Wrecked'. Other people's disasters are always fascinating, even at a century's distance. One Saturday morning in October 1914, a steam lorry smashed into the cottage, knocking a six-foot-wide hole in the front wall. The photo shows a group of philosophical looking villagers, with shovels, aprons and brooms, standing in front of the chasm, where the parlour and bedroom wall should have been. Today, taking a closer look, I realise that my amusement was misplaced. The cottage in the picture is ours. The wall that had to be replaced is, as I write this, about four feet from my back.

The lorry, according to the report, was labouring up the lane opposite (Church Hill) towards William Abbott's bakehouse, when for some reason it began to run backwards. By the time of the impact with our cottage it had gathered 'considerable force'.

* * *

I find Naomi to be set against having a dog. Sympathy towards canines was not improved by my showing her a book, *How to Have a Well-mannered Dog*, which I borrowed from Sue. I shall persevere.

Monday February 21

This has been a bumper year for catkins, but when I look for them around Cottesbrooke, I can find only one tree. It has a heavy burden of them, though.

At lunch, William asks 'Why did Nelson's hat fall off? Did Nelson sail his ship back to Greenwich?' He couldn't very well do that, I explain, because he was dead.

Thursday February 24

I go to Naseby, where I find Storm is much better. Pauline, the head groom, says that with a big horse an injury does not always appear quickly; big horses are better able to hide it from themselves.

In the afternoon, I visit the Dump and buy a quantity of children's books – about fifteen – and a watering can for £2.50. The books are sound but not new. They include *Alice in Wonderland*, *Big Book of Postman Pat*, etc., as well as a host of Ladybird books probably from the time that I grew up. They are full of scenes of mummy collecting milk from the milkman, going shopping in a hat while daddy marches off to work. There is one called *Daring Men* about chaps in khaki defusing unexploded bombs. William and Johnny will grow up talking about ration books and whalemeat.

By nine o'clock, I am ready for a drink. The pub is quite active for a Thursday, and Peter is looking forward to his holiday in Goa. Mike brings me a typescript of memories of a mate of his,

aged 85. We talk about gardens, growing vegetables and the problem of Peter's rabbits, which are the bane of Peter's big garden in Earl's Barton. 'No rabbit would go in your garden,' he opines. 'They'd say it didn't meet the EU directive on rabbit hutches.'

The English Versailles

Friday February 25

I am sitting in the office of the Duke of Buccleuch's agent, Alan Wordie, on a sparkling morning that makes you itch to be outside. Alan is a great guardian of the countryside: his Hong Kong years have trained him to repel townies and other incomers, who slip over the perimeter wall, wanting to change it.

I am about to be given a tour of the Boughton Estate, but before we can get going, I must be shown the computer which has a program to record everything about it. Before the Second World War, records were kept partly in copperplate-written volumes, partly in the agent's head. The new system means that all the little details a duke might need to know – the names of his tenants' children, and so on – can be produced at the click of a mouse. And it is brilliant for landscape history. All the old estate maps have been put into the system, and can be overlaid, one on another, to show how the land use has changed. Alan wants to make a computer game out of it. You would start off with an estate, and have to make decisions about what to do with it: whether to plant a wood, dig a lake, create a golf course, build a village, take a farm in hand, and so on. The object of the game would be to stay viable for a hundred years.

At last we climb into the Range Rover and drive into the landscape that was formed by the duke who is still known as Planter John. His avenues still stride out from the house, though they never got quite as far as London, which was his ambition (he wanted to be able to drive there in his carriage entirely under the shade of his own trees). After his time, the principal influence

on the estate was a century and half of neglect, when the house was shut up. Those parts that were not farmed were planted as forest. Then came the two World Wars, and the trees were cut down. The airfield at Grafton Underwood was laid. You cannot appreciate the scale, now that the runways have been dug up and planted with trees, but there were 7,000 American airmen at the base which covered 500 acres. Stand at the granite war memorial at what was the end of a runway, and it is almost possible to feel the ground shake as a ghost of a B-17 Flying Fortress judders into the sky, heading for Germany. There are websites for airmen stationed at Grafton, wanting to share memories and find old comrades.

When we go into the courtyard of Boughton House, we find Valerie Finnis. She complains about pheasants consuming her crocuses; all the yellow ones are gone, and it took her thirty years to establish them. 'The pheasants can be dogged out,' sighs Alan, 'but they just come back.' So does Valerie. Alan has had to write to her, requesting her not to phone him in the evenings at home.

On the farm at Warkton, next door to Kettering, cows wander into the milking parlour with darts sticking out of their rumps, or udders shot with air rifles. There have been a number of barns full of straw bales torched right next to barns containing animals, sometimes just a few yards from farmhouses. Sometimes the animals have hurt themselves, and had to be killed. Tractors and other equipment are set alight too. It is joyriders who do it, apparently: they pinch cars, do a little thieving for drugs money, and end the night sitting on a hillside watching the flames and the blue and red flashing lights of the emergency vehicles.

We see some sheds where cast-iron baths, the sort with feet, are being restored, and three-wheeled vehicles converted for use by the disabled. Without sheds these craft industries could not take root.

The business of the estate is supposed to keep the roof on Boughton House, and until now it just about has. The two sides of the equation are in balance. But farm rents are now wobbly. Forestry doesn't bring in anything, because so many trees were cut

down during and after the war; they have been planted again, but it is too early to harvest them. Shooting provides gamekeepers for vermin control and an informal police force (they go lamping at night and see suspicious customers or find people trying to commit suicide in their cars in the woods). The only salvation is the property market – that is, renting houses and barn conversions to people like us, and selling land for Persimmon Homes to cover the outskirts of Kettering with trashy boxes.

Of course, if the estate did not do this, the Aslet family might not be able to enjoy the park, because the park might not be there. As it is, Alan tells me, we can get a badge for the car, and go almost anywhere. Not absolutely everywhere, however, because people make their way up to the back part of the house and simply use it as though it was theirs. A woman with a baby was found beside the duke's swimming pool, while a couple of men played water polo in it.

Sunday February 27

Last night we went to our first dinner party in Northamptonshire. We had lined up an immaculate babysitter but she phoned about noon to say she had been sick all night and couldn't come. So we went shopping, and when Naomi came home she phoned Jane, who sat for us last time. Jane said what a pity, because she had arranged to go out half an hour before. The Jackson-Stopses, whose party it was, said we should bring the children. Johnny went to sleep as soon as we got into the car. I made the journey doubly long by misreading Harringworth as Harrington on map, so we set out in the diametrically opposite direction. The Jackson-Stopses' 17-year-old daughter Clemmie, who keeps Pedro with Sue Muirhead, was on hand to settle William in front of a *Mr Benn* video. We had an evening with the grown-ups, more or less.

They were a set. The men all wore velvet smoking jackets, the women smoked cigars. The women trooped out before the port, but Naomi resolutely stayed, which did not cause undue concern

because by then Clemmie had come to join the party. Johnny had also made the first of his appearances. When I saw William, he said that Johnny had been asleep, but he had woken him up by forcing his eyelids up, like this (demonstration). He thought Johnny would be sorry to miss the *Tellytubbies* video. There was intermittent peace as they played with Lego but no sign of sleep, until we got into the car about half past twelve.

A fellow called Tim told me about the Agricultural Show which will soon be happening in Paris. Four times more people go to that than the Royal Show – 850,000!

On the way out we noticed a stuffed animal in the hall. 'Is that a pinemartin?' a guest asked Mark Jackson-Stops. 'No, it's a lemur,' he replied. (Reader, I cannot deceive you, that guest was me.)

The other great event yesterday was Rupert Golby, the gardener. He arrived from Valerie Finnis's. She had given him a posy of pussy willow and other buds (quite rare, some of them, and not native), which I am pleased to put in a cottagey brown jug from Cambridge. We walked around our tiny garden in wellingtons. The roses, which have stems as thick as logs and whippy green shoots waving at a level far above my head, should be cut down to eighteen inches from the ground. I would never dare to do this, but Rupert knows a gardener who can do the job. The japonica will be thinned by two-thirds (no waiting for blooms, though they are already on the way). The various cotoneasters will go. We have also bitten the bullet about the clematis; it will go. Altogether we shall feel distinctly naked after the Golby treatment. But I look forward to the plant holocaust with fierce delight. I am the Hindu god Vishnu (or is it Siva?) of the garden: out of destruction comes creation. I shall make a path round our parterres.

Naomi cooked chocolate brownies which we ate in the garden, then more around the log fire.

Thursday March 2

Sue Muirhead rings about Storm. She has the results of the blood tests that were needed after the mixed performance with Debbie on Saturday. Storm started off as jolly as anything, flew over the first fence, but then put his head down, apparently exhausted, and wouldn't, just wouldn't go over the next one. Perhaps it was because he was in a crowd. However, the blood tests show that his anaemia has returned. He had such a great burden of worms when we got him that probably his stomach lining was damaged, and he can't absorb as much nourishment as he should through his feed, so he must take an iron supplement. Also, Sue has to concede that he does not like heavy going. That is nearly a vindication for me.

Saturday March 4

Storm bounces along to the meet at Naseby Hall, snorting as we go over the bridge over the A14, with traffic rushing below. I am conscious that he has been given maximum oats, as well as an iron supplement, so anything could happen. I have always been afraid that one day a horse will buck and topple me on to the road below. I suppose it is unlikely to happen, certainly not with Storm.

I arrive in just enough time for a drink. My conversation with Rosemary Black goes as follows: 'Good morning, Rosemary.' Rosemary: 'That needs to lose some weight. Fattest horse I've ever seen in my life.'

After a couple of hours, we pause near some pits, in sight of the airfield for gliders. A plane is lofting a glider into the sky in the distance. I ask someone where we have been. She asks the person next to her. 'The hounds were screaming from Hothorpe Hall to Sulby,' she laughs. The hounds are always screaming from one place to another, nobody knowing quite where. There is plenty of bumpy old pasture, but also enormous seeded fields around the margins of which the horses struggle, sinking deep into mud. We

are on David Miles's land at one point. After the hunt has crossed one of his fields, flushed green with young shoots, he asks: 'Were they walking when you came?' They were. Cantering would have destroyed the crop.

There is not much jumping at this time of year; just two fences are offered. The first has a little ditch just in front of it; by the time I see it there is no time to give Storm a touch with the whip, but he sails over it all the same. The other is boggy but we surmount it. For the rest of the hunt, he is the old Storm, dancing down valleys and roaring up the hillsides.

I see David Miles and a contingent taking an attractive path across a field, while the rest of the hunt make their way round the outside. I join them. It is the way to go home. Never mind, we had fun; it was enough. A dandruff of snow falls as I make my way back. By the time we reach Naseby, it is quite cold.

We eat ham from the Franche-Comté brought home from the Paris Agricultural Show on Wednesday. The foie gras is in the fridge.

Tuesday March 7

Norman, of Geddington Farms, was in the Star at lunchtime, talking at length about his vegetables. He grows runner beans on a frame made of larch poles, four foot across at the top. This makes a kind of pergola, and the runner beans beneath it are specially tender because they are not exposed to full sun. He grows peas, which some boys once stole, leaving only pods still on the plants. Anne served my Torbay sole at a tactful distance, to provide an escape. Mike made me pancakes because it is Shrove Tuesday. Peter goes to Goa on Saturday.

Back in the cottage, I have work to do. I paint two chairs green. I am not sure about it. I think the others will have to be blue. I remove the washing from the dryer and hang it out. I brush my hunting coat. A short spell horizontal on the bed is disturbed by a telephone call. In addition, I speak to the gardener Ross Allen who thinks

the roses from the Chelsea Flower Show garden are only sulking because of poor London light and air; they will come alive again in Northamptonshire. So all in all it has been a productive day.

Wednesday March 8

The *Kettering Evening Telegraph* reports the inquest on the two Americans who were killed last October at Stanion. They looked the wrong way when they pulled out on to the A43. By the time the driver of the lorry hit the brakes, the car was already under his wheels.

SPRING

Give me the last bit of spliff

Saturday March 11

When God created the world it was for days like this. In our Geddington garden, the honeysuckle, which I see through the bedroom window, is in leaf. Little violet aubrietia flowers spill out of the crevices in the stone walls. I eat one of the eggs given me by a colleague for breakfast; they come from Maran hens which always lay brown eggs. Also, I find that the long, primitive-looking key in the cupboard for the electricity meter does work the front door, if you put it in upside down and turn it backwards. I open the door for the first time, to retrieve the milk. My face is brushed by the zephyrs of spring.

I find my flask (Milk of Magnesia bottle) ridiculously stored among the medicine bottles in the bathroom. Then there is hunting and I am off on a perfect day.

As with almost any perfect experience, the prognosis was dire. Too bright, too much wind; there couldn't be enough scent for the hounds to go anywhere. At the meet, Richard Spencer (with greater wisdom than I realise) says, 'You never know.' And, of course, he has something up his sleeve. The meet is in Guilsborough, at the home of Tina McCall; Guilsborough Hall, in fact. It hardly declares itself from the road but once you have got into the field you see two big wings going back, and the impression of lovely Northamptonshire walls and clipped trees is stately.

It is difficult to hunt at this time of year because of the lambs; many fields are out of bounds. Besides, if the horses' hooves mark the fields now, they don't recover in the way they would

have done before Christmas. Then Rosemary Black tells me off for holding my hunting whip upside down; you have to hold it with handle down, and lash only in one loop, not wound into a whorl. 'You're as bad as the Prince of Wales.' But I am too much in love with the day to let any of this dampen my spirits.

The hunt moves off, and Richard jumps a fence out of the field. It is quite a question: should I jump straight away, after having stood about for so long? But I take Storm in hand, we get a bit of space and he flies over that fence, and the next. At the third one, down in a dip, he refuses. It would not be quite true to say that I fall; I sort of slither out of the saddle. But we are over next go, and then the hunt assembles at the beginning of the point-to-point course. Storm flies it. After that, an hour's galloping over pasture, set aside and headlands. Tiny lambs bounce like pompons.

There was a message at home from John the gardener apologising for not having been, but it was on account of the wet. I don't know what wet he is thinking of. For once, it hasn't been raining. The pasture springs like a dance floor. But even today you can suddenly get into a deep bit, and sink as though in Lawrence of Arabia-style quicksand; Storm's head goes right down. Still – hurrah! – we lose no shoes. After an an hour and a half, Storm's puff is giving out and I wonder about going home. But life is too good. Besides, we have got on to the Cottesbrooke estate and those jumps are so inviting, even if I don't think Storm can manage one just yet. I talk to a visitor from the Vale of Aylesbury. While we are chatting, he spots a fox and hollas, then – and I am not sure about the etiquette of this – whistles. What a glorious whistle it is on this most glorious of days. The sort of noise you would expect from a train or barge. Admittedly this steamboat whistle does not carry right across the valley, with wind against. But it is a fine performance. The whistler is an amateur whip for his hunt, which is how he became good at it.

We move into the lee of a copse, all pussy willow and sticky buds, and I feel the sun soak into Storm's coat. We spot horsemen in distant fields, and calculate the progress of the hunt from the way they are facing, and the course taken by various hounds. The hunt goes away from us, but it doesn't matter because it is sure

to come back. I look at the landscape of folded hills, marked out by horizontal hedges and brooks, with a square white house in the middle, and think that I could stay here for ever. Then Peter Jones and his hounds are spotted coming past the white house, and after them – almost sinister – the body of the hunt. It makes me think of armies, and how silently bodies of horse must have appeared at battles like Naseby. Just the sight of the hunt stirs an emotion of pleasure in me; I can't help it. I suppose other people can't help hating the same thing.

We make our way downhill, meet the hunt itself, and are back in action. We gallop and jump, only now Storm is not so keen on the jumping. I should have quit while we were ahead.

Over one fence, I follow the lead of Michael Bletsoe-Brown, and as I ride away from it hear a squeal, look round and shout 'loose horse'. Actually it isn't loose; there is still someone clinging around its neck, but she soon falls, and the horse gallops past us. Bletsoe-Brown goes after it; I trot up to the girl on the floor. She is not hurt, but in tears. 'I told him I didn't want to jump, but he never listens.' It is Bletsoe-Brown's daughter.

The awful thing is I never get over the last fence I attempt. I have two goes at it; it is a tiger trap with the sun falling through it, which makes it dazzly when you get near. If I didn't have that stupid hunting whip, rather than a cutting whip, I could give Storm some proper encouragement; but as it is, with the hunting whip it is as much as I can do to hang on to him. By the time I am ready for a third attempt some people in four-wheel-drives have come up and parked in front of it. So the season ends rather ingloriously, from that point of view.

But we are still on the old pasture of Cottesbrooke, bounding towards the house; ducking down so as not to take an eye out on branches. I go on until second horses; then begin saying good night, with the nostalgia of it being my last day. They will have the hunt ball tonight. I couldn't expose Naomi to it.

I pass Ellie Bletsoe-Brown, Michael's sister-in-law, putting her horse back into the box. 'If we don't run into each other at the point-to-point, I'll see you in the autumn.' It has such a strange melancholy ring to it. But I find the right road back to Naseby,

where my knees seem to have bent rigid as I slide down the side of the saddle.

Thursday March 16

I arrive at 12.30 a.m. As I cross the bridge, feelings of trepidation creep over me. Has John come, or hasn't he? I notice the furry foliage cap to the wall next door and mistake it for our wall. I feel a flood of relief. Then, in horrid starkness, the jagged teeth of the stones on our garden wall, previously hidden by a rampant matted mass of clematis, are revealed. John has been. The pixie light shines cruelly on the bareness. Inside the wall, the tidiness is eerie; there are sticks of rose stems and bare earth. Even the children's cars have been put away in the shed. I feel as though I have strayed into an alien world of order and good taste.

I put out the wheelie bin with an oppressed heart.

Friday March 17

I was late to bed last night. This morning, I do not get out of my pyjamas till after ten o'clock. Hurrying out of the house at eleven o'clock I am again taken unawares by the bareness of the garden. There is no holly tree, or cotoneasters, just sticks of roses, a hydrangea, a misshapen japonica with red flowers by the house, purple aubrietia growing out of the wall. I can see the houses opposite, and I suppose they can see me.

I issue forth (not in pyjamas) to the post office to buy an envelope, and on the bridge Anona Hawkins tells me about a concert taking place in the church this evening. Before this big event, I lie on the bed for a few minutes, then wake at 7.45 unable to work out whether it is the morning, and if so, why I am still wearing my clothes. I arrive not long after the start because they are still on the first item. This is Weber's Concertino for Clarinet, played very well by an attractive woman with bare arms and a short dress in a church which now has no heating, following

the breakdown of the boiler. I don't know how she does it. Fortunately her style of playing requires much movement and caressing of the instrument which I hope keeps her warm. Next come a couple who are rather more in the amateur tradition. A warbly woman and a man in a dinner jacket sing Rodgers and Hammerstein, though he makes a surprisingly creditable Macbeth with the aria 'Pietà rispetto onore'. A young man does a number from *Les Misérables* very well. Then a really good mezzo sings 'Una voce poco fa' from *The Barber of Seville*. Since this is St Patrick's Day, an actor gives a reading of mixed Irish pieces – not quite my bag, but still. Then come various other performers, including a little girl and Anona herself singing Gershwin with some charm. Only the stalwart from the Corby Male Voice Choir, singing 'Old Man River', strikes the sort of note that perhaps one would expect from a concert in the church at Geddington; this little man in a dinner jacket, with his Paul Robeson inflections, lamenting the tribulations of blacks in the Old South.

In the interval, Lisa from over the road finds me, still stuck in my pew, and I indulge myself with orange juice (not Bulgarian red wine from a box). The Duke and Duchess of Buccleuch are there. The duke is a kind of one-man National Trust: a living embodiment of free enterprise efficiency in the unlikely context of the heritage. While national museums and art galleries employ curators by the cartload, the priceless contents of the duke's three great houses are managed by a couple of staff. There are, of course, compensations for the labour. Not everyone can say, when asked for directions to the lavatory, 'Past the Rembrandt and turn right at the Holbein.'

Tonight, in his wheelchair, the duke is suffering badly from the icy temperature, but he manages a wan smile, as he asks if people look through the windows of our cottage. It must be an interesting question if your own domestic arrangements are as extended as his. I say they are welcome to look if they want to. Actually, though, from my own experiments, the windows are so small that you can't really see anything. Our predecessors bequeathed us dainty lace curtains, and they provide a further defence.

I say that, having been shown the Boughton Estate, I now appreciate the difficulties of being in the urban fringe. The duke says, 'The surprising thing is how little we suffer from it, considering that we are between two towns of 55,000 people. It really doesn't impinge on us at all.' That was a very ducal reply. Alan Wordie finds it more difficult to be detached.

The duke asks me if I'm still hunting and says he followed Woodland Pytchley on Tuesday. But there wasn't much action because they got stuck in a big Forestry Commission wood. They didn't go on to his land. 'I was rather hoping they would,' says the duke.

I apologise to Lisa for having removed the clematis but she recognises it had to be done. 'I will have to be careful when I'm getting dressed,' she says.

Saturday March 18

This morning I drive Naomi to Corby, four miles away, for what she promises will be the last time. So far, we have made, I think, six visits to a dry cleaner's-cum-seamstress there, inspired by the prospect of cheaper prices for altering clothes than London. I must admit I may have encouraged the thought that Corby was the sort of place to find good but economical sewing. I was wrong.

The centre of Corby is the sort of 1960s pedestrianised street that makes you long to hunt out the architect, now presumably in a retirement home, and shoot him. It is just nothing – nothing shops, nothing architecture, nothing trees, nothing rubbish. Naomi sets off for a staircase next to Woolworths which leads up to the walkway on which Susan's Alterations is found. Susan has now altered the hems several times – sometimes higher, sometimes lower – but never hitting the lengths that Naomi specified; hence these attractive and family-friendly repeat visits.

I wait in the car with the boys, who play with the lights, break the glovebox and set off the alarm. As they do so, a steady stream

of people comes to the taxi rank. Taxis here are sign of poverty not wealth, since they mean people don't have cars. When Naomi fails to return within the promised 'only a minute', we go to the bakers. It has a long queue of pasty-faced people, one of them giving a long account of how he always wins when playing slot machines: 'Yesterday I put in 60p and got back £16.' The large woman serving is too friendly to think of hurrying him. The children have their noses and even tongues pressed to the glass of the cabinet displaying an assortment of cream buns. They choose doughnuts covered in hundreds and thousands, which Johnny calls hundreds of pounds. If only that were true.

Many of the accents in the bakers sound Scottish. Corby is full of second and third generation Scots. Their parents and grandparents came down when the steelworks opened, forming queues a hundred yards long outside the little cottage that served as the labour exchange, and there were so many of them that Corby could become, and remain, a little outpost of Scotland within England. There is even a Corby Highland Games.

When we get back to the car, the battery is flat. A taxi driver (Scottish) gives me a jump start. Goodbye Corby. Naomi now accepts that the clothes are now altered unalterably, or at least has given up trying to get a better job.

In the afternoon, we go to the antiques fair at Holdenby House. We are delayed by the need to help William start bicycling, dashing along towards the park with him, but not achieving self-propulsion. One of the stabiliser wheels snapped off at the end of last summer and he has not ridden the bike since then. Everyone in the car except me is asleep by the time we arrive. It is half past four, and the fair closes at five, so Naomi takes a look at it – no point in my doing so, I have no money – while I stay with the boys in the drive. The drive is lined with an abundance of primulas, daffodils, crocuses and other bulbs. We take out the bikes. I hold William while he gets his balance. He tries and tries and finally sails off under his own steam for a few pedals, heading towards the arch of a courtyard. 'Speed me

up,' he calls, to get going again. Johnny pedals when his tricycle is pushed along, but backwards.

As Naomi puts the boys to bed, I paint some chairs. With the door to the study open, I can hear the chatter of youths around the cross. Though quite loud, it is completely inaudible in the bedroom, which has small windows and thick walls. The shouts make me think it is worth locking the car in case of joyriding. As I go out, three boys and a girl are just passing: 'Give me the last bit of spliff,' says one. They are talking about 'blow backs'; I am not entirely sure I know what they mean.

Sunday March 19

I dig the garden again. Johnny is out looking for wriggly worms. This continues throughout the day. 'We're having a worm hunt, aren't we?' he says. 'No,' says William, 'it's not a worm *hunt*,' thinking that Johnny means a new kind of field sport.

In the afternoon, while Naomi watches *The English Patient* on the video, I take the boys to the garden nursery that is just a few hundred yards down the road. Christine's partner sits outside in the sunshine, with a cat on his knee. You wouldn't think it was March. As I drive out, I see a notice advertising planters on the other side of the road. We drive into the sawmill. There are two chaps sitting in chairs made out of bent sticks, appropriately rustic and (as they tell me) comfortable – but £95 each! They have planters made out of hollowed tree trunks, which are rather useless, but one man says he can make anything. We discuss a planter made out of the sides of logs – the Adirondack look. I go home, measure up, relinquish the 'measuring' to Johnny who proceeds to measure his car, and return. The man is also going to make a frame out of sticks for the sweetpeas. This will be more robust than bamboo poles, which might be demolished by the children. We agree on six foot, but I fear that whole thing will come out the size of a shopping arcade.

The children rush in to see Naomi just when Kristin Scott

Thomas is joining Ralph Fiennes in the bath. We look for more worms.

Front page of the *Kettering Evening Telegraph*: 'Woman Drinks Eight Pints, Then Attacks Four Men'. I don't need to ask where – Corby.

Thursday March 23

At *Country Life*, Rupert Uloth reports on the webcast he made with the Vale of the White Horse. A webcast is a video clip that can be down loaded from a website. To record his day's hunting, Rupert had a tiny video camera attached to his hat. The view that results is very like Snaffles's 'Finest View in England', which showed a stretch of countryside framed by the ears of a horse.

The fact that Rupert had a camera on his head, a microphone in his lapel and a pack of further electronic stuff on his back did not prevent strangers loading him with gossip. 'You know, he's on his fourth wife and she's on her fifth husband.' 'Not the brightest, that man. Fell on his head.' Recently? 'No, at birth.'

Friday March 24

They have started on the traffic calming scheme on the main road – a triumph for the A43 Action Group. The works will include new speed limit signs (30 m.p.h. rather than 40 m.p.h.), speed cameras, two new 'puffin' crossings controlled by traffic lights and what are known as 'gateway features' at the village entrances. They will cost £94,000.

As part of this exercise, the road is being 'de-trunked', as the jargon has it, or reduced in status. This opens the possibility of a new estate being built on the north side of the village, because the A43 will now be sufficiently quiet for an access road to be built off it. There is talk of a proposal involving 54 new houses. Many of the families coming into these homes will have children, as a result of which the roll of the village school could rise by

50 per cent. But the school buildings will not have the capacity to absorb them.

'If the Duke of Buccleuch really cared about Geddington, he wouldn't have sold the developers the land,' said somebody in the Star. Which is the sort of thing that people do say, when any institution threatens to behave as a private individual might, turning a profit. Besides, it isn't the Duke of Buccleuch who creates the demand for new houses. My concern is that the new houses should add something positive to the look of the village, but I am not very hopeful.

Sunday March 26

The hour changed last night. I get up early with Johnny but I cannot leave him to go to church, and don't want to disturb Naomi and William. By not going to church I should have saved an hour, but the hour lost is never caught up, and we are somehow hurrying for everything throughout the day, even though we have nothing in particular to do.

The first of my nothings-in-particular is to edge one of the newly created vegetable beds in the garden. This means carrying over stones from what must have been the demolished wall – there are so many of them. Under piles of stones I find the equivalent of a Panzer division of snails: big ones, small ones, glued to each other in clumps. I have feelings of guilt when I smash them and the snot-bodies ooze out. I think of the beauty of a snail shell, the implausibility of God having invented the gastropod. I hide the snail remains from the boys. They join me to look for worms. By the end of the day, William is digging for worms himself, and rushing into the kitchen with the curled specimens, pinched between thumb and finger, that he has found. By this stage he has dug a 'river' in a vegetable bed, and fallen into it, followed by Johnny.

'Let's Go Alfresco,' says the *Kettering Evening Telegraph*'s front page. They are reporting on Kettering's plans to 'go continental'

by introducing a table-on-pavement culture. 'In recent years towns around the country have taken on board the continental approach to street life and allowed pubs to have tables and chairs outside their doors.' There is talk of Kettering's pubs creating 'beer patios', though whether a beer patio in Kettering is quite what Balzac or Stendhal would have recognised as a café remains less than certain. What a shift in national psyche this would represent if it caught on. The womb-like fug of the British pub would give way to the sunny parade of street life. Let's see if we have a hot summer.

The Star in eclipse

Thursday March 30

This morning, I unload the hibiscus that I am rescuing from the dark, dank dungeon of our Pimlico garden; it is in a pot that has gone green with the damp. As I do so, a deeply tanned Peter comes over from the pub to say that he heard me on the radio last night, as he drove home after closing. It is amazing how someone always hears you on the radio, even in what seems like the middle of the night. Peter isn't in the pub at lunchtime so I cannot hear about Goa.

In the evening, I walk a few yards down the road to Jim Harker's house for a drink with him and his wife Jenny. Jim is a partner in the architect's practice begun by Kettering's finest architectural son, John Alfred Gotch. (Gotch, remembered principally for his books on old houses, became the first president of the Royal Institute of British Architects to come from the provinces.) Jim has other responsibilities which loom large: quite apart from being commanding officer of the Geddington Volunteer Fire Brigade, he is the leader of the Tory opposition on Northamptonshire County Council. He wears the politician's impeccable white shirt. When he retires later this year, he will devote himself full time to the council, and if the Tories take the council back at the next election – as everyone expects – he will be chairman. As a councillor, he represents 26 villages. 'The thing everyone complains about is the number of potholes in roads and pavements,' he says, as we subside into sofas. 'They don't complain about absence of bus services; they all make do, by having someone else collect a prescription or share a lift into town. It works.'

Jim is the son of the first and only chief of the Volunteer Fire Brigade, also called Jim, who was a farmer. Farming was a reserved occupation during the Second World War, so Jim senior ran the local Home Guard. It was the spirit of co-operation of that time that he sought to revive in the Volunteer Fire Brigade. Jim himself, before coming to this house, in the centre of Geddington, used to live on the edge, on the other side of the A43; that house had an acre of garden and wide views over fields. His present house was created out of a barn, and he finds it handy enough, but 'misses the horizons'.

Over a glass of beer, he gives me the low-down on the village. Having lived here all his life, he knows everyone, everything and everywhere in Geddington. He helped unpick the inglenook in our cottage when it was owned by a friend of his, 30 years ago.

Jenny is Jim's second wife; his first was called Jackie. Jim himself is young Jim, son of Jim, and has begat three children: Jim (youngest Jim I suppose), Jack and, I think, Jane. So a letter arriving addressed to J. Harker is seized upon by them all.

One bombshell explodes: the management of the Star is in liquidation. This does not disturb Jim unduly, because he doesn't think much of the Star as it is. It used to be a really good village pub, which everyone would go to, but it has fallen a long way since then; he hopes the new people will improve it. But I am rattled. We have liked it so much. Poor Peter. What will become of Mike?

As I walk back, I pass a girl on the bench by the church complaining that her friends mustn't leave because she is 'too pissed to move'.

Friday March 31

To the Star for lunch. Peter is burnished like a gong, but sub-
dued. He doesn't say anything about the Star's fate, or his
own; neither does Anne, nor Mike. I find it difficult to meet
their eyes.

There is a man there who is either drunk, or suffering some
disinhibiting condition. He whistles like a parrot, sings (often to a
different tune from the background music) and blows raspberries.
He shouts out random comments about the music, local rugby
teams, other customers, anything. The other drinkers ignore him,
or enter into contact, if not conversation, by means of of smiles
and winks. 'Hope you're not too put off by the cabaret,' says
Anne when she brings me my fish pie. I sit reading the week's
Kettering Evening Telegraph on how a fly-tipper dumped two
chickens in a chicken coop, along with furniture, toys and an
old mattress, on the Great Oakley to Little Oakley road (front
page, Monday). Car park charges in Kettering are to go up
5 per cent, from 50p an hour (front page of Tuesday's paper).
Two dogs have died in a fire in a shed on a Kettering allotment
(Thursday).

Mike calmly discusses how many pork pieces to order for an
upcoming function, and whether they should be the buffet ones
or the larger type which he can cut into four.

A bloke called John Fairlish greets me cheerily, and asks if I
have solved the housing problem, or something. I have forgotten
that the last time he was in the pub he was ranting about the
evils of incomers from London. John is known as the Husky
Man of Geddington. Since his divorce he lives in Kettering, and
is down to just two huskies; but in palmier days he used to have
fourteen of the dogs, racing them around the country (sleds for the
premier Jardine Challenge Sweepstake at Aviemore, where there
is a high chance of snow; steel rigs on bicycle wheels for other
competitions, mushing through mud). He moved house to be on
Clay Dick, the old carriage drive that runs through Geddington
Chase, to exercise the dogs. They are like greyhounds underneath
all that fur, and very affectionate.

Church bells ring. Children whoop around the cross being werewolves.

Monday April 3

It is snowing in Geddington.

Anona Hawkins has been telling me about the Millennium Wallhanging, of which she was co-ordinator, and I go into the church to look at it. There it is, at the back. Forty different needle people – the youngest aged five, the oldest ninety – made contributions in a variety of techniques. The result is a distillation of village life, with the church, Boughton House, the red telephone box, the village shop, the Happy Time Music Hall that is produced each year by the chapel, and the peacocks that used to be a feature of the village scene – until someone started breeding Jack Russells. There is a memory of the old butcher's shop, next to Lisa and John's house. Flowing through the centre of everything (ingeniously knitted) is the River Ise. Other contributions show blackberries, wildflowers, animals, football on the recreation ground, the bowling club, a Scout's badge and the Happy Faces play school, which takes place in the village hall. The VE Day commemoration, sewn by an American former resident and sent in from Minnesota, is made out of ribbon. As a nation, we may not have taken the Dome to our hearts, but needlework records like this have been made the length and breadth of the country: You can't say that the Millennium, in terms of our celebration of it, has been a flop.

Yesterday at Layer Breton my brother- and sister-in-law told me about the May Day procession of hobby-horses that takes place at Geddington. They had read about it in a guidebook.

Friday April 7

About five o'clock, I hear a tapping on the garden door and there is Lisa, with her small daughter Mattie, inquiring whether we will

be here on Sunday. We won't; it is the Pytchley Point-to-Point. Anyway, while chatting I happen to ask for the latest news of the Star and she says: 'Peter's left. Went on Monday.' I can hardly believe that I haven't said goodbye. 'Certainly his car has not been seen,' says Lisa. 'Unless he has got a new car.' Which, if you have seen Peter's car, seems unlikely (nobody would buy the old one, even though he used to be a car salesman). She points to the windows. They look bare.

At 8.30, I am ready to breeze into the pub. There are three or four people round the bar. The bar taps have their labels facing the other way. It is like a state funeral where the deceased field marshal's horse is led with its former owner's boots back to front in the stirrups. 'Has Peter gone?' I ask. 'Can't you tell? It's warmer,' says Mike. There is a fire, actually not so roaring as before, but it isn't the fire: the central heating has been put on. The office has gone; Peter always had his calculator and accounts spread out on the table, with the newspaper folded for the crossword. If you look for the corpse, it isn't there. Any sign of Peter and Anne has been cleared away. 'And the music, it isn't jazz.'

Mike says the end had been foreseen for some time, though the sword fell suddenly. Peter hadn't paid the rent for a year. The cost of court action over hygiene was £40,000 from which he didn't recover. The wake was on Sunday. At half past six, he turned the till off and said drinks were free. He took £2,500 that lunchtime. Mike was paid, but never offered a drink by Peter, not then or ever. When he finished a shift, he would help himself. He was never formally thanked for all he did to keep the place going. There was no handshake. Peter just had the wrong temperament for the work. He was too private, they say; he couldn't wait for eight o'clock when he could go upstairs and watch *University Challenge* and Anne would come down into the bar.

Mike introduces me to Robin who is the new tenant. He started with pubs in Nottingham city centre, but that is a difficult business because kids only buy on price; they have no loyalty. Now he wants to build up a set of country pubs. He will not change anything quickly, but already the six real ales have been

reduced to three. I praise the qualities of the Oakham beers; there are half a dozen of them, the latest being Springtime. I am not sure Robin is convinced.

Then Tony Griffin comes through from the other room. Tony and Penny have not been in the Star for six years and are dancing on Peter's grave.

Saturday April 8

It is lunchtime in the Star and I sit next to a White Harter. He is wearing a lumberjack shirt and a baseball cap and has an unshaven chin, like an American hunter. He is trying the Star to see how it is faring under new management. 'I heard they had Bass. Bass is a gorgeous pint,' he says with real love. For the first ten minutes, he nurses his beer glass in his hand. 'Cannot abide cold beer.' The cellar at the Star is not a cellar but a stone shed at the back, so it is temperature controlled, and they have it too cold, he says. Also, he doesn't like glasses washed in a dishwasher. It is the same at the Club. John at the White Hart hand-plunges them, as I used to at the Running Mare when I worked there as a barman, to parental disapproval, after leaving school; it is probably an incredibly antiquated technique now. A dishwasher leaves a residue in the glass 'that masks the taste. It doesn't matter with lager,' he says, with rictus of scorn, 'that's full of chemicals anyway. But with beer it's not until the third or fourth pint that the flavour comes through.' He is a beer connoisseur. I must be a disappointment, not drinking more than a pint or at most two. Yesterday Mike said, of a strong beer, 'after the fourth pint you might as well throw the car keys away'. I would throw the keys away after four pints of water. How do they do it? I say to the White Harter he should tell Jason – the boy behind the bar, who arrived at nine o'clock on Monday just as Peter and Anne moved out – about the glass problem. I'm sure he would rinse his glass specially. 'I'm not paying £2 a pint,' he says. 'It's not London yet.' Beer is £1.70 at the White Hart.

Jason says that the chiller stopped working during the week,

so they were serving *warm* beer. 'We had people drinking lager walk out.'

Sunday April 9

The other day I went to the sawmill and found something like a Norman fort, made out of tree trunks, with a pile of very robust sticks – ordinary timber really – inside. Into this monstrous fortification I shall plant my sweetpeas. I had in mind something more whimsical and rural, never mind. The man from the sawmill brought it round on a trailer, and we struggled into the garden with it – it was far too heavy for one man to lift. This morning, before church, I am out with my drill, screwdriver and hammer, making the trellis. It ends up as the sort of construction the Welsh soldiers at Rorke's Drift would have been glad of. (Incidentally, Lieutenant Chard, 5th Company, Royal Engineers, who was in charge of those soldiers, came from Kettering. Not a lot of people know that, as the second-in-command would have said in *Zulu*.) Naomi disapproves of the lead I am giving the boys in gardening. I admit that the essence of it is to get covered in mud. Yesterday Johnny again fell into the 'river' created by William, mud all over his face and his Breton fisherman's shirt. There were tears. I was cross with both of them because William thought (not unreasonably) that it was funny. I observe that we shall be late for the point-to-point. I am packed off to Kettering to buy necessaries, which I take to include manure. The other day Sue Muirhead greeted me with the cheerful salute: 'Do you want some shit?' I forgot to take it; besides, it would have taken a year to rot down.

We are indeed late for the point-to-point. We are still trying to wake Johnny, who has gone to sleep in the car, when the first race begins at two o'clock. I had thought it was *de rigueur* to have a picnic, and to that end I had purchased chicken legs, mini pork pies, quiche, apple pie – all things that can be eaten easily because I have left the picnic hamper in London – as well as plastic glasses, paper plates and napkins. But we seem to be the only people with

a picnic, and I am not surprised. It is warm enough in the sun, if you're in a sheltered garden at Geddington, but on the shoulder of the hill overlooking the course at Guilsborough the wind pierces like needles. The boys climb on to the roof of the car (they spot a bouncy castle), and we trudge off towards the paddock. That is where, fully exposed to the weather, the spectators throng, with the course in the valley below them.

I try my new system of judging horses by their rugs. The theory is that the smarter the rug, the more money the owner has to spend. This proves to be partially successful. The girls leading horses – they mostly are girls or women – look fraught and rather bad-tempered. (Sue's husband David's method for ladies' races was to pick the ugliest jockey, on the principle that she couldn't have been out on the town the night before. It always worked.) Winning horses from the previous race come in, white with sweat by their saddles. At the end of the parade, flinty faced, hammer-jawed jockeys, all looking as though they are immensely enjoying themselves, climb on to their mounts, their peculiarly thin white breeches only just preserving their modesty. I would be terrified. They show no emotion, other than a raw lust for adrenalin.

In the evening, I pile manure, soil and compost into the planter. It has an enormous capacity. Then, with the aid of the boys, we plant sweetpeas. In their pots on the windowsill, they have grown gangly and all tangled up.

Naomi wants to get Peter's address and tell him how sorry we are that he has gone. She says she'll ask Mike but doesn't. Perhaps it is just as well.

Friday April 14

I have lunch in the Star. Jason, the young man behind the bar, is hardly the person to cultivate a warm, village-pub atmosphere; he is so nervous that he cannot take money for drinks and food at same time. There is a restaurant-manager which seems pointless. Norman from the farm is there; he has just had an operation on

his spine, so he is feeling a bit sore. He hasn't forgotten his offer to grow plants for my window box. The conversation between him and other village people is archetypal pub talk. ('Ever been in the Dog and Goose at Earl's Legover? That's a Brakewinds pub, that is. They serve beer at £1.36 a pint . . . If I won the Lottery, I'd have a pub with barrels of beer lined up behind the bar. Big barrels with a tap on. Behind glass so they could be cooled . . . If I won the Lottery, I'd take this place over and serve beer at £1.36 a pint.') The music in Peter's time used to be Shirley Bassey, now it is head-thumpingly up to date.

Mike is at the bar, on a stool. Norman says there were no bar stools before. I suppose he must know. Bar stools in a lounge bar should not be, according to Norman's ideas of pub protocol. Anyway, there is Mike, saying how hard he is working, getting ready for the weekend with no one to help him. 'It's a good thing you enjoy it,' I say facetiously. 'I don't, mate. Bloody hate it. I've been cooking for thirty-four years. Always covered in grease. It was only the thought of taking the lease over that kept me going. I want to be out at the front, wearing a tie and nice clothes, reading the *Daily Telegraph*, putting logs on the fire.'

I have been invited to supper with our kind neighbours Lisa and John Wilkinson, who live opposite. I sit on a chair that came from the US Cruise missile base at Molesworth; with oak knobs and orange leatherette upholstery, it must have been in the officers' mess, I should think. Army surplus from Molesworth is part of the Peace Dividend, now that US forces are pulling out of Europe. John says that the chair cost £3. You can have a fridge for £10. Lisa bought 1,000 polystyrene trays for £1 (very useful, she says, for Scout suppers).

The chocolates I bring are not eaten, Lisa has given them up for Lent. She has also given up alcohol, which was very difficult after a fraught Scout management meeting, she says. She ordered a half of Guinness without thinking in the Star, and had to give it to someone else.

Sunday April 16

Against all prediction, it is a beautiful day. It is so long since there has been one that you can almost see life returning to the world. Everyone is in a good mood. The sweetpeas, which have been looking discouraged, are now all rampant DNA, thick and straining, wanting to race each other to the top of Rorke's Drift.

Today is Palm Sunday. It is a remarkable thing, considering that I must be the person living closest to the church in the congregation of St Mary Magdalene, Geddington, but I always arrive late. In fact latest, no one comes after me, ever.

Today, I hope the new vicar (his appointment has been announced) will be officiating, but it is the same old one bumbling through and fluffing his lines. Odd, when you think how often he must say them.

After church, Valerie comes to collect some papers which Tony Ireson has been drafting for the Merlin Trust. She says I am making a fairytale garden, with lots of little things for the children to discover, which is true. Wearing a jaunty green hat, she walks around it, very anxious, on account of arthritis in her toes, not to be runover by children's cars as they go round the narrow paths. She shows Johnny and William why a dicentra is called Lady in the Bath, making the flower open out and the lady pop up from the middle of it, with little white arms. She has brought a tiny Italian phrase book of David's, to enchant the children on account of its size; it was published in 1887.

After lunch, we plant seeds. The boys spend most of their time falling into their river and getting their boots stuck, so I find that what was meant to be an attractive episode ends in a degree of bad temper. I am left to plant seeds on my own, nasturtiums, godetias, a white misty thing which I don't much care for, purchased from William's school. I put my tiny tomato plants into biodegradable pots; I use a dozen of the seedlings, and I have to discard the rest. Then I nip down to the nursery and buy two clematis: Niobe (dark red with yellow stamen) and

Wadda Primrose (white with yellow streak). As I am leaving, a woman is buying a plant with a charming mauve flower called Phlox Geddington Cross. It was named by Valerie. The woman also buys Artemisia Valerie Finnis. I must have examples of both. I plant Phlox Geddington Cross where the cross can be seen over the wall behind it.

I have received a letter from the church asking if I will speak to them for ten minutes about *Country Life*.

Tuesday April 18

At White City, where I go for a meeting with the BBC's *Today* programme, I am searched by a security guard whose device bleeps by my pocket. It is half a packet of cough sweets, with a little silver paper in the wrapping. *Today* is part of a big open-plan floor. They are still having their morning conference, in a glass box, when I arrive. I am made a cup (with saucer) of filter coffee. It is all very quiet. Rod Liddle lounges in, and they make him coffee in a styrofoam beaker. The young Asian assistant producer, Zubeida Malik, is frighteningly on the ball. We discuss Geddington and how it reflects national debates. I say Grafton Underwood voted against building some new housing for the postmistress's daughter and other local people. 'That's great,' says Rod. 'There's a story in that.' They want me to be on the panel in the last half hour of the programme, which I suppose I have to do, for *Country Life*, though I am diffident as a newcomer to Geddington. They also want to do something on second homes, again with me. That's not so easy.

Ross Allen, the antipodean Adonis with shoulder-length curls, has taken the roses out of our Pimlico garden. There are six of them, now just bare sticks and a little root, huddled in a bin liner. They were so bosomy at the Chelsea Flower Show, and that was three years ago. Now all that growth, and the last three years, has been eliminated. Still, I am pleased to have them, we have a history together.

Easter Monday April 24

Last Tuesday, Naomi showed me the strip from a pregnancy test and there, faint but perceptible, was the second, tell-tale line. I was taken aback, overwhelmed, giggly, ten feet high. Poor Naomi, having to go through it again. This now dominates everything.

We visit a garden at Great Addington. It has an orchard with daffodils that the boys ran through while Naomi stays in the little summerhouse, which is mounted on bearings. Some naughty boys turn it round and round, once with her in it.

Then we have tea in the village hall. The little kitchen is filled to capacity with be-aproned ladies efficiently dispensing tea from enormous pots and offering trays. The cake table groans with coffee cake, lemon cake, fruit cake, fancy cakes, discus-sized biscuits and other fare. At the end of the room, is a display of paperbacks, pepper and salt pots in the form of tomatoes and an array of home-made jam and chutney. I buy strawberry and gooseberry, plum (beware stones), crab apple jelly (I have not had it since childhood and cannot remember whether you put it on toast) and green tomato chutney. They were all made by an elderly man, who says that every surface of his house is covered with jars.

On arriving at Geddington, William exclaims at the pub. Four ginger-coloured tables have appeared, with bright Carling umbrellas. Tables where none were before. There must have been tables at one time because I remember Peter complaining that they were piled up on top of each other somewhere by revellers. But the newness of these is indisputable.

William wants to cut and stick, and brings the materials outside, with a book of ideas. I water the little tomato plants. I note that some of the seeds I planted last weekend have covered the pot in a green five-o'clock shadow.

Naomi is tired so I cook dinner. I read *Fireman Sam* to boys and just manage to finish it before handing over to Naomi and going to sleep myself on the sofa. I awake to find that, when I go to bring in the cut-and-stick book, paper and paints, it has

been raining. The book is ruined. Thank heaven for Amazon. I am able to order another copy instantly.

Tuesday April 25

William opens the letter addressed to him and Johnny. It contains a poem about a river and a letter that has to be read in the mirror. It is from Valerie Finnis, of course.

I plant the Chelsea roses. This is not so easy as it sounds, with many roses in the garden already, and there being six of them. I position four either side of what will be the arch. The other two go on the sunniest wall. In their present state, they are horrid shrivelled things – just stalks with an unsightly appendage of root. If they come back to life, it will remind me of the legend of St Alfege, the Archbishop of Canterbury who was martyred at Greenwich, east London. When a dead stick was sprinkled with his blood and fixed in the ground, it burst into leaf the next morning.

'This garden's a mud bath,' is Naomi's judgement, and it is true that the full glory of the design has yet to emerge from the morass. But the boys are enjoying it.

Wednesday April 26

Zubeida, from *Today*, has been trying to get hold of me urgently, according to a message. She says Geddington people are too contented. They don't reflect rural crisis aggressively enough. I am being put forward to defend second homes. I explain that I would rather not, on grounds of security. This is overruled. But they cannot find anyone to speak against me. Everyone says, 'We couldn't have a go at Clive. He's part of the village.' They have secured an interview with the Duke of Buccleuch. The programme will take place from Boughton because the village hall does not have a telephone line, fax line or photocopier, without which news gathering grinds to a halt.

Friday April 28

It has been raining for 30 days without a break. Oddly, the Ise is not much higher than it was a couple of months ago. But everything feels very wet. As I come into the village at midnight and pass Burwells, there is a man in the doorway with his dick hanging out of his trousers and a great fountain of piss arching into the street. It seems a symbol of the times. While I am letting myself into the cottage, this Brueghelesque figure makes his way unsteadily up Church Hill.

Saturday April 29

I felt shivery all night and kept waking up. At 7.30 a.m., I heard voices outside the cottage. I managed to stagger outside for a paper. There was a gaggle of men, cars and canoes around the cross. Canoes were being taken down to the ford. Some of the men were proficient canoeists. They could be recognised by their wetsuits, with frilly skirts around the thighs to keep out the water. They lay down in their canoes on dry land and did exercises. The others put on as brave a face as they could beneath their crash helmets. The proficients shuffled themselves into the water, using exaggerated bottom movements, then glided off between the piers of the bridge. The not-so-proficient found launching themselves was more difficult than it looked. There is barely any depth of water on the little weir. So they scraped themselves along, sideways to the current. On the other side of the bridge, a few less confident souls were getting cautiously into Hiawatha-style kayaks. And then they all went off, down the narrow channel overhung with saplings. There was a proficient at front, middle and back, and if there was an incident they would blow whistles so everyone else could get out of the way. The Volunteer Fire Brigade call this adventure Blazing Paddles. It was all videoed by a professional cameraman, dressed à la hunt saboteur in combat gear and big boots and with a ponytail.

I talked to a man on the Flood Committee of the parish council. The waterboard has agreed to put in a bund alongside the river. A bund is a wide trench which will take overflow water off to the recreation field. It will mean cutting down the saplings but they will grow up again. The problem is that the Ise suddenly narrows after the bridge, so in times of flood, water rushes along and has nowhere to go. It seems hard to imagine it now; even after a solid month of rain the ford is still only a couple of inches deep.

I attempt to lift the turf off the little path in my garden. When I went to Burgundy before Easter, I stayed with my predecessor as editor of *Country Life*, Jenny Greene. She is such an accomplished gardener that the French equivalent of the Royal Horticultural Society has given her a prize. Her husband Michael Boys won a medal from the French Ministry of Agriculture for his vegetables. They gave me good advice for the cottage. For example, turf which is left covered over by black plastic for a year makes the best compost in the world. So I must lift the grass from the path and save it. I manage to do just a quarter of it before collapsing back into bed.

I see that the pub is advertising live music tomorrow night – the Rigsbys. The steps of the cross have been occupied by young drinkers all afternoon. I don't mind; it is one of the things about Geddington that reminds me of Cambridge – young voices heard over stone walls. I wish the men wouldn't belch, though. It has become an English habit. Even a man waiting in the Eurostar terminal in Paris, obviously English, confirmed his nationality by belching.

There have been bees buzzing in and out of the shed. The first ones I thought got there by accident, attracted by the warmth of the tumble-dryer. This morning there were four or five, which seemed too many for coincidence. This evening, there is a whole advance guard, climbing over crevices, looking into nooks – rather like special agents before a presidential visit. Presumably they were the harbingers of a swarm. I call to Naomi who tells

me emphatically that *she* doesn't know what to do. I close the shed door and stuff cracks with paper. Doing so explains why cracks in the wall have been stuffed with paper before. It is not the first time that the bees have come.

I am so exhausted by the effort that I have to lie down. About eight, William comes up to tell me that the bees have gone. It may only be temporary.

Sunday April 30

I was completely unable to get up yesterday evening, not even to brush teeth or change into pyjamas. At 4.30 a.m. I came downstairs, needing a glass of water. Ants were swarming all over the dining table. One of Johnny's half-eaten bananas was a particular magnet. Fortunately, I had bought ant powder at the garden centre – along with propagator and stiff brush – but it was in the back of the car. I could not bear the thought of Naomi and the boys coming down to a breakfast table covered with ants so I walked out into the night without trousers or shoes or socks. It was surprisingly mild. I applied powder, and went back to bed.

I surface sufficiently to greet Valerie Finnis. My tomato seedlings need more sunlight, she tells me. Thinking that Valerie has missed the Artemisia Valerie Finnis in the garden, I ask her to identify a very important plant. 'Yes, I can see that's me,' she says matter-of-factly. 'Now where's the one you want me to identify.'

Johnny is filling a bucket to give a snail a drink, which turns into a swim.

The Star is in danger of becoming cheerful. I comment on the new tables outside. Had there been tables before? I seem to remember some, and yet not lately. The answer is that the old ones were confiscated by the council. 'He didn't have a licence to have them there, did he?' Tables were allowed during summer but had to be

taken away during winter, which Peter didn't do. 'To be fair he had been warned, several times. Then they turned up one day and took them away.'

Mike is there, and the food is unchanged. He says, hurt, that Peter returned to pick up something from the pub, but didn't even go into the kitchen to say hello.

It is raining by the time we leave. Still, we decide to go to the Scarecrow Festival at Aldwincle, recommended by Lisa and John Wilkinson. Aldwincle is a prettier village than Geddington, stretching out along one street, with lots of green between the houses. For the last three years they have had Christmas tree competitions; this year, they thought they would try something different. Every family, it seems, has made a scarecrow. The pews in the village church are occupied by a congregation of scarecrows. There is a scarecrow vicar and a scarecrow choir. The lady playing the organ isn't a scarecrow, I don't think, but you never know. There are some disconcertingly plausible faces, mostly papier mâché. Outside, we find a scarecrow Bo-Peep, on a swing in a tree; a scarecrow French onion seller with a bicycle and bottle of wine, one of many scarecrows shown as drunk; a couple of scarecrow cooks; two scarecrow Postman Pats; a scarecrow on skis; a scarecrow tart being ogled from across the street by a scarecrow builder, complete with bum cleavage. At the entrance into the village hall stands an alarmingly convincing Women's Institute scarecrow in tweeds; inside, a fertility goddess scarecrow (huge tits, nothing on), which frightens William, and is meant to represent one of the models for a WI calendar. There is a scarecrow Puritan, representing a seventeenth-century antiquary who had lived in the village. Even outside the home of the Baptist minister there is a scarecrow Jesus Christ, looking more like a kebab chef with an old towel for a headcloth. We puzzle over a surreal scarecrow half emerging from, or sinking into, the earth, with a cigarette in his mouth; apparently he is meant to represent someone smoking himself into the grave.

As we walk along the village street, viewing the scarecrows, the boys are transfixed by a moving scarecrow in the window of

a cottage. It waves to them, waggles its head, moves its limbs. There are people watching television beyond the scarecrow, but none of the party of children – there are quite a lot of them – can be prised away.

Monday May 1

I am in the garden, planting daffodils from pots we had indoors, when Lisa knocks on the door and asks if we know that we are eligible for May bread from the church. Every 1 May, people who have slept the previous night in Geddington can collect bread. Naomi, when I tell her, is not too impressed by this prospect. William has a cold and wants to stay with Mum, so I say I shall take Johnny. But then, as I start off with the bells chiming, William calls from the window, and tempted by the prospect of being allowed to climb out of it, says he will come too. Naomi climbs out, too.

At the entrance to the church stand Ken and Margaret, the churchwardens, behind a table. On it, there is a modest supply of bread from Safeway. Four hunks are put in a plastic bag which Johnny carries. Ken says: 'We like to maintain the tradition. We don't know how it started – lost in the mists of time.' Margaret thinks it has something to do with a Duchess of Buccleuch. I wonder how many people take advantage of the custom; I do not see many. But the main thing is that it continues.

Lisa says that last year bees swarmed under the old clematis on our wall. Our predecessors in the cottage didn't do anything about them. After a while, as the temperature fell, they came down off the clematis and ended up on the pavement. So the Wilkinsons put a cardboard box over them, wrote a notice saying 'Danger: Bees' and phoned round some bee-keepers. There is a serious bee-keeper in Geddington but he has Alzheimer's disease. Another one turned up after a while and took the swarm away.

In the afternoon, I drive to the supermarket for milk, and on the way I pass Boughton woods, full of bluebells. I take William, then

make another journey with the others. Opposite the bluebells, the rape fields are like a great helping of scrambled egg.

Tuesday May 2

I have received a letter from John Hughes, president of the Mess Committee of the Geddington Volunteer Fire Brigade. I am invited to their next meeting on 16 June. 'We would be thrilled skinny to see you.'

Friday May 5

Today the bees are playing possum on the ground at the bottom of the shed door. I thought they were dead. I suppose the weather makes it rather cold for them.

I go along to church looking for the May Festival and the churchyard is full of people having their lunch. Some are huddled in the porch, with a thermos and sandwiches wrapped in silver foil. They are recording the gravestones, which is quite a big job in Geddington, apparently, because there are 600. There is no sign of the May Festival, though. As I leave, I pass two recorders by a gravestone, a man with a clipboard, a woman on her knees with bucket and rag: 'Just scrub that 23 a little bit, would you?' says the man, conforming to gender.

I meet Jim Harker who says that the service is at 1.45, not 12.45. Then I see our photographer William Shaw coming out of the Star, and take him back inside again for a drink. The young man who used to serve drinks but could not fetch meals from the kitchen has gone, marking his departure with a punch-up with Gary. He turned up again this morning and Gary told him he was banned. 'He was trying to intimidate me, and I won't let myself be intimidated by anybody, least of all a customer,' pronounces Gary. I suppose that's what the army teaches you.

The piping voices of children make the church service very charming. Our young May Queen looks rubicund and full of

health. Her coronation takes place on the cross. The vicar does it. We all stand around in a gaggle, and then make our way to the school. The maypole, which stands in the middle of the tarmacked playground, could be mistaken for a washing line. It is not very picturesque. I watch pairs of children skipping along to the Cumberland Reel, then forming a spider's web around the maypole, and that is as much as any normal human being could be expected to stand. Not that the parents are unduly sentimental about their offspring. 'Where you going, boy?' I hear one dad – stubbly chin, earring, missing tooth – say to the child who was meant to be looking after his younger brother. 'Idle little shit.'

The May Festival was restarted in 1948. Restarted, emphasises Jim. It might have been going for millennnia before that, or perhaps not. Hopes of a hobbyhorse race, raised by my-sister-in-law, prove false. There isn't one.

It is a beautiful evening as I walk to the quiz in the village hall. A bonfire by the river adds to the light mist. Children are riding bikes through the ford shouting 'fuck off' at each other.

In the hall, teams of three are seated at either end of Formica tables, which are formed up down the whole length of the room. Every table has bottles of wine and other refreshment. It is a real hall, with a stage; not the room where the parish council meeting took place. Two white-haired ladies are selling raffle tickets. In the kitchen, a team of ladies is making buns. I wait self-consciously, the sole member of the team that will be called It's a Dog's Life, making conversation with John Hughes of the Geddington Volunteer Fire Brigade, as well as the other people on the table, who come from Corby. Blazing Paddles has been completed, with the canoes reaching the Wash. 'The first stretch, down the Ise, took us through a landscape of old mattresses and cast-off motorbikes that had been thrown into the stream. But from the moment we reached the Nene, the wildlife was magical, with kingfishers flashing across our bows.' But the canoe with the film man capsized, destroying £3,000 worth of video equipment. At last, Lisa and John arrive. They are carrying baskets of food

and drink. As it happens, I ate a whole tin of baked beans on toast before leaving, but I cannot let on. I consume pizza with modified gusto.

I don't know what everyone else thinks about the state of general knowledge in Britain, but this is an incredibly taxing quiz. Where was Henry VIII's first wife buried? (Peterborough). Who fled the City of Destruction? (Christian). What would you be eating if you were served bigoureaux? (winkles). We are given a barely decipherable map of the British Isles and expected to mark all the weather stations on it. Yet some teams score very nearly 100 per cent.

I am afraid hunting is going downhill

Saturday May 6

The hunting season is over, but that does not mean to say I don't think about it. Today I have been looking for the Mission House in Kettering, without success. There used to be a monument on the building fairly low down on the wall. It had previously been seven feet off the ground, and the inscription read: 'Who-Whoop. This stone marks the spot where a fox found at Legards Gorse was killed by the Pytchley Hounds January 14, 1907. Frank Freeman, Huntsman.'

Legards Gorse is five and a half miles away, and in the course of the run the huntsman and first whip had to climb over the garden fences of Kettering, peering into pigsties and hen coops. The fox dashed across a busy road, but this daring effort was not enough for him to escape. There was a very tall fence in front of the Mission House, and he just failed to climb over it. He was seven feet up when the hounds caught him.

I found the Mission House, a dignified, white-painted Georgian building, uncomfortably situated above the building site that will become the new Lost City of Atlantis-style Morrison's supermarket. There was indeed an inscription fairly low down on the wall, set within a handsome Edwardian frame. But on inspection the text referred not to fox-hunting but the missionary society founded here in 1792, the various gentlemen present having subscribed £13 2s 6d (do not forget the 6d) to promulgate Christianity to the heathen.

Perhaps Who-Whoop was out of keeping with the image that the mission society wanted to project, and the memorial was

169

taken down. Even the fox-hunting crowd does not go in for putting up memorials to foxes these days, or talking about them as 'brave', as though animals understand the Queensberry Rules. Still, I must have another look for the memorial. All hunting people are pleased to see strong, healthy foxes, because they love the fox as a species; the sentimentalists who oppose hunting expend a great deal of emotion and effort on individual animals, and yet their efforts do nothing for the welfare of foxes in general; sometimes they make it worse. More foxes will be killed if hunting goes, and the condition of country foxes will deteriorate to that of the mangy specimens that scavenge in towns. Foxes will disappear from some parts of the countryside altogether.

Before the reign of George II, foxes were not considered to be worthy of hunting. They were regarded as vermin (which they are), to be killed by any means that came to hand. They had none of the status of hares or stags. As a result, they were much more scarce than they are today. When someone had the idea, about 1730, that hunting would both destroy a certain number of foxes, while providing horsemen with the pleasure of riding across country and watching the skill of the hounds, there was suddenly a reason to respect them. Beatrix Potter represents Mr Todd as a gentleman, though a wily one, with some unpleasant personal habits.

I have been reading more of that great work, Guy Paget's *History of the Althorp and Pytchley Hunt*. The Pytchley Hunt came into existence about 1750. This was when Lord Spencer, who had originally kept his hounds at his country seat of Althorp, moved them to Pytchley Hall. Men rode enormous great horses in those days; they were enormous fat men. Women did not hunt. Because the countryside was unenclosed and often boggy, hounds were valued for strength rather than speed. On the other hand, some things never change. In the Althorp Chace Book, in which Lord Spencer recorded his hunting, comes an entry for Boxing Day, 1775, when the company included 'a number of holiday people from Northampton who made an immense crowd, and began to fall at the leaps as soon as the Chase began'.

In the nineteenth century, the Pytchley was one of the most

fashionable of all hunts. In a speech to the House of Commons, the great orator John Bright made the mistake of pronouncing it Pitchley, rather than Pie-chley, and had to endure hoots of laughter from all sides. No one, thought his fellow members, no one – certainly not an MP – could be so ignorant as not to know the correct way of saying Pytchley.

For six glorious weeks in 1877 the Empress of Austria came out with the hunt, having taken Cottesbrooke Hall. To Victorian eyes, she was deliriously beautiful, with a wasp-waisted figure that showed very becomingly in a riding habit, and a mass of auburn hair which reached down, it was said, to her knees. She was also quite a girl. In Vienna, she scandalised the court by keeping a private circus and riding in it herself. In Northamptonshire, she went so far as to carry a fan out hunting. She also drank beer, and after dining at Althorp one night actually smoked a cigar. Lady Spencer felt a draught and sent for a screen. Her presence on the hunting field attracted enormous numbers of riders, particularly men, in the hope of glimpsing her. The suggestion was made that the strangers should contribute to the damage they caused, but, as Paget comments, 'such a revolutionary and plebeian idea was instantly turned down'. The empress herself had eyes only for her 'pilot', the dashing Captain Bay Middleton, who had the much-envied task of escorting her. When her time at Cottesbrooke ended, she put on a race meeting at her own expense, happily watching Bay Middleton win the Empress's Cup. She was cheered as she left for the railway station.

Later, the future Edward VIII blessed the hunt with his presence, as did his brother, the future George VI, who took Naseby Hall for the purpose. Naturally, this royal endorsement made it the hunt of hunts. The appeal came from the old pasture which was such a pleasure to ride over, and the fearsomely big hedges which were such a challenge to jump. 'Except in the Monday country,' wrote Paget, 'a ploughed field is as rare as a swallow in November.' Hunting depends on the character of the countryside; and the character of the countryside depends upon farming. The explanation for the springy grass and heart-stopping hedges was that this part of Northamptonshire was used to fatten bullocks.

Bullocks are strong animals, and need stout fences and big hedges to keep them in.

All that has changed now. Half the lovely old pasture was ploughed up during the Second World War, and never went back to grass. Where cattle remain, they are dairy cows which can be contained by smaller fences. Only the last time I was out, a farmer said: 'Agriculture will finish hunting in the end.' And there is another paradox here, because the sort of countryside which most warms the hunting man's heart is exactly that which the anti-hunting urban public wants to see. And they won't see it, unless the governments that the urban public vote into office change the direction in which they are allowing agriculture to go.

So the Pytchley is not what it was. This is entirely as it should be, because hunting itself is in a permanent condition of being not what it was. What else would you expect of an activity whose character is, for some participants, a long moment of suspended disaster? 'I am afraid hunting is going downhill,' wrote Whyte-Melville in 1861. In 1885, the Duke of Beaufort introduced his volume on hunting, in the famous Badminton Sporting Library series, with the sombre words:

> In these days of change, alarm, surprise, when the brutality of field-sports is being denounced with so much eloquence and energy that one cannot but wonder how the world has remained unconvinced through so many years, it is, perhaps, idle to speculate how much longer our attention will be suffered to employ itself on a pastime which so many wise men have agreed to brand as wanton and debasing. A sort of melancholy pleasure, therefore, has attended the researches into which our studies have led us.

It leads me to hope that the Pytchley will continue to be 'not what it was' for a long time to come.*

* Later, Tony Ireson told me where the Who-Whoop monument had been put. It is further along from the piece of wall with the missionary society inscription on it. I shall lay some flowers in front of it next 14 January.

Sunday May 7

Are the bees buzzing around our shed masonry bees? Masonry bees eat mortar, or rather collect it, presumably to make nests. They are still there, but there is no swarm yet.

I continue making the path around the garden. The stones are not even so it is taking on the aspect of an obstacle course. Naomi says that I am starting to potter, like someone in cardigan and carpet slippers who is on the way to a dribbling old age. Perhaps she's right.

A yellow toad hops out of the stones as I am working. Hello, toad.

Tuesday May 9

I visit Boughton for the estate's open day. The park is full of marquees and school buses and crocodiles of schoolchildren. In the gamekeepers' area, I talk to David, whom I have previously met in the village shop, and also Roy, the new head keeper. The retiring head keeper looks incredibly rosy and young. I learn a lot about the destructive effects of squirrels, which ring bark trees to mark their territory, eat the sweet sap and the trees die. They particularly like trees of fifteen to twenty years old – think of the investment they ruin. The gamekeepers show the different weapons in their anti-squirrel armoury: poisoned trap, live trap, a long pole which can be extended to 60 feet to rattle their 'dreys' so that the squirrels have to run out and are then blasted with shotguns. 'Quite fun but incredibly tiring, wobbling the pole.' The poisoned bait, warfarin, can only be used for a few months a year and it may be outlawed in future. I ask what happens after the squirrels have been trapped live. 'They get a bit of a knock on the head,' says David cheerfully.

I walk over to see Trevor, who, in a way, is responsible for us coming to Geddington. He is the father of Leanne, who works in Sue Muirhead's yard. When I was thinking of renting a place, she told Trevor who asked the agent, and the answer came back

that perhaps he could help. In the summer, near his remote, pretty cottage, he showed me the pens where he keeps the pheasants, all bred from existing stock, and those for rare breeds of chickens and guinea fowl. While most gamekeepers hate foxes, it is in Trevor's contract to make sure there is always a fox for when the hunt comes. 'So if I see a brace, I'll only knock over the one, like.' Trevor's dogs are buried near the house, each with a headstone painted with a portrait of the deceased. Now, partly through his own stubbornness at not being prepared to train an assistant, he faces the prospect of being moved to a village house which will be specially done up for him, with extra bedrooms. He hates it.

Leaving the gamekeepers, I pass a notice telling children to Wash Your Hands Now, in case they have touched any chicks. Since there are no washbasins in the middle of a park, they are given little bottles of antibacterial gel – one bottle to every ten children – for the purpose. I am happy to say that I do not see any being used. The environmental health people have been busy. The lake is roped off, there are lifebelts stationed around it and signs read Deep Water. Children are not allowed to have their picnics anywhere that animals have been for the last three months. There could be animal faeces. This rules out most of the countryside. But again the children ignore the special animal-free human feeding areas that are provided.

The duke is fighting a cold but still joins us for lunch in the old stables. I sound off about new housing in the countryside, which I realise afterwards may not have been tactful, given that much of the development land around here used to belong to the estate. 'We are very torn,' says Lord Dalkeith, the duke's son.

I am introduced to Wayne Davis, who lives in Geddington and has a business flying hawks. He uses them to clear large public areas of pigeons and other vermin. He has cleared the Millennium Dome and is about to start on Wimbledon, before the tennis.

In the afternoon, Lord Dalkeith – young, enthusiastic, relaxed – takes me to the tree felling. In a wood beside the main avenue the estate needs to remove some dying poplars, in order to let chestnuts to either side grow bigger. We watch as tree men remove a wedge from the front, bang wedges in the back and

then 'Timber', as all the little boys shout, and go on shouting for some time afterwards.

Lord Dalkeith has a problem with the double avenue. The trees in it are limes of the variety Hatfield Tall. They are more elegant trees than the common lime, without the latter's hairy knees. They are not very big because they are planted so closely together. Should every other one be felled and be replaced with a sapling? Or should one line of trees be pruned, then removed when its neighbour has grown up sufficiently to take its place? 'You are talking about a hundred-year plan to bring this to fruition,' says Lord Dalkeith. Oddly, the landscape as it was originally conceived would have been at its peak for only a decade or two after the 1730s. Duke John overreached himself with water features and jokes, and there was not enough head of water to keep the lakes and canals from running dry. The jokes annoyed his mother-in-law, Sarah, Duchess of Marlborough.

That is about it for the open day. The school buses need to get back for the school run.

Alan Wordie, the agent, drives me to see the gullies, or gullets, that survive from old ironstone workings. I am interested in these, because you cannot normally see them, and yet they were once so important around here. There were four furnaces or smith's forges in Geddington Chase even in the twelfth century. We cross over the A43, open a padlocked gate and rumble across a former cross-country course which is not used because the reclaimed field is too waterlogged. The gullet, with its immense blocks of fallen stone, looks like a painting by Salvator Rosa and would have pleased Edmund Burke, with his theories of the Sublime. The workings were abandoned only in the 1950s or 1960s – it is amazing how quickly Nature reasserts itself. A huge 'horse' – that is what Alan calls the machine – used to come along, digging up the overburden of clay and limestone and throwing it over its back. The ironstone was taken off by railway to Corby. The duke had told me that a Labour Minister of Industry once had a dinner party for eight people in the bucket of the horse as a stunt. The estate did very badly out of the quarrying, because the leases had been signed in the 1920s and the return had come to seem miserable

by the 1950s. Afterwards, they were left with a lot of reclaimed land, of little agricultural worth. But the sheep graze it, and each year their droppings impart a little more fertility to the soil.

As we drive around, I jump out of the car to open the padlocks. 'Sometimes they have been superglued,' says Alan. I assume that is a metaphor for being very stiff. But he means it literally. People who aren't able to open gates because of the locks put superglue on them. Two out of the three locks we try won't open. The estate needs the locks against motorbikes and New Age travellers. A couple of weeks ago Alan interrupted a rave. Sixteen hairy men and a girl had come from Oundle, presumably took ecstasy tablets and spent the night banging heads and jumping up and down on the spot. They were still at it at seven o'clock the next morning. It was not highly considerate as 20 yards away was a party of schoolboys camping as part of the Duke of Edinburgh Award. 'Don't worry about them,' said the hairies. 'We looked in their tents two or three times during the night and they were snoring their heads off.'

We watch some enormous lorries reshaping the landscape with inert landfill. Alan's predecessor had wanted to fill the gullets with waste from Manchester, which caused understandable local opposition, on the basis that Manchester's bad smells belong in Manchester. Today's landfill is from soil scraped off Northamptonshire's building sites. A smooth shoulder of land has been created where previously there was a gullet. Planter John would have been proud.

In the woods, bluebells shine like powdered glass.

Friday May 12

I shop in Harvey Nichols for croissants and cakes for the *Today* programme breakfast. On the drive down, I stop at the Northampton Homebase and buy two cafetières. Then I drive to Sudborough, to visit Mrs Huntingdon's lovely garden, with its tulips, rose garden and unfairly rampaging sweetpeas. Rupert Golby, the gardener, is there, and I stay for lunch.

When I reach Geddington, I feel self-conscious unloading so many bulging Harvey Nichols bags. I should have bought the croissants in Kettering.

Saturday May 13

The *Today* programme is broadcast this morning from Boughton. I wake at 4.00, 5.00 and 5.45. I switch off the alarm which was set for 5.50 because really I don't have to get up until 6.00. And then it is 6.25, and I am meant to be there at 6.30.

At Boughton I meet Alan Wordie and the *Today* deputy producer in the courtyard but not Zubeida, the acting producer for the occasion; she has overslept, the hotel having changed her room and then given the early morning alarm call to the wrong one, or so she says.

The big classroom where the show takes place is full by the time I arrive. It seats about 80; apparently 500 people applied for tickets. I am taken to the green room across the corridor, and Alan starts to produce a cup of coffee. The religious lady who is presenting *Thought for the Day*, says that the coffee provided at the back of the hall is 'even better'. I fetch a styrofoam cup from a lady in a sort of mob cap.

Gary Richardson, who reads the sports news, does a warm-up act. I can't hear what he says, only the roars of laughter from the audience. Jim Naughtie is ineffably polite but tense; I notice his styrofoam cups are chewed all round the top. He has a difficult job, keeping the audience informed while London is speaking, quieting them down when Geddington is about to go live, coping with unexpected losses of sound. I have my debate with a man from the Royal Town Planning Institute. But we agree really. Certainly I cannot see any justification for second homes not being made to pay 100 per cent council tax.

I have been dropped from the panel at the end (which comprises three politicians, a Lib Dem, Tim Yeo and Michael Meacher) in favour of Zac Goldsmith, editor of *The Ecologist*. They think he adds a different note. Editorially, I cannot fault the choice. There

he is, young, tanned, exotic, pacing the corridor beforehand to fix his thoughts in his head. In the end, he is only asked to contribute to the discussion twice – typical. Lots of other people whom I know have come a long way never get a chance to speak at all. There is a cheer for Alan Wordie when he asks Michael Meacher who will look after the land after all the townies have gone home from their leisure breaks?

Afterwards, a big confident man with a broad grin introduces himself, and I realise (not hearing his name) that he must be David Reynolds, the big farmer whose family used to own the local firms of Weetabix and Whitworths (Whitworths are the people who box raisins and other dried fruit. I don't know how this came to happen in Northamptonshire.) He is a jocular bulldozer who berates all the politicians.

They don't want to come back to the cottage for breakfast, having arranged – I didn't know – something in the stables at Boughton. So I telephone Naomi who has already filled the oven with croissants. I sit opposite Michael Meacher. Afterwards he is going to the dentist, a sort of relaxation I suppose for a busy minister. 'You don't get anaesthetic if you're a minister,' he says.

At home, I meet Lisa brushing the steps of the cross. Did I hear the ruckus last night? I did not. At about one o'clock, the police came to disperse youths from the cross. But they came back again and threw a wine bottle through the Tea Shop window. Lisa came out and performed virtually a citizen's arrest, aided by Gary from the pub, with his Dobermann. Which was good of him, because the bottle-throwing didn't have anything to do with the pub.

Penny Griffin comes up and says that Robin, the tenant, will not get the lease of the Star. It is going to a local consortium, led by Jim Harker. It wants to take the pub up-market. It will close it and redecorate it. There will be no Carling umbrellas to make it look like the Costa del Sol. There will be good food. I put in a word for Mike.

I go off to the station to meet the Browns. We have lunch sitting at one of the Costa del Sol tables. Inside the pub, tomorrow's ser-enade by Barebones is advertised with a raunchy photograph of

a topless woman. Afterwards, we drive the children to Boughton where the adventure playground is really that. It looks like the fort at the Alamo, with slides a mile long, rope ladders, nets and an overhead pulley. The wooden walkways rock as the boys romp across them. At the top, the three-year-olds insist on going up a steep ladder into one of the towers, before hurling themselves down a slide. It is not quite as hair-raising as it used to be, according to Lord Dalkeith, who laments the modifications that have been introduced at the behest of council inspectors. 'No one has actually been killed,' he says in vindication of the original structure.

The afternoon is so warm. Hardly anyone is here. When we are not chasing after the children, we enjoy the view of sheep grazing between the trees. Then we go back to the cottage to consume more Harvey Nichols cakes. For the first time we eat in the garden and feel warm.

Sunday May 14

I get up with Johnny. I prepare plant pots by cutting up old fertiliser bag and lining them, and plant out etiolated tomato plants. I also plant some basil seeds that came free with our epoch-making new gardening title *New Eden*.*

Having looked at the National Gardens scheme on the Internet, we visit Kelmarsh Hall. As we turn into the drive, I realise it is from outside these lodge gates that I was once picked up after hunting. Kelmarsh used to be owned by the decorator Nancy Lancaster but the Miss Lancaster who owned it last, dying in 1996 or so, was her sister-in-law. She created a trust. We buy tickets from the gardener who is sitting next to the steps to the house, in the sunshine. We have tea and orange cake on the shady lawn in front of the house, and then go through the stables into a long border marked out with box hedges; the afternoon sun makes them look almost fluorescent in their greenness. We find

* It folded in July.

179

a little bit of a maze (shades of the *Watership Down* video). Then the church of St Dionysius is in view, across the fields. It looks so pretty but we don't have time to visit it. I go off down another border with Johnny, and there is a herd of white cattle, with calves. Oh, this is enchantment. After the wilderness, along the side of a stream to the lake, we scramble up a bank on to a lawn in front of the house, and next to it there is a heavenly blue and white garden, smudged with the pink blush of tulips. There are tulips everywhere. With the boys running in front of us, we have the most perfect time. There is a door through the quadrant back on to the courtyard, where the car is parked. Naomi commences a long, interesting conversation with the administrator (a young bloke who has only been in post for two weeks) while I try to prevent the boys from tooting the horn of the car.

We arrive home. William notices that the tables from the pub have gone.

We cook steaks and lay the table outside, but the sky turns the colour of liver and it spots rain. By the time we are eating, it is a deluge.

Outside the pub I hear the strains of Barebones, but Gary, standing gloomily by the doorway, says there are only six people inside. It will be the last of the live music. The last of the tables, too, since one of them was smashed up during the night, along with two hanging baskets. The damage came to £100, which must be serious for a pub with no customers. As a result, the remaining tables have been taken to the other pub, wherever that is. I can feel this developing into a feud.

Tuesday May 16

The Wanderers Gallery in New Barnet, knowing my connection with Geddington, have sent a photograph of a watercolour that they have. In size terms, it must be quite a thing, measuring four feet by three feet. The scene was painted a few feet from our cottage. In fact, the wall on the left must be our wall, except it seems to be made of wood, with a wooden plank leaning

against it. Surely the wall must always have been stone? The cross is not terribly well drawn; to my eye, the artist has made it too thin. But it is jolly to see all the shops with their tools and wares outside. The smithy doors are open, and so are windows and shutters everywhere. That is one difference from now: then people were at home, working. The building to the left of the smithy has a big candy-striped awning. There is a big yellow diamond, presumably wood, hanging in the smithy's gable, which is something of a mystery. In front of the cross are what I take to be stocks.

The artist is James Lawson Stewart. The notes read as follows:

> Watercolourist who painted old buildings, docks and boats and who flourished 1885–89. He exhibited at the Old Watercolour Society. Examples of his work are to be found at Bishopsgate Institute and Maidstone Art Gallery. Very architectural in style and popular for his attention to detail.

I don't know about the very architectural in style. I don't know about the price, either: £2,650.

Curiously, in the same post, a letter from a reader in Edinburgh says that she also has a watercolour of Geddington, four foot by three foot, by J. Stewart, and asks if I know anything about him. Again, this picture shows the smithy, but with a donkey and cart.

Thursday May 18

The forget-me-nots make it look as though the sky has fallen on to the grass. People in suits the colour of Dundee cake assemble in a marquee. A former naval officer with a Captain Birdseye beard is blowing a gas-canister hooter to hurry them on to four coaches. This is the regional Country Landowners' Association annual general meeting at Belvoir Castle. Alan Wordie brought me along in his Land Rover Discovery, and now I am introduced

to the Duke of Rutland, who inherited last year.

The duke gives the shortest speech in the history of public speaking. 'Thank you all for coming. Now let's get on to the buses.' I am packed into the first coach, and taking a reserved seat, find that it is next to him. He is quite small, dark haired. Conversationally, I inquire as to his thoughts about Prince Charles's Reith Lecture last night. 'These GM crops, we ought to try them out on prisoners. I mean, we've got all these people in gaol. They could eat them first. It would be their contribution to society.'

'Perhaps it could be offered as an option, in return for a reduction in sentence,' I suggest.

'Oh no,' he says. 'They should get five years longer if they refuse. I'm fed up with this namby-pamby society.'

I ask whether he goes often to London. He says the last time was two months ago, and the previous visit four months before that. We tour farm land and villages, noting a planning permission here, a tenancy issue there, a barn conversion somewhere else. The agent says that 450 acres is now the minimum for a workable arable farm – anything less and it isn't worth buying the machinery. This is a sadness to the estate.

We visit a Site of Special Scientific Interest, waving with yellow buttercups and cowslips – the sort of fields people remember from their youth. In the old days, the estate ploughed up a lot of old pasture, which it now regrets. The area that is now protected was farmed so inefficiently by the tenant that it survived in its old-fashioned state, complete with green-winged orchids – only two in the field we stop at, but thousands in fields further from the road. The two orchids in our field are marked by canes so we can find them. The orchid has a symbiotic relationship with fungi; without fungi seeds cannot take. That is why it does not spread.

Needless to say, English Nature want to have signs put up, but some visitors would pull up the orchids.

We pass a barn conversion where the contractor had to replace the roof three times because the slates kept getting stolen. The duke points out a remote cottage that has been burgled five times in two years.

An old racecourse has been turned into gallops, with some farming in the middle. Curlews used to nest here, but one by one the breeding pairs have been driven away by dogs being walked from the new houses nearby.

The duke is enthusiastic about his new chicken sheds. There are two of them. They contain 62,000 birds. There would have been 65,000 but the number was reduced for environmental reasons. We don't go inside. He wants to build more, saying that this is a good time to do it, during a slump. You have to get ahead and be ready with your chicken sheds when the prices start to rise again. I do not think I would want to buy a chicken from the duke's sheds but it would be better than one imported from Thailand.

The duke has built a Millennium Cairn, 'a sort of pyramid with the top cut off', on a hill; it stands on the site of the Armada Beacon, where a bonfire was first lit in 1588.

In the marquee for lunch I am sitting on the top table. Something of a misnomer, because the lawn slopes and the top table is lower than the rest. Not only that, but it slopes backwards, so one has to sit forward to avoid tilting over. I am sitting next to Mrs Barnett who is a Master of Bicester.

Afterwards, we walk around the Spring Garden – so called because of springs, not because it flowers in spring. In the castle, the entrance hall is full of Wellington-era arms – muskets, swords, powder cases. Mrs Barnett wonders how many bodies the bayonets have been stuck into.

I talk about alpacas with Mr Barnett – he is importing a hundred top breeding animals from Chile – and manage to miss Alan and Mrs Barnett. We wait 20 minutes or half an hour, during which alpaca talk runs quite thin. When we find them, Alan and I set off for Oundle to collect his thirteen-year-old daughter and friend, screaming at her father to drive faster because there is a boy in the car behind.

At Geddington, I collect snails in a bucket, and I'm afraid I pour salt into it.

Waiting for a taxi to the station, I am able to contemplate the masonry of the cottage in some detail. On the façade there are holes; the mortar looks like Emmental cheese. By the garden

door, I notice a covering of spider's web, or similar, and poke in my Cartier pencil; out falls a bee. This is serious.

Friday May 19

I phone Richard of Acorn Properties about the bees. He is not encouraging. Masonry bees bore through mortar and make nests inside the thickness of stone walls. I say with confidence, they can't have swarmed, there are not enough of them. But he points out that the ones we see may not always be the same ones, i.e. there could be hundreds coming and going. Masonry bees are protected so they cannot simply be killed. But he doesn't see any obvious way of having them removed, without killing them. If he is correct, we have a problem.

Saturday May 20

Yesterday, 1,400 urban schoolchildren were bussed into Syon Park, west London, and swarmed around the Countryside Live fair that we at *Country Life* had helped organise. Annie Tempest, creator of our Tottering-by-Gently cartoon strip, was near some Asian children when they were in front of the foxhounds. One said to her teacher: 'Can we feed the pigs, Miss?' There were, alas, precious few paying visitors this afternoon when Naomi and I went back with the boys and their friends. Nevertheless, I stayed longer than I should have done, given my date in Geddington.

Just as I am hurrying from the cottage – an accident having blocked the A4, near Syon Park – someone in a four-wheel-drive asks where the village hall is. He gives me a lift, and it turns out he is Mark Bradshaw from the National Trust, who will be talking about Lyveden New Bield. He has brought slides which throws me, since I have not prepared anything, or indeed thought about it. The village hall is full; there are two lines of tables, everyone sitting down in expectation of dinner. The theme is What I Do. I'm on first. I describe how *Country Life* started, then tell stories

of the copulation hat used by falconers (in certain circumstances, they have to persuade peregrines to mate with their heads, which requires a leather hat with a brim), 'Who Killed Princess Pushy's Pussy' (the *Daily Mirror* headline to the story reporting the death of Princess Michael of Kent's cat, which she claimed to have been killed by a squirrel) and my interview with Tony Blair for *Country Life*'s centenary television programme – and the quarter of an hour is up.

I am followed by supper: pork pie, egg and salad (English salad, rather like the English rose, relies only on its native beauty, without fancy foreign dressing). Then it is the National Trust. Lyveden New Bield was never finished – it is still roofless – but the builder, Sir Thomas Tresham, began a garden, which they have been excavating. The viewing mounds have been found beneath copses of trees, and the moats have been dug out.

The next on is Ian Addis, the former headmaster of the village school, followed by Peter Spence from the village, the avid gardener. He worked at Weetabix 37 years ago, and interviewed the Crown Prince of Estonia for a job sweeping the yard; he could not give it to him, because his employers feared the publicity. Last, John Hughes and someone whose name I don't catch, doing a double act on the Geddington Volunteer Fire Brigade. Interesting historical fact: the Eleanor Cross floats on a raft of bog oak, directly over a spring. Some of the original oak has gone into the commander's baton for the Volunteer Fire Brigade. John and Lloyd Marlow (that is his name) also display the trophy for the Squirt: an old brass nozzle mounted on wood. Apparently the nozzle is of some historical interest to people who know about nozzles.

I sit on the end of a table, next to Angie Cooksley. She is so grateful to the Volunteer Fire Brigade for sandbagging during the floods. The sandbags supplied by the council were full of holes, so the Volunteers filled new sandbags all night. Water only seeped into her cottage, no more. In the morning, they knocked on her window demanding coffee. They had been up all night.

We talk of allotments. I had rather fancied getting one. But there is no water on the Geddington allotments, down the road from the cottage; absolutely everything has to be carried to them,

including water. Angie had one once, and would go there early in the morning or just after lunch. This was to evade the old boys who said, 'That wouldn't be the way I'd do it, my dear.' In the morning, they hadn't got up; after lunch, they were having a snooze.

The wife of Cecil Tonsley, the bee expert, comes up. I mention our apiarian problem. 'Oh, you live in the cottage next to the Tea Shop, don't you? My husband's been there to get bees out of the bathroom. Half Geddington has bees. They're in the school, and Boughton House is overrun with them, but the duke won't do anything because he says it would be unlucky if the bees ever left.' I put the question to Mr Tonsley, all white hair and RAF moustache, now afflicted by Alzheimer's. On bees he is perfectly lucid. They are *mason* bees. 'They go away after a year. The problem comes if other bees, or the descendants of the originals, come back, and make the nest larger.' He doesn't think they are harmful. I could block up the holes in the autumn or winter. His own bees have come down with varroa, a mite which attacks them. Throughout Northamptonshire, the bee population has been reduced to a mere 10 per cent of its original volume, he says, and no one knows whether it will recover.

Gordon Binley introduces himself. He lives opposite, and is clerk of works for the council. I mention my bee conversation, and say I have been thinking of pointing the wall. He can get the mortar analysed, and there is a place that makes it at Brigstock. I do not need to worry about the bees. Our cottage will not be like certain brick-built houses in Northampton which had fallen down after bees had invaded them. Some naughty bricklayers had mixed washing-up liquid with the mortar to make it foamy and easier to work; but with washing-up liquid, it takes longer to dry – in fact, it never really sets. The bees smelt the lemon fragrance and thought there was fruit inside.

Sunday May 21

Graham Sharpley from the Tea Shop had his car stolen last night. I saw him on my way back to the village hall to collect my coat; he

was wearing an Australian hat and a long waterproof against the rain, walking a sodden-looking dog. I think the car was there then. Graham collected it from the car pound in Kettering. Whoever took it abandoned it, leaving the door open. I am pleased I have started to lock the car.

Friday May 26

I have just been searching for 'mason bees' on my new Imac, and behold – a whole chapter on them on the Natural History Museum's website (Entomology Department). There are different types, but they are all perfectly harmless; they don't even sting unless more or less compelled to, through being trodden on or squeezed. They don't nest in hives, but individually, though sometimes the individuals gang together into what could pass for a small swarm. To control them, you just rake out the affected mortar and repoint it; or paint on a sealing fluid to harden the joints.

SUMMER

Fuck-Up Editor of *Country Life*

Saturday May 27

This has been one of the wettest springs ever. Today I started to go through the ford at Geddington but backed out quickly, in case I was marooned.

I take the boys to the park with the kite that Gabriella, the Italian au pair, gave William for his birthday yesterday. It is ultra-light, just thin strips of plastic with long tails, all fastened together with something like Sellotape. It has a wonderful orange monster face. People on the bridge say we'll have to hang on to it but initial attempts to launch are only modestly successful, because of trees. Once we get out towards the cricket pitch it soars away. William holds on to the handle very tight, with an expression of thrill, wonder, responsibility, his hair blown back by the wind. The kite gets caught in a tree but William manages to tug it down without breaking the string.

We have supper of ham and smoked trout from a recent trip to Suffolk (the high point was to discover that there is a house near Orford called Gobblecock Hall). The new train set buzzes throughout.

There is an ant crawling across the computer screen.

Sunday May 28

I go to church, quarter of an hour late of course. No heating, because the system is still broken. No Scouts, because they are camping – it must be a swamp in this rain. They are mentioned in

Audrey Clarke's sermon, in the context of St Teresa of Avila who undertook travels to found nunneries in appalling conditions and blamed God afterwards. An appropriate reference, but I am not sure about the moral.

This is Rogation Sunday, when prayers have been assigned throughout the whole of the Church of England for the farming crisis.

Afterwards, Gordon, the clerk of works, offers to fix the garden door which is still swollen. I am told by someone that boys deliberately kick balls into my garden in order to retrieve them. I am not sure I believe it. The new consortium owning the pub will not have big tables with benches; instead, little tables and chairs, which are regarded as better taste. The tables and benches attracted people to hang around.

Hanging around is becoming a recognised social problem, to judge from a report in yesterday's *Kettering Evening Telegraph*. Councils are attempting to stop young people congregating where they are not wanted by erecting special meeting places in what they regard as better locations. The meeting places look like small bandstands with bench seats. I saw a copy of the *Magistrate* magazine, and there was the chief constable of Thames Valley saying they were doing the same thing. But they do not please everyone, even those whom one would imagine they are meant to help. Plans to put shelters in Corby Old Village are being opposed on grounds of visual intrusiveness.

Walking back home, Tony Griffin tells me that they have been seeking orders to pollard trees in the churchyard for five years. They are protected because they are in a conservation area. But one is overhanging other people's property, one – a lime – is cramping the style of a chestnut. (This chestnut is already suffering from people pulling off lower branches from the wall of the churchyard, which the youth sit on.) Someone is now going to conduct a survey by climbing.

We go to Cambridge for a family party at the Garden House Hotel. The sky blackens and there is a power cut. It happens just as I am in the lavatory with William, so the automatic flush does not work, nor is there any water for the handbasins. The Cam

is almost over the banks. There is another thunderstorm on the way home.

Monday May 29

It has only been raining intermittently.

I finish the rest of the garden path today. Where it was smooth hard grass, I put pieces of stone made to project from the surface, so the effect is bumpy and ankle breaking. I think this is more rustic. Now I must plant some hummocks to make it even more of an obstacle course.

At midday, I have another go at flying William's kite in the playground. It is good exercise for me, running after the kite and then dancing around to launch it, while William holds the string. For a five-year-old, he is very good at it. I say what we really need is a hill. So he has the brainwave of standing on the mound that prevents cricket balls from running into the river, and it makes a big difference.

This afternoon is sunny for the Grafton Underwood Fayre, strung out along the village. The Kettering fire brigade has brought its engine, and Johnny and William sit in the driver's seat and wear helmets. We have lunch of hot dogs cooked on a stall. The heat is now on for the Geddington fête, which happens on 25 June. 'We need to have a beer tent, and a bouncy castle next to it, so that people can sit down; also a fenced-in area for under fives.' Geddington already has the Sealed Knot coming, 30 of them, making two bijou regiments.

There is a jazz band playing very loudly next to the bouncy castle, which is just as well in view of some of Naomi's comments. 'Who was that frightful woman with the double-chins? And so rude.' As the 'y' in Fayre suggests, the entertainment tends towards the traditional: coconut-shying, guessing the number of tadpoles in a bucket, treasure hunts, etc. There are a lot of stalls selling garden plants at 20p each. Best of all is a stall selling toys knitted by two village ladies, mother and daughter. I buy a man in a bathing suit with a ball that is a real piece of folk

art. Naomi sends me back and I buy knitted mice in Victorian dresses, some puppets that I thought were gloves and two knitted ladybird badges.

I come back to find that Gordon has mended the door, so we can lock it again. Later he comes round with a mirror in a frame, made of old fencing, for Naomi. She is touched.

Lisa Wilkinson gives a horrific account of camping with the Scouts: 800 children, and the tents pitched in dips that were running with water. Some children had come without any waterproof clothing. The expedition was ended a day early, but when the coaches arrived to take everyone home they could not go down into the park, so there was an evacuation-style scene as Scouts and parents tramped through mud, carrying tent poles, sleeping bags and cooking utensils. The defeated army then dispersed.

Tuesday May 30

At home, I find William and Johnny in builder's hats, with a three-volume edition of Malthus's complete works in their tool box. They are fixing it. Something has got muddled here. William says: 'Johnny is being Derry and I'm being you, Daddy.' William has assiduously scribbled out three lines of Malthus, on the grounds that it must be very boring to have so much to read without pictures. He has a point.

The plants that should have borne sweet, yellow tomatoes have been blitzed by the rain. I take the remaining threads of green inside but I don't think they will recover.

Thursday June 1

I go to F. E. Cole and Son, at Twywell. Their shop is behind a grass verge, with their house next door of stone, gables and bargeboards. A notice outside reads: Our Own Finest Quality Home-Killed Meat. Behind the shop, there are beds of flowers. I trudge round the back, and there is Mark Cole just like a

butcher, rosy cheeks and John Bull shoulders. Inside I meet his mother, Marilyn, and father, Frank. Frank is not at all like Mark, being smaller and less rubicund, but, of course, he has a complete grip on the subject. We stand in the parlour, with little ornaments on window sills, and drink coffee in mugs. They are proud of what they do. They buy animals from local farmers, within a twelve-mile radius, one farmer for sheep, one for pigs and one for cattle. They hang their meat. Supermarket meat cannot be hung, because the scale of the big slaughterhouses would mean that, as Frank says, 'they would need cold stores as big as football pitches'. Their business revolves around the local community. 'Customers want local meat.'

Wholesale meat does not meet the Coles's standards for quality. But each year greater expectations of meat inspectors and vets mean the overheads of their business go up. They don't mind the meat inspectors. It is the contradictory edicts they get from the Meat Hygiene Service vets that they object to. There used to be nine abattoirs in east Northamptonshire, now theirs is the only one left.

This has had an effect on shows like Thrapston fatstock show because there are no butchers to buy there, so there is no point in showing top quality animals. They barely attract any premium.

We walk around the shop; it is empty because they are closed for the week, but I see where Marilyn's pies, sausages and black puddings would be, if she had made them. There is a small kitchen where they are prepared, with a big red mixer, and cooked, in battered stainless steel tanks and ovens. They also make home-cured bacon. After that, I see the abattoir itself. 'Beasts' are kept in layerage where they rest – they have had only a short distance to travel. They only kill on Monday mornings, and just enough for the shop. They used to employ a man but did not replace him when he left. They don't take in animals for farmers, or smallholders like the duke's agent Alan Wordie. They don't find it is worth it. The farmers complain too much. The Coles are investing in a new machine for scalding pigs to take off bristles. At present they just have what looks like a big tank, and Mark has to manhandle the dead pig.

I go to Geddington, and on then to Naseby where I buy cake

from the village shop, and say hello to Pauline and Leanne at Sue Muirhead's yard. Then, rather late, I go to the Pytchley puppy show. I cannot find the kennels, which are outside Brixworth, but then I see a flash of black bowler hat and white coat between the trees, and there it is. I arrive just too late to see the puppies. The kennels, rather American Federal in style, were built in 1965, and have just had all the windows replaced: 57 of them. The company making them went bust but someone got a tip-off the day before and went and cut through the gates with bolt cutters and removed them, as they had already been paid for.

The barn is full of tea tables, each laid with a different cloth: white, coloured or check. Boughs of laburnum and laurel decorate the walls. Michael Bletsoe-Brown, one of the Pytchley masters, gives a short speech. Then the bashful master of Surrey Union addresses us: 'That is about all I have to say. As you can see I am not used to giving speeches.' Third, holding his lapel, comes another judge of hounds – a huntsman friend of Peter Jones – dressed in a three-piece suit. Unfortunately I cannot understand anything he says.

The point of the puppy show is to thank the people who have been walking young hounds. This means looking after them for their first year of life, which is quite a task, seeing that they need a lot of exercise and are not house-trained. Hounds are pack animals and can never be domesticated, but they remember the families who have walked them. When they tumble into the ring to be judged, a few will always bound over to where they see their erstwhile minders, lapping at the faces of the children in a way that would probably horrify environmental health officials. All sorts of people walk hounds, not just those who follow the hunt on horses; it is an activity that helps bind the hunt into the rural community. There are many activities of this kind. Once hunting finishes in March, a whole programme of hunter trials, point-to-point meetings and social evenings unfolds, while the masters direct the full beam of their charm towards local farmers (otherwise so beleaguered these days), to make sure they are still given permission to ride across their land. Broken fences have to be mended, in both the literal and metaphorical senses.

After the speeches, Peter Jones tells me about the enormous problem of fallen stock. Moving animals that have died from natural causes requires special equipment, and the hunts collect them as a service to farmers who allow them to ride over their land. There are no knackermen these days; they were seen off by the BSE regulations. Farmers don't want to call the vet so much either. New regulations prevent beasts which have broken legs being slaughtered, so huntsmen like Peter Jones put them down. This all means that there are more and more dead animals to collect. The Pytchley is out with two lorries all day, and the incinerators at the kennels operate around the clock. Even so they can hardly keep up. Foxhounds live on a diet of raw meat, and need a lot of it; but they are consuming only a quarter of what is now being collected. There has been trouble from the hygiene police about the conditions, but, shrugs Peter, what can he do? They are taking him to court.

I talk to Jan, the wife of a land agent, all of whose time these days is spent telling farmers how to maximise the return from their buildings, since there is no money in farming itself. She is part of Farmers for Action. They are already living up to the action part of their name. The idea is that they meet suddenly to picket a supermarket or other target which treats British farmers unfairly, with no obvious command structure but an efficient bush telegraph through e-mail and mobile phones. I say I want to go on the next action; she says she will tell me, but you have to be ready to drop everything because the call comes without warning.

I drive to Shepton Mallet for the Bath and West Show. Just as I am leaving a Range Rover drives past and it is my friend the beer connoisseur. 'Are you the man who wrote that article?' I confess to it. The piece in *Country Life* described Geddington's history and what the place is today. If you take the inhabitants of Geddington as your sample, it is the most widely read four pages in literature. 'You've upset a lot of people, you know. Half the village think it's disgusting.'

'What is it they don't like?' I ask, knowing already. 'You give such a black picture of the village. Anyone would think it was

full of drug addicts.' The trouble is that I quoted the words of the children as they passed the door of my cottage, arguing over the last of the spliff. I was not censorious; it was just something that happened. It happens everywhere, even in villages. That was my point. I'm sorry if I have given offence, but he continues: 'Some of the people I was talking to nearly came over and broke your windows. You're a townie, aren't you? You've never lived in a village? I thought so. How long have you been here? Six months! You haven't any idea about the life of the village. You're like the bloke who lived in the house next door to you, the Tea Shop. He was a city boy,' he says contemptuously. 'Wanted to change things. There have always been people round the cross. I played round the cross when I was a boy. Of course, there is noise.'

That was another subject of contention in my article. I mentioned the episode of the wine bottle being thrown through the window of the Tea Shop. It took place. I don't mind the noise round the cross, because we cannot hear it through the thick walls of the cottage, and people have played round the cross for centuries. 'Yes, you put that,' he concedes. He does not appear to be mollified but after half an hour smiles when he drives off. I shall have to make peace in the White Hart.

It is a long drive to Somerset. There is a smell of cows – very Somerset – when I get out of the car; it is a different smell from Northamptonshire. I eat a salad, ravenously, in the long, low, very local bar. It is now just after midnight. The knocking of the headboard from the next room, which went on for an heroic time – I almost applauded – has finished, to be replaced by equally loud snores.

Saturday June 3

I am banning slug pellets. At the Bath and West Show I chaired a panel on gardening which included the environmentalist, Jill, Duchess of Hamilton. She says that slug pellets are the devil's work, on a par with asbestos if not nuclear radiation. The snails and slugs that are killed by them are then eaten by song birds,

which die too. So I spent the afternoon discussing alternative anti-slug strategies with everyone I met. One lady recommended half a grapefruit; the snails congregate beneath it, and you then pop them in disinfectant. Eggshells were much touted; when ground up the snails do not like to crawl over them. Roy Strong simply gestured, a pinch between finger and thumb, and then squish.

In Geddington, I saw a washing-up liquid bottle in half, put the halves in the ground, and fill them with left-over Chardonnay, not having beer.

At lunchtime the Star is almost empty. The menu is depleted, with only bar snacks, curries, Torbay sole and a few other delicacies, not the long list of before. Mike says that the new owners are obliged only to buy wetstock, so he is under instructions to run the menu down. Apparently the new manager gave him nothing but abuse when Mike phoned him. It seems hardly fair, after the loyal service he has given to the pub. But there are new owners, so new ways. According to Gary, they are going to turn it into a tapas bar. Mike says, 'Half the people only come here for me. They want something special. They ask if they can have something a little different here or there, and it's a pain in the arse – but I do it for them.'

Gary will go where the company send him. He has worked in countless pubs, some of them known trouble spots for which he was paid danger money. In one, where the clientele would sit there hacking at the seats with knives, a group of Irishmen came in, he challenged them, and with two bouncers to back him up, told them to go. There was a fight. After twenty seconds, Gary's team was underneath, 'with blood squirting from every orifice'. They had taken on some gypsy bare-knuckle fighters and lost; but ever afterwards, they had the respect of that pub.

A young bloke comes in. The public bar is flooded, after rain. He sits next to me for some lunch. We talk about the car thefts. Gary's wife has just had a screwdriver broken in the lock to her car. The young bloke says he got back to his car in Kettering to find two boys in baseball caps trying to open it. He had left perfume worth £45 on the seat. 'It was in a little bag and you feel a bit of a poofter carrying it around.' One of them ran away, leaving the other, whom he clocked on the face. When the thief

ran away, the young bloke ran after him, and would have clocked him again. He cannot understand what the Norfolk farmer Tony Martin, who has been given a life sentence, did wrong by shooting the burglars who broke into his farmhouse. 'They shouldn't have been there in the first place.'

'It's that heroin that they're after,' the young bloke continues. 'Kettering is full of it. It's like these kids round the cross – though that's not so serious.'

We stare into our beer. 'Nottingham is the place for girls,' he starts without prompting. 'There are five chicks for every bloke. I don't know why that is. I couldn't keep my eyes off them.' He is a lorry driver, born in Kettering and now living in Corby. It is perhaps no surprise, given his eye for chicks, that he has come to the pub following a spat with his wife. But he will take her out to Sunday dinner tomorrow. This afternoon, he has withdrawn to watch the match (England are playing) with a couple of beers.

As I leave I shake hands with Mike, and say it is very sad. And unless I imagine it, the big man has the beginnings of tears in his eyes.

Two cream-coloured Rolls-Royces stand outside the church for a wedding. This forced the two tourist guides who are meant to be conducting a walk around Geddington to retreat into the pub. They are not hopeful of a good turn out; the details of the event have been incorrectly announced by the tourist authority.

Later, I see Tony and Beryl, as I now know the guides to be called, walking up Church Hill with only one person to conduct, so I join them. We stand in the churchyard, wild with cow-parsley, graves mantled with ivy, looking towards the old people's flats where the gatehouse used to be. According to them, the high point in Geddington's history came a hundred years before the cross was built, when Richard I planned the Third Crusade from here. It was unsuccessful, of course, and the Infidel pursued the crusaders back into what is now – or I should say was – Yugoslavia.

Tony and Beryl say that along the grass verge beside Church

Hill stood an abattoir; that is what shows in the painting by James Lawson Stewart.

Monday June 5

I read in John Clare, *Selected Poems*:

> These children of the sun which summer brings
> As pastoral minstrels in her merry train
> Pipe rustic ballads upon busy wings
> And glad the cotter's quiet toils again
> The white-nosed bee that bores its little hole
> In mortared walls and pipes its symphonies
> And never-absent couzin black as cole
> That Indian-like bepaints its little thighs
> With white and red bedight for holiday
> Right earlily a morn do pipe and play
> And with their legs stroke slumber from their eyes
> And aye so fond they are of their singing seem
> That in their holes abed at close of day
> They still keep piping in their honey dreams.

John Clare knew his bees.

Thursday June 8

This morning, Lisa Wilkinson phones me in London, a little tearful, to tell me of the terrible repercussions from my article. People seem to think she wrote it. Some of the attackers are old people whom she has helped drive around; but they have proved fickle. I phone John Padwick who is a councillor. All the youth of the village is up in arms, objecting to being called yobs. But I didn't call them yobs.

Two girls have written me a letter. This was at the suggestion of Councillor Padwick who felt they needed to vent their anger.

Unfortunately, he says, they didn't show it to him first. I don't know whether I shall open it. I don't need to. The envelope is addressed: 'Fuck-Up Editor of Country Life'. They have a point, probably.

I go out to the car for something, and see Lisa, but she doesn't see me, not having her spectacles. Ashen-faced, she is setting off for the White Hart.

There is a notice saying that normal service at the Star will resume tomorrow. In need of drink and conversation, I go over there and it is closed. Through the windows I see some young people, doing it up. Gary has gone. Mike has gone. I do not get my beer.

Beating the bounds

Storm is as fat as butter. I look down to see why spurs are having no effect to discover that I have forgotten to put them on. I think it will rain but it doesn't. It is so stifling I feel I am going to have a heart attack. Everything looks so lush after a month of rain, which somehow makes the effect worse.

In Sue Muirhead's kitchen, I meet Gren the Naseby village shopkeeper and postmaster. His post office safe was burgled by a group of Kosovan refugees; at least that's what he took them to be. His wife was away on an official Post Office course learning about the new computers, so he was there by himself. They distracted him and broke into the secure cubicle (a child could do it, he says). Unfortunately, since he had been doing some accounts, he had left the safe open, and they stole £7,000. They then went on to the Fitzgerald Arms and various other places, which shows some cheek, given that people who look like Kosovan refugees are not a common sight in the Northamptonshire countryside.

Originally the Post Office didn't want to compensate Gren for any part of his loss, but they have now agreed to pay half. He has had enough of it, though, and is going out to get another job. His wife will continue with the shop, with an assistant, but not for such long hours.

At Geddington, I stop in the village shop. 'Have you been down to your cottage?' ask Mrs Chew. 'There have been police cars, fire engines, ambulances – everything.' I immediately think the critics of my article must have burnt it down, but no. There has been a real-life police chase through the village. The people they were

after crashed into the enormous farmyard door of Church Farm. I can't say that I hurry to the scene, because I start to tell the Chews about Gren, and then we have a long discussion of the risks of keeping a post office. But I get there eventually, just as the police officers, in bulletproof vests, are packing up their computers. The door of Church Farm has been put back on its hinges. They have caught the people. Apparently they have been responsible for a lot of burglaries and car crime around Kettering.

When Christine from the nursery comes along, to advise on plants, she has her own story to tell. She had just been phoned by a friend to say that the suspect was on the loose, when she saw him, with police officers in pursuit. She pointed to where he had gone into the bushes, and they got him.

She makes notes on my garden, and I'll go to the nursery next week. There must not be any bare earth, and bosomy profusion everywhere.

Tables and chairs (not benches) in dark brown (not ginger) have appeared outside the Star.

The *Kettering Evening Telegraph* comes through the door. It contains a mercifully short and hidden piece on 'Village Fury at Townie Aspersions'.

Before John Padwick comes, I read the letter from the angry young people; it is quite a good letter, albeit unsigned. They write that 'this bitter powerful man' has disgraced 'OUR beautiful, friendly, safe village to the world, but he has also taken it upon himself to mock the police service and Geddingtons [sic] youths who were portrayed as drug abusing vandals'. Geddington has a large number of pubs, 'a youth club for 5 to 11 year olds, a bowling green for over 60 year olds and nothing for teenagers at the between ages. We gather on the cross to socialise as there is nowhere else to go as we are not allowed down to the recreation ground (park) after dark so therefore if on the occasional chance that there is an incident with say a smashed window we are the culprits.' They then let themselves down by being rude about Lisa and Gary.

We sit in the garden, John with beer and me with tea. Some of the kids and long-time residents are 'hopping mad'. He was at the community centre when the reporter from the *Kettering Evening Telegraph* came. Everyone who lives in the village used to sit round the cross at one time. 'There used to be a curfew in my day,' said one old lady. So misbehaviour is nothing new either. 'They would have gas-tarred his door,' said one old boy nostalgically.

I agree to reply to the letter and send an e-mail to John Padwick (the letter not being signed).

Tomorrow is Trooping the Colour, which we always watch from a balcony, and I start to pile my things into the car. As I do so, one of the three boys on the cross gives me an ironical thumbs up, or some other sign. I go over to talk to them. I explain that I never called them yobs. 'Cheers for coming to talk to us,' they say as I leave.

It is opening night for the Star with John Hughes glorious in his role as host. He offers me my first drink on the house but I don't take it up because it seems hardly worth it for a shandy. On the way in, I pass Norman, from Geddington Farms, emerging from the public bar. 'Not as well as you obviously are,' he replies when I ask him how he is. I detect a frost. I only make my way to the bar with difficulty it is so crowded. Crowded! When has the Star ever been crowded? It is also light and cheerful, and full of people I have never seen there before. At the bar, I find myself next to John Wilkinson. I sheepishly apologise for the embarrassment to Lisa. 'Not a bit of it. It has brought a lot of things out into the open that needed to be confronted.'

'This is the second topic of conversation for the week,' says Pam Dennis, a parish councillor. 'The Star. The first one is you.' Paul Hopkins, her partner, has the sort of broad, open, eternally English face that you would find in a Rowlandson engraving. He also used to be a parish councillor. I say that a white mark has appeared on the kerb – a sort of neat white notch, fifteen yards from the junction, presumably to indicate the length of road along which one should not park. 'That will have been Keith. He takes it too seriously.'

Pam was burgled a couple of years ago. Half a dozen years ago there was an armed burglary in the post office. Kaye, black-haired and petite, was postmistress at the time. She pushed her assistant into the secure cubicle in the post office, slammed it shut and won a commendation for bravery. At that point the heroine herself comes up: 'I think you were quite right,' she says, referring to my article. 'We want more of it.'

Paul Hopkins has an affection for sitting round the cross. 'In my day you had to graduate to it. Wait your turn.' Turning sentimental, I say how sorry I am that the kids have taken my remarks the wrong way. 'They will overstep the mark, if given a chance,' he warns. Suddenly the bell is being rung for last orders; even then I don't leave immediately. I arrive in London about one o'clock.

Sunday June 11

Yesterday was not Trooping the Colour, so we came up in the afternoon. And lo, a new sign has appeared at the Star. There is just a star, not a picture of the Eleanor Cross; it is very smart.

The bees have gone. They haven't been around for a couple of weeks now. At first I thought it was the rain that kept them indoors; but no, they are not about any more. The panic is over. What happens to them? Have they died, ready for the next generation to begin the cycle next year? Or are their little mortar holes full of grubs?

The reason why snails do well here is because of the limestone. They need it for their shells. In Northamptonshire dialect, they are called hoddy-doddies.

Friday June 16

There is a new face behind the the beer handles in the Star. It belongs to John who is in love with the racking for beer barrels. It is all he dreams of, he says. At the Star, the old barrels used to be entered at the top, whatever that means; now the job will be done properly. They will restrict the choice of beer so that it is fresh. You can't keep it more than a few days, and besides, the system at the Star means there are long pipes. So I suppose the beer hangs around in those and is not fresh. The pumps from the public bar have been removed to aid freshness. He is so enthusiastic in explaining this to me that I never move beyond my half pint; I have no lunch.

I go back to the cottage. The garden is dry. The radishes have bolted. The tomato plants now look surprisingly butch, given their spindly start. I can't find the twine to tie them up. The sort of evening you really need to spend in a garden, but I don't, going to Burwells instead.

Burwells is a club, founded a couple of years ago by a young couple, Nick and Nicky Burwell, the male half of which is the son of a cowman on the Buccleuch Estate. You wouldn't have thought that a village with three successful pubs was the right place to take over a moribund working men's club, and reinvent it as a popular, lively drinking place, but they have done it. Burwells has become, in just the couple of years that it has been open, a village institution.

You have to ring a bell to get in, and membership costs £2. It is free to the Geddington Volunteer Fire Brigade, and tonight I am going to their meeting, which they don't call anything so obvious as a meeting, but a parade. We go up a narrow staircase into a room that is part lined with pitch pine. There are various memorabilia on the walls: a fireman's boot, presented in association with the walk from Lincoln to London, in 1994, when they were escorted through the City of London by the police (because of bombs); a plate presented by Lahnstein, a village in Germany with which Geddington has relations, and various photographs. In front of Jim Harker, who

sits behind a desk at the front, rests a nozzle, mounted on a wooden plaque, also from Lahnstein. Above the panelling, there are a knitted fireman, an old tin of pink paraffin, a zinc bathtub (for some reason). The room was derelict until decorated by the Fire Brigade.

Jim presides over the parade as the CO. Others are called Adjutant Officer, President of the Mess, Quartermaster, etc. The whole performance is a parody of something – the services, the masons, anything with a tradition, with echoes of the hunting field – but they do it thoroughly. There are an agenda and full minutes, which are meant to be funny, but are still taken quite seriously when it comes to planning 'actions'. Men – there are no women Volunteer Fire Persons – need organisations with structure, and have to create them if they don't exist.

Near the beginning they discuss new members, welcoming two who were voted in last time. Jim asks if anyone has other new members to propose. John Hughes says he knows this scurrilous journalist who is a well-known disruptive element around the cross. I am told this is the moment to present the picture that I have had blown up from a photograph in the *Country Life* article, which I do sheepishly. Someone – another John, who is a policeman – objects. My John tries to talk him down, and Jim to finesse him, but he persists, so John (mine) and I have to leave the room. Downstairs I buy a drink. John's dad, whom he has just visited in Oswestry, was a para (he carried the flag during the 50th anniversary of Dunkirk at the Albert Hall), and John was in the King's African Rifles. Why was he in the King's African Rifles? He had gone out to an African mission station, after someone had told him about it in the vestry after church. Within a year he had gone from being a missionary to a mercenary, in the Belgian Congo. He saw fighting, real fighting. From there he went into the regular army.

They must have finished talking by now, so we go back upstairs, and Jim has indeed fixed it. I am welcomed as a new member.

The Volunteers raise money through their activities, which

is then distributed to village causes. They have just had their first win in a cricket match (by one run) in seven years. The quartermaster reports on the state of polo shirts, Millennium ties and other merchandise. I buy a white polo shirt which I shall need for the ceremonial march to mark the Queen Mother's birthday. They are going to build an arch over the bridge, and we shall march through it. The Erection is a considerable undertaking. Queen Eleanor (the fire engine) will also go over, or more likely through, the river. There is evidently great symbolic significance in her going over the bridge; they talk of sawing down the bollards to let her through.

There is a break to recharge glasses, and then correspondence. The last letter comes from Joan Tice, the master, who bought for £100 at auction the promise of six men working two hours. She wants to make use of them to provide entertainment during the pony club camp to be held at Teeton.

As I leave, I pass a young man who has to be guided to a seat he is so drunk. For all that, Burwells has quite an atmosphere. I am very nearly sorry not to be there tomorrow night, when England play Germany. A big screen pulls down to provide cinema-style TV.

Saturday June 17

I get up at 5.45 a.m. I water the garden, because it will be a scorcher of a day. I pick armfuls of elderflowers. The countryside is white with elderflowers everywhere, great foaming billows of them.

I have been inspired by a tour of the Belvoir cordial bottling plant, made on our Country Landowners' Association visit. The duke's uncle started making elderflower cordial commercially, using a redundant turkey shed. For economy, the vats came second-hand, having previously been used for cheese-making. Farmers don't like elders because they weaken the hedges they grow in and let the stock push its way out. The Belvoir crop mostly comes from the hedgerows, but such is the demand that

an elder plantation has been put down in a field, much to the mirth of the landowners who saw it. You can hardly stop elders growing when you don't want them, but few of the specially planted trees seem to have taken.

The present duke's father did not charge his brother for the water that goes into the drinks. The new duke has put an end to that nonsense. 'If he doesn't want to pay, he can go.'

Monday June 19

This is the weekend of Rothwell fair, according to the *Kettering Evening Telegraph*. Rothwell is pronounced Rowall hereabouts; local people are proud of the peculiarities of their non-phonetic place names which act as a shibboleth against arriviste outsiders. Presumably Rothwell has a bailiff; certainly it has a deputy bailiff, because at dawn he rides around the town, proclaiming the charter outside the town's pubs, or the sites of those that no longer exist. This tradition is supposed to date from 1204. The proclamation is followed by ritual street punch-ups, known as Halberds, which involve young men fighting each other for the possession of poles.

Grey-haired old men reminisce about the availability of local girls when walking back to Kettering. Their eyes mist as they remember Ford Anglias, whose front seats could fold back to the near horizontal, and old vans with mattresses in the back.

Wednesday June 21

From the beer trap I extract four or five snails, unpleasantly bloated and extended.

Thursday June 22

Last night Lisa Wilkinson phoned to remind us, first, about the village fête and street cricket (this is not cricket played in the street, with danger to windows, but a day of matches played by small teams formed by each street). This will be on Sunday. Secondly, she reminds us about the party to celebrate the reprieve of Newton Field Centre this evening. We will be elsewhere on Sunday (in Lewes) but I am happy to bump over the fields to Newton church.

Inside, I am offered sausage rolls, slices of cheddar and a plastic cupful of wine. Paul Hopkins is there. Once, he used to operate the enormous machines for the ironworkings here, and he now works for the Corus steel plant in Corby making steel tubes. It is the last part of the steel works to survive, and now partly Dutch-owned.

Tony Cook, the field centre warden, tells me that snails expend 80 per cent of their energy on producing slime. Why?

Friday June 23

By the door to our garden, the thick stem of the climbing rose looks bald and arthritic, but the upper parts have begun to erupt with cerise flowers. We shall have to harvest the radishes. Does a bunch of jumbo radishes make a suitable present for Lady Dalkeith who has invited us to lunch at Boughton tomorrow? I think not. I douse the nasturtiums with washing-up liquid to see off the blackfly.

The sound of football around the cross makes me feel like a district commissioner hearing tomtoms when the natives are playing up.

211

Saturday June 24

I cook bacon and eggs for breakfast. 'I love bacon and eggs,' says William before eating. 'I've never had it before.'

It is more or less midsummer's day, and as cold as the North Pole.

I go to the plant nursery. I choose a golden hop as a burst of sunlight, a blue clematis to go with what have emerged as pink roses, and scented white jasmine because 'white is always cooling', though nobody needs cooling today. Then I bundle together nappies, bathers, change of trousers, etc. and we head for Boughton.

It is always strangely low-key, the approach to Boughton, given that it is such a treasure house. But the incongruity is made all the greater by a burnt-out yellow car lying on the edge of the road just before the lodge. Once through the gate, though, you could be in one of Virgil's Eclogues, with sheep scattered over the soft undulations of the park as self-operating woolly mowing machines.

The house is the size of a village, and I have no idea how to get in. I explore an open door and find a line of washing which I take not to be the Dalkeiths's. I eventually make my way around to the avenue side of the house where people are playing croquet. There is a house party. William and Johnny don't wait for an introduction to the croquet players but start rolling unstoppably down the bank from the terrace.

Since there are acres of lawn and the rolling is all-consuming, they are safe while I have a drink. When William comes in, he is awestruck by the painted ceiling and wants to know what it is. Richard Dalkeith tries to stall him, but then has to look it up in a book. Then William asks for the loo, and Elizabeth Dalkeith leads us down corridors lined with masterpieces, the walls painted in a sort of sludge colour that is original to the house, to – surprise – an ordinary sort of a bathroom, with people's swimming trunks hanging on the towel rail.

Lunch is in the great hall. There are two circular tables. They are so considerate of children. Nan, who was nanny to a

neighbour in Scotland before coming to the Dalkeiths on the birth of their first child, presides over the children's table. Immediately on our entering the room Johnny dives under the table to be a cat. It has a cloth which he is not used to. William holds his own but Johnny wants to be picked up, so he is given a place next to me at the big table. Chicken, potatoes, carrots, courgettes, bread sauce – it is perfect Sunday fare. As soon as the children have finished they run outside, under the eye of Nan. The grown-ups sit on talking.

Then we go outside to find the children, and – after a few heart-stopping minutes – William is located in a remote sitting room with Nan and some toys. Nan is hugely impressed at his having eaten everything without fuss. Richard conducts a children's tour of the house. We enjoy the remarkable optical illusion of a naked lady on the ceiling appearing to sit up as we walk through a room. The great hall used to be the great hall of a monastery, whose hammerbeam roof survives above the present ceiling. There are tapestries everywhere, because the builder of the house had a share in the Mortlake tapestry works. We try unsuccessfully to fathom what is happening in the Acts of the Apostles. Until quite recently, the wall behind the tapestries was nothing but bare brickwork, because it would never be seen; now plasterboard has been put up to prevent damp. 'Remember this door to the cupboard,' says Richard. Then we go along corridors and down staircases, and emerge into the unfinished wing. 'There it is on the other side,' he declares, pointing to the first floor. The unfinished wing is just a shell, with windows but no floors, built for a state visit that never happened. It contains a Chinese pavilion which came from Montagu House, and stood in the garden, slowly decaying, for years. 'Won't you put it outside again for one of the girls' weddings or something?' asks Elizabeth.

Outside I make noises about going but Richard proposes a swing. He may not realise that Johnny can swing for England. William and I need to make the long journey to the car for new trousers, and Richard is still swinging Johnny when we get back.

Then it is a walk to the swimming pool to look at it. The water is kept at a Caribbean temperature. William is keen to have a swim, but since his idea of swimming is floating on an inflatable boat, and Johnny would need a paddling pool, and it would be very cold with no clothes when not in the water, I decide against it, much to William's disgruntlement. So it is only with difficulty that we coax him to approve the alternative entertainment of watching the milking at the farm. Richard ends up carrying Johnny while I have William on my shoulders. The cows are contentedly munching in their lines. We go between them, into the pit where the cowman is wiping their udders, putting on suckers and spraying teats. I am holding Johnny when a set of suckers bounces off alarmingly, having come off the teats automatically when the cow finished. The cowman opens the gate, and the first lot of cows troop out. Another two files, one on either side, make their way in, eyeing us suspiciously. They don't expect to see us at the mothers' meeting. We leave on tiptoe.

We walk back to the shop. There is more rolling along verges. Richard provides ice cream from the shop, and I'm sorry to say that William complains at the one he has; it is not a White Magnum or a choc ice. And do you know, by a miracle, Richard is able to provide a choice of White Magnum or Crunchie ice-cream bar from the freezer when we get back to the house. I say that William should not be indulged, but he is indulged all the same.

Friday June 30

I go to Naseby. Traditionalists turn their horses out during the summer, leaving them to run around their fields without shoes, gorging themselves on grass, idling the summer away in company with their friends as though it were the equine equivalent of Tuscany. Then comes August, and the long process of walking the horses, to bring them back into the condition that they had lost through their summer of *dolce far niente*. This was thought to be necessary – and still is, by many – because the 'work' they do during the hunting season is so hard. Also, it is cheaper than

the alternative. However, we at Naseby do not follow this regime. The horses have their holiday, but it is about the same length as a modern human vacation, two or three weeks. Otherwise, they are maintained in good, if not peak, condition the year round. The intense contrast of half a year's energetic hunting followed by half a year's growing fat cannot be good for their systems. If I did not spend the late spring and summer growing fat myself, I would take part in hunter trials, team chases, three-day events and small-scale showjumping competitions. But the trouble is that I need a summer off as much as the horse. I just hack around Cottesbrooke, now and then, so that I do not forget who Storm is.

It is to Cottesbrooke that I am going today. Needless to say it is raining, but the horses are jolly. Storm is not only bursting to canter, but wants to turn the canter into a gallop. I wonder what he will do if I do not succeed in slowing him before the end of the field. Will he fly over the hedge?

Going back along the road we encounter a black, smoke-belching, wheel-clanking, tall-funnelled, foul-smelling dragon (as Storm would have seen it), which superior worldliness enables me to identify as a traction engine. It has a roller at the front, which grinds everything before it in a fee-fi-faw-fumish, fear-inducing way. Debbie waves for it to stop but it just steams slowly forward, clanking like a convict in chains. Eventually it does stop, and just as we move towards it, lets out a gust of steam from around its wheels, in the manner of an old-fashioned steam train in a station. Debbie and Leanne, Sue Muirhead's assistants, succeed in negotiating this spectacle. Debbie has just shouted to me that I must turn Storm's head away, because there is a deep ditch by the side of the road. But each time I turn his head, he goes rigid and will not walk forward. When he does walk forward – head not turned – the inevitable happens and he backs towards the ditch. There are by now several cars behind the traction engine. I kick and kick, and at last he sort of tiptoes past the fearsome machine. We shout thanks to the drivers of the traction engine but they don't return the acknowledgement – miserable men.

I have read somewhere that the point of the law requiring men

with red flags to walk in front of early motorcars was so that they could help horses pass. I don't know why that law was abolished for traction engines. Leanne says the monster is going to the Steam Rally at Hollowell.

Afterwards, Sue explains that Storm suffers from something that sounds like Asil Nadir. This is something to do with his metabolism. It means that a horse can go very well for a couple of hours, but then slows with a kind of cramp (some horses seize up completely). This is exactly what happens with Storm. So at least we know, but he should be all right if his diet and exercise are carefully managed.

Heaven knows how I am going to manage to hunt this year. I had it in mind firmly to tell Sue that I was going to stop. But she says, 'Well, I expect you could manage six days only. Get them in before Christmas.' I must say after our jolly canter I would find it hard not to hunt.

I go back to Geddington, where I notice a potato pushing roundly above the soil. The baby carrot which I pull up is a reasonable size for a salad.

Saturday July 1

We are in July already. What happened to June and the summer? It is a mouldy day. In the evening, we have tropical rain without the tropical sunshine before it.

We pull up the first of the potatoes. We thin the carrots, harvest some rocket. Long after these operations have been completed, the boys keep arriving at the kitchen door, saying 'Here you are – some more carrots', offering what look like orange pieces of thread.

Naomi: 'Johnny, you've got to put your wellies on.'

Johnny: 'They are called willies, actually.'

We go to Hollowell, where I have so often ridden around the cross-country course. Today it is transformed by the Steam Rally, which is a big event. As we approach, a mushroom cloud of smoke rises over what is presumably a traction engine. It costs £15 for all

of us to get in, but never mind, because the money goes to charity. Last year they raised £45,000 for good causes. We go first of all to the steam roundabout, with its horses and ostriches, its pipe organ and whistle. The Northampton Delta Jazz Band lumber around with tuba and trombones. They are led by a man in grey morning suit, carrying a parasol, who shuffles around doing an absurd, suggestive dance. Following him are three girl dancers, with feather boas, careful to look at their feet as they perform steps in time with each other. Two people dressed for a safari pass by on a pantomime camel.

We make for the show ring. Into the ring go a team of drum majorettes, made up of different ages of schoolgirl. William and Johnny scale two nearby bouncy castles. The excitement generated results in me trailing round the whole of the showground looking for another pair of trousers. There appear to be no stalls of children's clothes, but there are a man bodging chairs with a pole lathe, a woman fire-eating and stalls selling cakes and crafts. A parade of carts leaves the ring. One man nonchalantly lounges on the side of his cart; an ox of a fellow, with arms like hams, stands up to drive three horses harnessed abreast, like some mythological giant; a chap in a bowler hat walks behind a seed drill. Then there are the long lines of traction engines. They are horse-frighteningly magnificent, glossy, their pistons working like aerobic dancers in a gym. Some people hunt, some people polish their traction engines. Just look at the programme notes:

1912 Allchin Agricultural Works No. 1546, Reg. No. AP 9079, 7 NHP, 12 ton. Owned by Jane Eaton from Creaton. 1911 Davey Paxman. Works No. 16849, Reg. No. AF 3373, 6 NHP. 'Little Audrey' was built in 1911 and delivered by rail to Cornwall to H. H. Truscott for £350. She worked for them until 1937, was sold to Mr Evans of Wigginton for haulage, finished working 1947, went on to Mr Tomkins, St Eval. Then sold into preservation to Mr W. Day in Kent. Later bought by Mr W. J. Dakin in a totally dismantled state in 1983, took 6 years to rebuild,

rallied ever since in UK and Isle of Man. Owned by Mr W. J. Dakin from Sandbach.

Little Audrey look six years to rebuild, and Mr Dakin, from Sandbach in Cheshire, has not only transported the beast to Hollowell, but once took it to the Isle of Man! There are lots of motorcycles, puffing tractors and a vintage bus. Eventually I find a stall selling combat gear, and buy trousers marked for a 9–10-year-old.

William is waiting with his mother by the bouncy castle. When I start to measure out strands of blue plastic rope, left over from tent pegs, a man says, 'We need that.' So I pull off a section of red and white plastic tape that is caught round the wheel of a van; I use this as a belt for William and the effect is reasonable. We go to watch a magic show put on by Mr Alexander, a showman who is able to keep an audience of children brought up on videos spellbound, as he makes coins disappear, performs tricks with pompons suspended from staves of wood, produces crystal balls where none was before, sings and juggles with flaming torches. We buy ice cream, banana-and-chocolate cake and a large flagon of New Forest cider and go home to wallow in the programme, which delights us with so many things we didn't see, but can imagine.

Anglia Marina Model Boat Club are here to display their crafts on the Boating Pool. The tea tent is to be run by the ladies of the village. Helicopter flights will be available on both Saturday and Sunday. The Westerby Bassett Hounds will be represented on Saturday. The Pytchley Hounds will attend on Sunday. Brian Cocking is here showing his ferrets. Oxford Bakery are attending with their cast-iron 1911 Jones drum dough mixer to demonstrate the traditional methods.

People sometimes say that England is losing its individuality, but at the Hollowell Steam Rally it isn't.

Sunday July 2

We go to Jim Harker's for the Samuel Lee lunch. Everyone is more dressed than me, but I only have jeans at Geddington; I can rise to a blazer but that is it. The boys, being the only children there, are given a *Mickey Mouse* video which distracts them for a time. I take my lunch outside into the newly created garden like an Italian cloister. Jim has put in columns and terracotta pots, steps and a terrace. Over the wall is the churchyard, where Samuel Lee is buried. He died in 1708, leaving £100 to help the poor. That £100, invested in land, would have been worth quite a lot now; unfortunately the then trustees sold the land during the agricultural depression of the 1880s, and the capital almost disappeared. The present trustees are trying to build the endowment up, in order to help young and old people in the village.

Afterwards, we go to Naseby to see the battlefield museum, which is closed. So we have tea at Kelmarsh Hall instead. We walk through the garden which now looks different, with hollyhocks and delphiniums, and sweetpeas on twigs, and gay summer colours clashing like cymbals. The roses are almost over, but the melancholy is appropriate to their Victorian colours.

At Geddington, Greg comes over with two slices of cake made for his half birthday. He is seven and a half. 'I didn't know I was seven and a half until mummy made the cake.'

Friday July 7

Debbie has phoned to say Storm has an allergic reaction to something (huge lumps and spots all over), so no riding this morning.

I cross the road to the church, wanting to find Samuel Lee's tomb. But the churchyard is occupied by Margaret and the other ladies of the flower show. Nine of them have been decorating the church. The church is full of flower arrangements in odd places –

on top of the font, up and down the nave. I offer to carry some debris out; it turns out to be a bag of fish and chip wrappers. They have a tradition of eating fish and chips in church before the flower show. One of them is keen to reassure me that my stance on the cross was correct. The council built a playhouse for the children but it was vandalised, used in the manner of Sue Muirhead's 'bonking shed' (where Pauline once found two schoolchildren *in flagrante* when she went to collect hay), and dismantled. I am directed to Lee's coffin-shaped table tomb with the writing barely legible. I am just able to read that he was the Duke of Montagu's ranger in Geddington Chase.

I go to the Star where they are telling stories about Peter, the former landlord. His lack of hospitality has become something of a legend; perhaps it was only his manner. 'In my pub you have what I serve,' he is supposed to have said to a woman who mentioned that she would normally have expected rice rather than chips with a curry. Collective memory is healing the wound caused by his sudden departure, by bandaging it in myth.

I also hear ancient stories of water fights under a previous management which ended with the landlady being dunked in the brook. A lot of stories around here end with someone being thrown into the brook, or perhaps that is how they begin. You cannot escape water when it flows right through the village, sometimes rising into the houses. In 1848, when some anti-church radicals were holding a protest, the parish officers got out a water engine and drenched them. They probably talked about that in the pub for years afterwards, too.

I leave after closing time with Paul Hopkins. My friends around the cross call out various ironical salutations: 'We're all yobs. Give us a spliff. Wanker.' I am beginning to feel that 'taking up the cross' has a new meaning for me.

Saturday July 8

The church flower show is like a mini-fête. I go through the gate and I am assailed by Anona Hawkins, who sells me a strip of tombola tickets. I walk away with two little jars of shower gel, the kind you find in the swankier hotels. The Volunteer Fire Brigade has moved the books, as it said it would. I buy four children's ones including another *Treasure Island*, the *Ladybird Book of Roman Britain* and a book illustrated by Ardizzone. There is a paper dart throwing competition. I can't think how it is possible to make darts fly quite as far as the markers indicate that they have done. Certainly the contestants I watch are unable to emulate the feat. One of them – about seven – complains, 'But the winner was thrown by Brad, and he's seventeen. He ought to be in a different league. I'm still third, aren't I?' Naomi comes shortly after me, and eyes a green jumper on a stall selling knitting. William wants the knitted Dennis the Menace.

Afterwards, we go to Kettering, and find ourselves looking into a travel agent. I still have hopes of being allowed to spend the summer holidays in Northamptonshire but the rain is against it.

Sunday July 9

At ten o'clock, Jim Harker appears by the cross in uniform and brass helmet. The boys lean out of the parlour window and hail him. There is an assortment of other characters wearing combat fatigues, one person in a German helmet. They are beating the bounds of the parish. Charles Lockwood, a retired shoe designer, tells me that he will be leading a children's walk at two o'clock, in fancy dress.

I have to go into Kettering, taking Naomi and the boys to the station, and some garden rubbish to the Dump. As I walk round the stalls, I hear one of the foreign-sounding men who work there explaining about a car engine: 'You don't need to change the carburettor, just adjust the jet. I am a qualified mechanic. If

I do it for you, it is £30 an hour. And that is after an Italian discount. It is the year 2000 we are living in.' I have seen a red bicycle leaning against the wall, perhaps belonging to a customer. It puts the idea of buying a bike into my head, so I approach the Italian hard-bargainer, and ask how much he wants for one. 'A rusty bike, or a decent one?' I want a decent one. 'Ten pounds. We have a red one outside that would do you.' That is the one I have seen, so I buy it. As I ride it round the car park, he calls out that the front light is on; the dynamo works.

I arrive back in Geddington at two o'clock. Charles and assorted rabbits, queens, the Statue of Liberty, Firemen Sam, etc., have congregated around the cross. By now, Charles is also in fancy dress, of tartan tam-o'-shanter with ginger wig underneath, and a ginger moustache revoltingly attached by means of two cottonbuds stuck up his nose. A placard round his neck reads 'Braveheart'. The children will get a prize for every Volunteer Fireman they find hiding in the woods. There is only a mild drizzle.

I have an ambrosial lunch of salad, own potatoes, eggs, a single radish, organic courgettes. By the time I am ready to leave it is 2.30. As I do so, a Spanish girl is being photographed on the cross. She has walked from Kettering and she comes from Burgos, which is Queen Eleanor's birthplace, and is the object of some interest, looking quite picturesque. Paul tells me I can't walk in shoes without socks. I go back for wellingtons. By this time it is getting on, so I make the first part of the journey on my red bike. I ride up Wood Lane, than along the path. Then the hard path ends, in a sort of *Darling Buds of May* ramshackle barn. I follow the track called Clay Dick, and plunge into Geddington Chase. (When I was growing up in Surrey, there was a joke which went: 'Why was the Oxshott? Because it had a Leatherhead.' I am trying to work out something similar with Clay Dick.)

I walk fast along the track. There is every shade of green in the hedgerows. Roses and blackberry flowers look like scraps of paper thrown on to them. I could be a hundred miles from anywhere. I think: Perhaps I have gone on the wrong path, and I am a hundred miles from anywhere, and that I'll have a very

pleasant long walk on my own. It is too hot to be wearing a Barbour. Then I spy in the distance a couple of bobbing headdresses, like a royal progress. Eventually I catch them up. 'Are you one of the people we are meant to have found,' asks a young rabbit.

'I'm the one who was trying to find you,' I reply. The children are disappointed.

I am pleased to see that John, the policeman, who opposed me at the Volunteer Fire Brigade meeting wears an enormous purple wig and breasts, with a T-shirt bearing the slogan Ground Force. That is a kind of revenge.

We go on, through the Chase. Eventually after a long arc we arrive at Trevor Harker's farm. Deadly nightshade twines its way prettily through hedgerows in front of it. Trevor, brother of Jim Harker, is the fifth generation of his family to farm here. Above his rather large tummy his T-shirt bears the words 'I have been a farmer all my life and it shows' and a picture of a crow picking at a scarecrow, while on the back is the slogan 'Drink the White Stuff' and a picture of a glass of milk. It costs 17p a litre to produce his milk; it is premium milk, made to the highest standards and therefore commanding a slightly higher price, but he still only gets 14.5p a litre for it. With the pound so strong, there is no improvement in sight. 'I've tried to think of diversification, but last year I had to make my one farm worker redundant. That means that I now do all the tractor work, which I *don't* like; it rattles me up. And I am working from five in the morning till seven at night – when do I have the time to think about diversification? I have had the stuffing knocked out of me.' Looking at the tummy, you might think there is quite a bit of stuffing to knock out; but these are sad words – close to despair for a man who is 55, has always been a farmer and has four children under eleven.

The children provided the inspiration for the project that could save the family. His wife Lesley has started a pre-school, and hopes to obtain nursery status. Even this has not been easy. It took two years to get planning permission for the mobile classroom; the fact that Trevor's brother is leader of the Conservatives on

the Labour-controlled council may not have helped. With little money to put into it, she had to reuse whatever she could from other schools. The element of homespun is part of the character, and character is the selling point. She has called it the Udder Pre-School, and all the staff wear black-on-white spotted trousers as though they are part of the herd. In other words, she has identified an asset which all farmers take for granted but which is worth an increasing amount to the rest of the population, whose lives are increasingly remote from the land. It is the idyll of a country childhood. Who wouldn't want their toddlers' first school memories to be of hedgerows, guineafowl, milking parlours and pasture? As for the children, Lesley says they don't think of it as school. At going home time, they want to stay. It would be nice to think that Lesley is on to a winner.

Thursday July 13

Recently the *Rough Guide* volume on England claimed that Northamptonshire was only worth driving through. Rather than capitalising on this judgement, and keeping the tourists out of a county whose main asset is being real, the Tourism Strategy Steering Group has launched a consultation process to bring more visitors in. There has been talk of branding us Diana Country. Since my image of Diana is of a manipulative, cunning, extravagant, quite pretty, genuinely tragic, utterly destructive ego freak, I wouldn't be entirely comfortable to find myself living in Diana Country. Besides, I notice from the *Kettering Evening Telegraph* that Althorp House, where she learnt the country values that she comprehensively jettisoned in later life, comes only ninth in the order of the county's visitor attractions, with 165,000 visits. Silverstone race track comes top, with a million visits; after that – would you believe it? – I see Wicky Park, as Wicksteed Park is called around here, on 385,000 visits. It would be better to call it Wicky Park Country.

Friday July 14

I go to a party given by the Spooners at Pytchley Hall. It says
informal on the invitation but I am pleased I take this with a pinch
of salt. There are three men controlling the parking. The catering
is by Mustard. I make my way round to the front of the marquee,
and I am struck by the sudden feeling that I know nobody, and
cannot even see my hosts. 'They were here a moment ago,' says
someone by the bar. I plunge off to get a glass of cranberry juice
(I am driving back later) and I begin to discover that, actually, I
know quite a lot of people.

I find Sir James, and invite myself on a tour of the house that
his wife Alyson, a painter, is giving to a friend. The dining room
is full of her cheerful pictures of horses and riders; they give the
room a jaunty air. A photograph in the loo shows her parents,
him a Master of the Pytchley, looking down their noses at the
camera as only toffs in the thirties knew how.

Sunday July 16

I attend church for the last service of Audrey. There is a
christening for a boy called Colby, who is about six or seven.
He sits a couple of pews in front of me. Every time he shows
symptoms of talking his grandfather in the pew behind pokes
him and puts a finger to his lips. At the end, there is a speech by
Ken, the churchwarden, thanking Audrey for her ministrations
over two years. On her arrival, she was announced in the parish
magazine as A. Clarke. At her first service Ken hid behind the
screen to watch the congregation's astonishment when a woman
priest appeared.

Before leaving the church, I notice the wall monument to
Richard Best of the Haberdashers' Company in London, where he
worked for forty years. 'The rest,' as the inscription declares, 'he
spent on his own soyle.' Since Best died in 1629, the phenomenon
of City money moving to the country – perhaps back to the
country, in Best's case, though the monument doesn't say – is

nothing new. There was no dynastic motive with Best, because 'Hee wedded was to single life.'

In the afternoon, Naomi takes the boys to a party at the Tea Shop, while I slope off to the plant nursery. Christine and her partner are sitting in the sunshine, having a cup of tea. I buy bay trees; I don't want box bobbles either side of the gate because of the disease that box gets. I also purchase rhubarb chard, which with its red stripes will add a dash of style to the vegetable patch, and a drifting blue campanula,

I call in at the Tea Shop. On its gable, visible only from the garden, is a sun dial dated 1767. It makes a splendid sight, Graham the owner says, when he comes back home in the car. Lisa Wilkinson tells me that the barn dance in aid of the school was a storming success. Unfortunately, the nice American woman who lives opposite fell and broke her wrist very badly. 'I think someone stood on it,' says Lisa.

Monday July 17

I have bought a copy of H E. Bates's *In the Heart of the Country*, 1942, partly because Bates, who wrote *The Darling Buds of May*, was born a few miles away, and brought up at Kettering, and partly because the book was published by *Country Life*. It is one of those books about Englishness which were encouraged for their contribution to the war effort. This one is printed on surprisingly good paper, considering the shortages.

The English are not a very literal people. Phrases like 'Watering the horses' and 'It's a nice day' are often just jokes. The English always long for summer, and they know that some time or other it must and will come; but when it does come, they are, as in war, never prepared. They go about in an attitude of astonished and delighted discomfort at the sudden blazing of sun. To them summer-time is an impermanent and ephemeral thing. Earlier in the year, on a cold, raw, May evening bright with sun and golden slopes

of cowslips along the railway cuttings, I travelled with a Canadian airman. 'I can't get warm,' he said. 'You never have two days the same.' I said: 'Yes, but that makes us what we are. The most unprepared people in the world, and yet never surprised.' He looked at me and said, 'I beg your pardon?' and I could see that he had never thought that perhaps the English had been both hardened and softened, shaped and yet kept plastic, by their extraordinary climate that changes day by day or even hour by hour.

Summer is now so grey that we are in serious discussion – at least, lengthy discussion – with Constance, my mother-in-law, about a family holiday in Italy.

Tuesday July 18

It is a sunny day; yes, a sunny day! There is holiday in the air.

I have been looking for the new village at Mawsley, but it has not been built yet. Lunch is at the Red Lion, Broughton (pronounced to rhyme with sprout on) nearby. I have arranged to meet Ken Stanbury who thought I might like to hear what insights a delivery driver could provide into Northamptonshire. I look for a delivery lorry but instead, just as I pull into the car park, a shiny black Mazda sports car draws up, and out jumps a spry man, nattily dressed in a sports jacket, who hails me. It turns out that Ken has a job with the Kettering Chamber of Commerce during the day, and drives an oil tanker in the evenings. He has his own customers, hiring the tanker from the man with the tanker business that operates during the day. It works well, because the man likes to be able to call on Ken in emergencies. He has over a thousand customers on his list. He loves it. Getting out into the lanes, chatting with people: it is his way of loving the countryside. We sit in the garden of the pub – the weather is that good!

In Broughton there is a quite good development where the old

petrol station used to be. The new close in Geddington is awful. That also used to be a petrol station. They have built right up to the road, which will be a nightmare for the people in those houses; except they won't have the nightmare because they won't be able to sleep.

The new farmers' market in Kettering makes rather a sad sight when I get there. There are ostrich burgers, home-baking, duck eggs, blocks of beeswax. I buy honey, a chocolate fudge cake and a dozen eggs. The stallholders insist that it was much busier earlier, and since the cake stall, piled high this morning, now only has a few offerings left, I suppose it must have been.

I drive to Geddington, where I pass Charles Lockwood in white sports shirt and trousers; he has been judging the school sports day.

The steps of the cross are covered in hessian, and a young woman is inspecting them, as two men look on. They are repointing them. Someone had patched up the steps but with the wrong sort of mortar, so it is all being replaced with lime mortar.

Giles Godber's induction service starts at 7.30, but I have been instructed to come at seven o'clock which I do. I arrive carrying *The Seven Lamps of Architecture* as appropriately austere reading during the wait. In fact, I spend all that time chatting to Pam Dennis.

The sun is still shining, and the choir have to shield their eyes against it as they come out. Sitting on a throne is the Bishop of Peterborough, wearing a white mitre that looks like a chef's hat from McDonald's. The Rural Dean does a warm-up act. It is quite a good service, with people from every organisation – borough council, school governors, Volunteer Fire Brigade, etc. – welcoming the new man. During the sermon, a baby at the back has to be carried out because of hiccups. This is appropriate because the bishop is expanding on a point in St John's Gospel where Jesus likens himself to a vine. We end by singing 'Onward, Christian Soldiers', lustily, but to different words.

Pam goes off to the Star. I nearly join her, except someone else says I should be going to the village hall. On the way, I lament the state of farming with David Reynolds, and he says how rotten it is, though, of course, there's never an ill wind – he intends to double the acreage of his farm. The right moment for this will come in eighteen months' time, when the fat built up during the good years of farming will have worn away. 'Farming will have to come back in the end,' says David. The village hall is laid with a long table bearing sausage rolls, scotch eggs, mince pies, sandwiches, sticks of celery, chocolate cake and pork pies.

Tony Griffin is already prejudiced in favour of Giles Godber, because they went to the same school (at Bedford), Tony being a contemporary of his father. 'They are an old Bedfordshire family, you know,' he says, adding the seal of approval. If Mr Godber had gone to Borstal, I expect the congregation would still be relieved to get their new vicar.

'I thought you were only here at weekends,' the Revd Godber says to me as I leave. When he came for interview, my article on the cross had just appeared. Perhaps I am seen as a pastoral worry.

Friday July 21

The local paper reports that a farmer on the Rockingham Estate will have to abandon part of his farm, after arsonists torched his straw bales for the third time. He would have sold the straw to a power station.

The figures published in the Geddington newsletter suggest that the crime wave is not exactly tidal; nor is the village crime free.

Burglary – dwelling	6
Burglary – other	12
Theft of motor vehicle	9
Theft from motor vehicle	9
Theft of pedal cycles	0
Other stealing	9

Violence	1
Arson	1
Criminal damage	10
Other, i.e. drugs	5

Six house burglaries and nine thefts: the fact is that people living in villages these days have many more material possessions to steal than they would have done 50 years ago. Everyone is insured so even small crimes are reported. Still, even a small trend is a trend, and people are right to worry about it. As towns continue to put up CCTV cameras and other fortifications, country areas provide easy pickings. People did not use to feel the need to lock their cars or even houses; now they do.

Saturday July 22

We arrived last night. William had been sick in the car and Johnny could only be strapped into his car seat using the sort of measures seen in *The Madness of King George*, and Naomi is pregnant. In fact, it was a thoroughly jolly journey, and the unpacking of the car just about rounded it off.

We did so as though on a stage, acutely conscious – at least, I was – of the audience on the steps of the cross. As dramas go, the entertainment value was probably slight. But it was enough to make me feel that my white trousers, topped off with the T-shirt decorated with Benvenuto Cellini's 'Perseus' suddenly didn't seem that appropriate. Out came bicycles, Globetrotter briefcase, organic vegetables, computer and other things, requiring many public trips to and fro.

This morning, I strongly suspect, but don't say, that in every other part of the country it is a glorious sunny day. At Geddington, the morning dawns as cold as November in Cromer. They tell me this weather comes from the Wash; when the wind is in the east, the mist blows in. It is not just fresh, but penetratingly cold. I light a Cambridge log fire after lunch.

Then we pile off to Broughton to a fair. Although it is only

four o'clock and the event is meant to last until six, everyone is packing up because it is so dispiritingly cold. So we go on to Newton to pick some fruit: strawberries, raspberries, blackcurrants, redcurrants – summer pudding ingredients. The strawberries are the best ever. There is a shop selling carrots, tomatoes, home-made jam (home-made in Devon), cream and horrible little Pokemon lollipops which I am forced to buy for the boys, before realising they are 99p each.

We go back to our 'country' as Johnny calls the cottage (not distinguishing between the interchangeable phrases 'going to the country' and 'going to the cottage').

Thursday July 27

The papers say that five cases of new variant Creutzfeldt-Jakob disease, or CJD, the degenerative human brain disease associated with BSE, have been found at Queniborough, in Leicestershire. I have been to Queniborough. It is a real John Bull hunting village, with pubs called the Britannia and Horse and Groom, which once upon a time thought it would become Leicester, and grew industrial parks and modern housing estates. It is not very far from Geddington, and not much different either.

As yet, we know about as much about BSE as the doctors of Henry VIII's time did about the plague. I followed BSE closely when the enormity of what had been perpetrated on our beef and dairy industries was first realised. I was sceptical of the scare stories at the time: 'Worse than Aids', was the headline of one tabloid newspaper. These days I have to rub my scepticism harder to keep it bright. There is growing evidence to suggest that the eighty or so cases that have so far been identified could grow into hundreds, thousands, tens of thousands. A cluster could be caused by some local factor that would give an insight into the disease, or it could simply have occurred by chance, in which case the epidemic would be very large indeed.

I cling to the thought that some of the things that we first thought about BSE – that it jumped the species barrier from

sheep into cattle, for example – have not proved to be right. Cattle probably caught BSE from eating the remains of other cattle. Initially the brains of one cow with a rogue encephalopathy were put into cattle feed, then the cows that this animal infected were fed to others, and so on in a sickening geometrical progression, until hundreds of thousands of cattle had to be slaughtered. We buy meat only from butchers like F. E. Cole and Son at Twywell, whose suppliers have never suffered a case of BSE. Trevor Harker has never suffered a case of BSE, and, if I had the chance, I would only drink milk from his farm. But the trend is against Trevor's style of farming; despite all the food scares, nothing is done to stop farms getting bigger and bigger, and more and more specialised, increasingly remote from the common inherited experience of generations. While we buy our meat from Cole and Son, most people take it from the supermarket shelf, and it is the supermarkets for whom the whole agricultural system is organised. There will be another disaster, I know it.*

Friday July 28

We have decided to go on a family holiday to Apulia. I regret that this time will not be spent in Geddington. Already there have been discussions over whether to hire a people carrier or not, when I don't want to have a car at all, but take taxis. Imagine a people carrier, with eight back-seat drivers.

I go to the Game Fair at Blenheim. I hurry to the president's marquee, but it is miles from the car park. The Agriculture Minister Nick Brown oozes past. He has just delivered a speech that was billed as declaring that the countryside could get along without field sports – which would have been an odd thing to say in the context of an event entirely dedicated to them. In the end, he confined his remarks to agriculture.

The *Field* party takes place at six o'clock on the terrace in

* There was. Foot and mouth disease returned to Britain after an absence of more than thirty years in February 2001.

front of the orangery. It has been a mixed day for weather, but now the evening pours a golden light on the yew topiary and the flamboyant geometry of the parterres. This is apparently the garden that the duke likes to keep for himself. I am told that he was so cross with the printing of the photograph taken for the game fair programme, which made his suit look stroboscopic, that he insisted every single page on which it appeared was cut out of 80,000 programmes.

An offal-coloured sky now hangs over Geddington. They have erected scaffolding for the Queen Mother's arch over the bridge.

Happy Birthday, Ma'am

Saturday July 29

'I hope you aren't doing anything at nine thirty. We're meeting on the bridge to put up the arch,' says John Hughes, when I go out to move my car this morning. Graham at the Tea Shop needs the space for a skip. I joke that the scaffolding looks ready for a lynching, and I wonder who the victim will be. As though I don't know.

As we wait in the bright sunlight, Geddington seems to be transported to southern Spain, with us preparing for a fiesta. Less romantically, the venture has been given the Volunteer Fire Brigade name of PRATT – Project for Royal Arch Technical Team.

After a certain amount of hanging about, team leader, or chief PRATT, David – a systems engineer – comes with a length of chicken wire wrapped around plastic tubing. Then a truckload of fir branches arrives, and we set about poking them through the chicken wire. The branches are secured with electrical tape. The arch is still a bit wobbly when we flip it over to do the other side, but we go on attaching furry, itchy fir limbs. 'If you close your eyes, could be anywhere, where you're putting your hands,' says John Doran. We are joined by a reporter in a black suit from the *Kettering Evening Telegraph* and a crew from Anglia Television. We haul the arch on to the back of a truck, to move it into position, and retire to Charles Lockwood's garden for a cup of tea. Created from what used to be a paddock, it is a big garden going down to the brook. His house has been made from the barns that used to be the butcher's abattoir. We have an

234

Old Rectory, an Old Quaker Meeting House, an Old School House, an Old Forge and an Old Smith's Yard in Geddington, but for some reason Phyllis, his wife, balked at calling it the Old Abattoir.

We study photographs of previous arches, in various places around Geddington, for Queen Victoria's Diamond Jubilee, the Coronation of George V, etc., each with a row of heavily buttoned, tweed-encased villagers in bowler hats, glaring suspiciously at the camera.

Using rope, the chicken wire and fir branches are pulled up into place. After further tugging it begins to look more like an arch and less like a green sag. 'Seems a bit Gothic,' I say to the flower maidens – Esther, who has an artificial flower business in Nottingham, and Margaret from the church – as we watch progress. Eventually it is tied up with wire. It looks a very credible arch, though with too much of the scaffolding showing.

I go up a ladder to put up signs reading 1900, Birthday, Happy, leaving 2000 for a builder called Jezz. It is a little scary at first, since the boards are at the edge and it involves leaning out over the brook. But it gets better after lunch, which we have sitting outside the Star.

'I'm not sticking flowers in,' says Jezz. 'That's for the women. We're only meant to be putting the structure up.' There is no political correctness in the Volunteer Fire Brigade. The men do the heavy work, the women titivate.

Gordon, the clerk of works, and his wife Jackie join us. 'What did you do to cause that tirade last night?' asks Jackie. 'What tirade?' I say. 'Didn't you hear it?' she asks incredulously. 'Right outside your cottage.' Four people, one girl and three men, got out of a taxi, and started hurling foul-mouthed drunken abuse at me. I was there, of course, but I didn't hear a thing because of the thick walls and small windows.

By the time we get back to the bridge, the skies have darkened. A thunderstorm can be heard working its way around Geddington. I skip up to secure the portrait of the Queen Mother, which is not quite as easy as you might think. The air takes on that minatory, end-of-the-worldish quality, and we wonder whether it

is such a good idea to be on a ladder attached to a metal scaffold during a thunderstorm. Then the rain starts.

At lunchtime, I say I would like to borrow the ladder to put up some window boxes. 'It was a good idea of someone to use those old lavatory cisterns for window boxes,' says John. So 'the Norman' refers to the flushing system (presumably a more modern version is the Plantagenet). The fact that they are cisterns would account for the one round hole underneath.

Sunday July 30

We pick armfuls of rosebay willowherb and wild sorrel for the cottage. Naomi, brought up on Flower Fairy books and nature rambles, is very good on wildflowers. These ones grow luxuriantly in the verges around Boughton. To someone like me, victim of a Flower Fairyless childhood, they give the illusion of rampant biodiversity, but the illusion is precisely that, I fear. I have just read that Northamptonshire lost 93 wild plant species between 1930 and 1995, the worst record of any county. As the shy local beauties disappear, they are replaced by the commoner, more vigorous plants, which can do better on soils that have been artificially enriched with fertiliser. And so one part of Britain comes to look like any other.

Monday July 31

I see that the Queen Mother's image has been used as a target, with a number of hits with clods of earth. Leaving the cottage, I wave to Jezz the builder and Paul Hopkins outside the Star.

I buy a Johnny seat for my bicycle, and drive to Boughton with the bikes in the car. The playground is closed but we park under the trees and I begin the arduous process of attaching the seat. I have brought two spanners and a screwdriver, which appeared to be all one would need. I failed to appreciate that one also requires an assistant, complete tool kit and degree in physics. Eventually

the seat is attached, though the stirrups are impossible, since the rubber straps keep pulling away from the bolt. Perhaps I should have used a washer; it is too late now. We set sail – William and me on our respective bikes, Johnny in front of me on the seat – down the hill. William falls off at the bottom, probably because the brake of his bike is wrapped round the wrong side of the handlebars, I realise afterwards, but bravely he does not cry. We do a few turns around the corner of the house. William gets stuck on the cattle grid both ways.

If I were less frustrated over the seat, I would be able to notice that it is the sort of perfect summer afternoon that almost makes you cry: the right temperature, a sky creamy with cloud formations, indicating that the dream won't last, nobody about, big trees and sheep and bumpy pasture, next to a vast great creamy stone palace which is just sort of there. Just a dream, too insubstantial even to register.

When we come back from all this, I hail Jezz and Paul, still outside the Star. The boys immerse themselves in the traditional country occupation of watching *Toy Story*.

Friday August 4

We arrive in Geddington to see a ladder on the bridge, and at the top of the ladder Jim Harker is cleaning pondweed (as we now know it to be) off the Queen Mother's image. It is remarkable that the arch survives at all, given the temptation it represents.

Outside the Tea Shop, Graham is cutting bricks. Yesterday the concrete in his yard was taken up with a jackhammer, and now the yard will be relaid with a herringbone of old brick. The job has turned him into the Red Man of Geddington, absolutely covered, like everything else around him, with brick dust, as though from an atomic explosion.

I make tuna sandwiches, iron my GVFB polo shirt, put on black jeans and hurry outside for 7.30. The Queen Eleanor fire engine is there. Graham, showered, deposits the boys in the Tea Shop for the duration of the march. All the other firemen are

wearing proper trousers and black shoes. When I tuck in my polo shirt, my brown belt is revealed, and my brown suede moccasins feel luminescent. Peter Spence does not march; he says the Volunteer Fire Brigade has become too posey, all this dressing up.

The march is organised by John Doran, the policeman, who wears a fireman's cap for the purpose. In front comes Peter Rowney carrying the flag. He is in full uniform; badges showing the Eleanor Cross sewn to each shoulder, his chest bright with medals. He says he can't remember what they all commemorate, since the Fire Brigade create medals at the drop of a hat, but one is for active service (that means doing something useful in the village).

Peter is wearing the Singapore trousers. They came from John Hughes who was given them by Brigadier Percival, his commanding officer in the army, on the grounds that his own looked too tight. 'They belonged to my father,' he said. His father was General Percival who surrendered Singapore to the Japanese. So these were the trousers that lost a colony. 'They march by themselves,' jokes Peter.

Jim Harker wears a spectacular spray of sweetpeas. They have been grown specially by Peter Spence this year because they are called Queen Mother. I have to ask someone whether they are real or not. With their slightly lurid colour and more-than-life-size appearance, they look like one of Esther's silk creations.

As we cluster around the cross, Giles Godber, the new vicar, intones prayers. The theme is the 'Lord Is My Shepherd'. This was one of the hymns chosen by the Queen Mum for her wedding. It was regarded as outlandishly Scottish and never likely to catch on down south.

We line up three abreast. An old pump on wheels, a kind of mascot, is in the middle, but it is not easy to move because of the flat tyre. The march is more of a quick stroll. As we go over the bridge, the Queen Eleanor splashes through the brook, ringing its bell. We line up in front of her, and sing happy birthday to the Queen Mother, followed by three cheers. And that's it, except

photographs for the *Kettering Evening Telegraph*, wives and girl friends and interested villagers.

We then adjourn to a buffet of rolls and slices of pork pie – charge £2.

I fall asleep on the bed while reading to the boys.

Saturday August 5

The boys have got friendly with Jack next door. First thing, after having watched the usual cartoons, refused to eat proper breakfast and dropped biscuit bits all over the sofa, they go round there, just walking in. The brickwork to the yard is almost finished. There is a big-screen TV in their play room which is part of the attraction, and I must say it is surprising how good *Toy Story* looks on it.

Past our cottage comes a stream of people carrying produce – geraniums, sweetpeas, vegetables – to the Geddington show. I have come to realise that around here, and probably everywhere else in the English countryside, the problem is not to how to fill a weekend, but how to fit every event that takes place into the time. There is something happening in Geddington, or within a few minutes' drive, every weekend of the summer. These fairs, fêtes, festivals and shows are all different, and yet oddly the same. They are a new universal experience, formed from teas, bouncy castles, jazz bands, tombolas, ice-cream vans. Gone are the squire, the policeman, most of the farmers and generally the vicar – the old hierarchy who used to give substance to the community through constantly being there – and in their stead we have the 'fayre': an idea of community formed around leisure and the weekend. Perhaps they even express a new English self-image (for a part of England, that is): genial, egalitarian, consciously old-fashioned, anti-metropolitan and compassionate (they are in aid of charity).

The Geddington show is really about growing and making things, not bouncy castles, and it has been in existence for years. But even this has been decked out as a kind of fayre, with a cake

stall, raffle and a very good temperance wind band from Raunds in the car park outside the village hall. These elements satisfy what seems to be a deep craving in the soul of village England, and I love them like everyone else.

The boys buy Mini Milks from the ice-cream van: it must have been a bad summer for ice-cream men. Inside the village hall, the tables are neatly laid with runner beans (giant), onions, flower arrangements, jam, lovingly wrought Christmas stockings, artworks. We do not linger; the boys were given giant punchballs on elastic in consolation for a raffle they did not win and punching them threatens the displays. Paul Hopkins will be auctioning the produce at teatime; I shouldn't miss it, he says.

The afternoon becomes Mediterranean. We go to the playground at Boughton. As we are trying to leave the cottage, a woman accosts me. She was brought up in Geddington, she says, but moved to Kettering – 'best thing I ever did'. Geddington is nice, but not so nice as it was before she left, when people met each other in the shops and the council estate had not been built. Her husband's family owned the bakehouse at the top of Church Hill, and as a lad it was his job to dig the cinders left from the fire into the road. 'It was unadopted and they had to get rid of the ashes somehow.' Her father-in-law had lived in our cottage; he was there when the steam lorry demolished its front. Later he sold it for £300. 'I could tell you a lot of things about that cottage, but I shan't, because you'd only print them,' she says.

We return to the village hall halfway through Paul's auction. By now the judging has taken place. It was a serious business. The lady who judged the cakes arrived with a briefcase full of spatulas and other implements, and tasted every single entry for flavour, texture and colour. The tops of onions and garlic have to be tied up with string, and bent over, or you lose marks.

Paul is very good at the auction. People are sitting all round the room on chairs, while Paul is taking items from the tables in the centre. Bidding goes up by 10p a bid, unless some daring person leaps to £1. There are gasps when the Christmas stocking goes for £12.50. I don't think much goes below its true value. We leave with sweetpeas – indecently vibrant and large – chocolate

cakes with figures from the *Beano* on them, an assortment of vegetables (broad beans, tomatoes, two potatoes, a couple of carrots) and raspberry jam. Since we are on bicycles, and I am carrying William's shoes, wet from putting them in the ford, as well as the produce, it is difficult to balance, the more so since Johnny, on the Johnny seat, refuses to hold on to the handlebars. But we get home.

And I then go into supper mode while, if you can believe it, the boys watch *Toy Story*.

Sunday August 6

I go to church for my first service with Giles Godber. He sweeps in wearing an enormously long (because of his height) white surplice. All is relatively normal until the sermon which he gives in front of the altar, swooping from side to side like a great swan. It is the Feast of the Transfiguration, and he has taken the text 'This is my Son, whom I have chosen. Listen to Him.' He says: 'I'd just like you to break up into groups and chew that over; then we'll review what you've come up with.' So I have to turn to a lady in the pew behind, and a man in the pew behind her, and we come up with some ways in which we could listen to Jesus. And then he goes round the church as though it were a management workshop. 'There is one thing I am wanting to hear, and I'm disappointed I'm not hearing it . . . That's right, reading the Bible.' Of course, we all have to shake hands during the Peace, and at Communion he kneels in front of the altar to take it from Burt and the other ancient attending.

At the end, the procession leaves to the 'Battle Hymn of the Republic'. The hymn books of the choir are swinging.

At lunchtime, I see Paul Hopkins and Jezz outside the Star. They are brothers. I didn't realise – they don't look very similar. Yesterday I showed them a photo of the James Lawson Stewart painting of Geddington, and they suggested that Jim Harker might be interested. Now they say he has rejected it. The cottage next to Jackie and Gordon in West Street is shown as brick. 'I've

known it all my life, and it's never been brick,' says Jim. It seems that Stewart made a mistake. Presumably he sketched Geddington and painted the picture from notes, at home, misremembering the stone cottage as brick. I shouldn't think it was artistic licence – he wasn't the type. Whatever the case, it didn't impress the Hopkinses. 'Nobody in Geddington would buy it,' says Paul. 'It might be worth something, but not £2,650.'

Looking carefully at the cottage causes them to observe other houses. There is a brick band at the top of a house on the other side of Jackie and Gordon's. That is because the roof used to be thatch. I suppose all the houses were thatched. Thatched roofs have a steep pitch because the water has got to run off them quickly. The Tea Shop used to be thatched. Paul and Jezz remember hauling old thatch off the Tea Shop; it had been covered with tin, as was the custom, and had got fairly disgusting. So they were covered in sooty dust when they were finished. They burnt the old thatch in the field. They tell a story of how Jezz lifted up the floorboards in Paul's mother-in-law's house, to find not a mouse but a starling. It gave him a terrible fright when it flew out.

Last night Naomi heard scufflings overhead and thought they were rats. 'Not rats,' says Jezz, 'they make a different noise.' Besides, our thatch was put up during Peter's time at the Star so it must be quite new. We have to be careful about the wire mesh over it. When it rusts, that is when birds get in.

We go to Kelmarsh, and by now the sun has come out. I fall asleep on a bench for longer than I would have thought possible. We have an awful drive to London. William is insistent on having another drink bought for him, but we have already stopped many times and by now we are in Hendon and I refuse to stop again. After several attempts to make me change my mind, he says suddenly: 'Very well then. You have my pity.'

Thursday August 10

The burnt-out car on the A43 at Boughton is still there, now with one of the front headlamps kicked in and glass and bits of bumper

over the road. I phoned the council to ask when the car would be removed, but the woman in environmental services merely asked for its registration number which I didn't have.

In June, Graham's car was stolen from outside the Tea Shop. It only cost £470 and was a runabout just to take him to Kettering station. The damage done by the thief cost £350 to put right. The police found someone to charge but he didn't turn up at court. According to the local paper, the number of abandoned cars in Northamptonshire has doubled in the past couple of years, to nearly 2,000.

Friday August 11

I drive to Naseby. On the way, I notice, or think I do, something added to the scene, or taken away, and on the way back I confirm that the abandoned car has gone, leaving only a scattering of headlamp shards on the road. They have also emptied the wastebin outside the cottage, perhaps following Graham's complaints yesterday. (Peter Spence had said that he overheard the dustbin men complaining that it was too heavy to move, being full of Stella Artois bottles. 'They were using some real old Northamptonshire, too. It did you good to hear it.')

The ride over to Cottesbrooke starts sunny and becomes overcast, still and airless. The willows by the river do not move. On the way back we encounter first, on the other side of the hedge, a flailing machine making a terrifying amount of noise, then an enormous plough being backed towards the road by a tractor. A couple of military aircraft scream overhead. However, there is nothing so bad as the steam traction engine.

Leanne has gone from the yard, sadly. No career in horses for her; all that work wasted.

Sue Muirhead comments on how difficult mobile phones make life. Girls come but instead of having to ask to use the house phone, or beetling off to the village – thereby giving warning of trouble by excessive use of the phone – they are now on the phone to home every evening. So they don't bond with the

Naseby team; they are physically there but they never really leave home.

Today, the *Kettering Evening Telegraph* reports the trial of the men who crashed the car into Court Farm. They are heroin addicts, and the proceeds of a burglary were found in the boot of the car. Twenty-one-year-old Gavin Appleyard admitted dangerous driving, having no insurance, handling goods stolen in a £12,000 burglary at Lowick, failing to surrender to custody and giving a wrong name. He was also given nine months in prison and a two-and-a-half-year driving ban. His 19-year-old friend, Peter Owen, got ten months' detention.

Saturday August 12

I drive to Northfield Farm, near Oakham, to buy some of Jan McCourt's delicious Dexter beef. On the way, I reflect on what an extraordinary slice through the heart of England this journey provides. Corby, then Rockingham – and rural England lies before you, tipsy with sunshine, her hedgerows all awry, blond stubblefields, with a crushed velvet sheen, pulled around her like a shawl. The villages are a world of shopping baskets and hunting prints and teacakes. Northfield Farm is as scruffy as ever, with children and toys tumbling around the yard. The little black Dexter cattle dot the fields like currants. I buy two chickens and some rump steak.

Thursday August 17

Our art editor Michael Lyons is enthusiastic about featuring the Northampton balloon festival on next week's news pages. One of our photographers lives in Northampton.

Friday August 18

Out riding, I wear bombachas for the first time, having left my jodhpurs at Geddington. I have come from Cheltenham without stopping at the cottage. The bombachas are a souvenir of Buenos Aires, where I went for the Earth Summit on climate change. Above my riding boots they bulge out in Cossack fashion. I have also left any shred of waterproofing behind. So I pull the pink shirt I wore at dinner last night over my polo shirt, and top off the ensemble with a yellow fluorescent tabard saying Young Horses Please Pass. My companion is Ruth, her slightly bronzed cheeks radiating health, who spends the whole of the next hour not telling me that she has handed in her notice.

Conditions vary from precipitation to driving rain, and I am soaked by the time we get back. The skies darken, and far from being midsummer it feels like the end of the world. England is sagging under the wet. The stubblefields turn orange with it.

Sue is astounded by the number of girls who say that the next step in their lives will be to have a baby. 'I'm 19 now,' says one, 'I don't want to leave it too late. I'd like to have one next year.' But does she think she will still be with David (who beat her up) next year? 'By next year it might be someone else, mightn't it?' she says. The relationship is immaterial to having the baby.

The balloon festival is not quite so jolly a spectacle for Sue as for our photographer. 'I hope the balloons don't come over this way,' she says firmly. 'When they switch on the burners, it terrifies my youngsters.'

I drive to Geddington. They are still building the strange stone walls, not parallel with the road, at the entrance to the village. These are the 'gateway features' that are meant to signal the beginning of habitation, but just look like stretches of wall that have been built at great expense in the wrong place.

In the garden, two tomatoes have turned red; well, reddish. I consume one of them. I could not say that the explosion of flavour turned my gastronomic world on its head but it

was undoubtedly a tomato. The best thing about home-grown tomatoes is the smell. Perhaps the aroma, like coffee, promises more than it could ever give.

At the Dump, I buy seven Crown Windsor white-and-gold side plates to put bait on, for 50p. Let's try a memory game to see which of the cornucopia of objects for sale I can recall: tricycles, a Raoul Dufy print, a Thomas the Tank Engine toy, an unopened box of chocolates, a set of liqueur glass with little paintings of Old English towns on them, three yellow plastic boards showing Disney silhouettes, a very large tape collection, even bigger than the one I bought from Grafton fête (not one of which I have yet played), the usual sad ornaments that must once have decorated a mantelpiece, having been chosen for their aesthetic or sentimental value, but which now look like worthless tat. Sad, and yet the Dump is always full of hope, hope of new life. In Geddington, I have still not put up the window boxes.

So I do it. I borrow a ladder from Brenda's coal hole at Court Farm – the sort of ladder with rotting steps that is designed to start a law suit when the borrower crashes to the floor under the weight of a former lavatory cistern – and put up one window box. I water the other one. The window boxes are too tasteful. Isotomia, or some such, and rock roses have already shrivelled to nothing. What we need is the petunia and geranium style of the hanging baskets that Brenda has put up. The doorway of Court Farm has three of them; the big courtyard door is thrown back and there are rows of pots around the gravel drive. The pots and hanging baskets came from Brenda and Roger's old house, and Brenda takes them seriously, starting them off in greenhouse. They are all colours and cheerful, confident, a merry wave at whoever happens to be passing. They are not like the oh-so-tasteful blue simper of my Isotomias, or the dying gasp of rock roses.

I have never been into this garden before. I have never known this door to be open. It is another world. There is a flower garden, going back from the house, the borders full of nothing but golden rod. And then there is an orchard all the way to the river. There

is a new view of our cottage, you see the part of the roof with the inferior tiles. The roofs of the farmhouse barns have pantiles. The cottage is squeezed in by the Tea Shop, being, as it were, a bite of out the tea cake.

There is nobody in the bar of the Star when I go in, but round the corner John and Bet Hughes are having dinner with Johannes. Johannes is carnival prince of Lahnstein, where the Volunteer Fire Brigade has just been. He is a fireman – a real volunteer fireman, so to speak. In Germany, most firemen are voluntary, so he fights genuine fires, on average twice a week. It is a great but costly honour to be carnival prince, since you have to pay for your outfit, photographs of everyone, glad-handing and other things, which come to thousands of pounds a year. He is here to witness the Kettering carnival which I'm afraid will be a disappointment. Lahnstein is in the Catholic part of Germany where Mardi Gras means something. Kettering carnival, tomorrow, is modest by comparison. Claudine, Roger and Brenda's daughter, is in the Air Cadets, and they are mounting a display of Red Arrows on Sainsbury's trolleys.

Saturday August 19

I get up at six. I still have to put on the lights because of the rain outside. I have last minute things to do like writing a cheque to Express Dairies, putting circulars to Mr Leo in the post marked Gone Away, bleaching washing-up cloths, cleaning up the last of the flying ants who have expired against the windows. It is as though I am going on a voyage to the Other World, not Apulia. Rain is pouring off the thatch eaves, as though from Humphrey Bogart's felt hat. I cut back a shoot of rose which for some weeks has been hitting me in the eye every time I go out of the gate. I lock up and leave. I suppose it will all be there in a fortnight, but by then it will be September. So this is goodbye to the summer that never was.

Royalty in Grafton Regis

Monday September 4

I returned home from Italy last night. The driver from Gatwick, Mr Lorimer, was apocalyptic in his descriptions of the English weather since we have been away. 'They've had two foot of ice in Hull. There have been hailstones, Madam, as though it was the middle of winter. Some people have had floods. We've had every type of season, Madam. When it rained, the car became like a sandpit from the amount of sand blown up from the south coast.' This evening in Geddington the sun shines with infuriating ripeness on my tomatoes – as red as guardsmen, some of them – and the last of the white roses. Bees crawl over the rose-tinged sedum flowers. The basil plants remain stunted through lack of water. We might as well have stayed here after all. Except that the contrast provided by the holiday heightened the quieter pleasures of Geddington. Apulia was not just free of hailstones, but so hot that people were dying in the province of Lecce, not far from us.

There was a festa in Ostuni. The little street up to the main square was so packed with people that we could only inch the buggy up, half a step at a time. In the morning, the brass band in the temporary bandstand had played selections from Puccini as though for a funeral. In the evening with the arcades of lights around the square twinkling and the bandstand itself glittering like a vision from the Arabian Nights, they upped the tempo and the volume. By the time we gravitated back down the hill, it was midnight, and time for fireworks. The walk above the car park happened to be the natural place to view them from,

so we stopped there. How could a little town, in a poor area of Europe, afford them? The first detonation rocked the town and set off the alarm of the car next to which we were standing. Then the sky seemed about to entrap us in successive nets of red, blue and green streaks, each appearing from the darkness out of a white dot. Going home, the boys, now wide awake, sang songs as we waited for an hour or so in the traffic jam of cars leaving the town.

What else happened on holiday? William learnt to swim, almost. On the last day, he said he had had a dream of the pool being full of sea creatures, only they were soft and 'cuddling', and it somehow took place while we were having lunch at Geddington.

This morning, Charles Fitzroy phoned to make sure I had received an invitation, sent while we were away, to a tree planting ceremony at Grafton Regis. Grafton Regis has had a Lottery grant to compile a village history. This is now finished. The village hall, formerly the school, has been enlivened with murals on Grafton Regis's past painted by an artist from nearby Milton Keynes. The tree planting celebrates both achievements, and makes one of its own, by replacing the Queen's Oak which is now a shell occasionally set alight by the local youth. The tree will be planted shortly before lunch by Prince Charles, who is able to fit in the engagement between opening a psychiatric wing at St Andrew's Hospital, Northampton, and touring new visitor facilities at Brixworth country park. I say I will go.

If you were to drive through Grafton Regis on the A508 nothing much would strike you other than the curious name. There are not that many places called Something Regis, with the notable exception of Bognor. If you tried to notice anything it would probably be a mistake, as you would run the risk of being flattened by one of the lorries thundering between Northampton and Milton Keynes. But the village that lies off this road is full of thatched cottages and history. The Queen's Oak is supposed to be the place where Edward IV – young, tall, athletic, a man

who lusted after life in every way – met Elizabeth, daughter of the upwardly mobile Woodville family who owned the manor. She must have been exceptionally lovely, because he forwent any more prestigious or diplomatically useful union by marrying her. In due course she became the mother of the two little princes in the Tower murdered by Richard III, and a daughter Elizabeth who helped end the divisions caused by the Wars of the Roses by marrying Henry VII. Otherwise her role in history, as a singularly greedy and frivolous consort, is best forgotten. I happen to know about her, having written a book on Greenwich. I described her as a local girl, since the Woodvilles owned the nearby manor of Lee (convenient for Greenwich Palace). In Grafton Regis, however, she is a Grafton Regis girl. The story goes that Edward met her while hunting.

Later, Henry VIII built an enormous palace at Grafton, and bestowed the suffix of Regis. The building was entirely destroyed, except for the chantry, during the Civil War. There is not so much as a drawing to show what it looked like. For some inexplicable reason, though, Charles II seems to have retained an affection for it, taking the name for the dukedom he bestowed on his illegitimate child by Barbara Villiers. Charles Fitzroy, as a son of the 11th Duke of Grafton, is Charles II's descendant; and since it is no longer possible to obtain an acorn from the Queen's Oak itself, the sapling being planted today has been grown from a clone of the Boscobel Oak, the tree in which Charles II hid to avoid being captured after the Battle of Worcester.

I drive into the car park, which is being marshalled by men in yellow tabards advertising Barclaycard (it has offices in Northampton). I walk back across the dangerous road and over a field to the Hermitage. The Hermitage is now a lot of bumps in the field, having disappeared centuries ago. It has been cordoned off with Union Jack bunting supported on hazel sticks – more green and therefore prince-friendly than the metal equivalent. Inside the cordon three rows of plastic seats await the bottoms of village worthies. One of the bumps has been labelled, ambitiously, PRESS, in white. Around the outside of the enclosure is a surprisingly large crowd with Panama hats,

cameras and Sunday best. We are only a hundred yards from the road, and the scene could not be more rural: stubblefields, a scattering of trees, an ugly chicken barn, in the distance a little field with hay piled into the rum babas that you see in southern Europe. A gentleman wearing ruffles and knee breeches arrives. Next to me, a man who has been to Mount McKinley, Alaska, according to his T-shirt, has a video camera on a tripod.

Then four police outriders can be seen and the traffic on the road stops. Prince Charles steps out of a Bentley flying the royal standard from its bumper. A little cavalcade advances over the field and there is an outbreak of polite hand-clapping. A man in a blazer makes a speech, remembering the shortage of good ale that detracted from a visit of Elizabeth I. The prince, now standing beside the little tree, takes a gleamingly new spade, deposits an ounce or two from the pile of beautifully sieved earth beside the planting hole, and waves the spade in the air. He then works his way around the crowd, asking people whether they live in the village and other such penetrating questions, winning people to him with the face that he pulls – a sort of laugh with no sound coming out. As soon as he moves on, each little group, which has been standing to attention, ears pricked, while the royal gaze is upon them, subsides like a deflated balloon; and despite the undertakers' black suits worn by the men, the iridescent purple favoured by the ladies, and the outsize school uniforms of the children, people become themselves again, laughing about what he has just said, and what they should have said (but didn't) in reply.

Prince Charles goes on to inspect the Hermitage. The chief constable eyes the six or eight photographers who form the local rat pack from beneath a spume of silver braid on his peaked hat. The prince is already on his way out again, ignoring the lady in pearls who is frantically waving a flag, to talk, with royal capriciousness, to a man who looks a bit like a tramp.

Afterwards we repair to the marquee that has been erected beside the village hall for a lunch of sandwiches and wine. To the music from *2001, A Space Odyssey*, someone introduces the village hall committee and the Millennium project team, and the

Duchess of Grafton (her husband having hurt his back) opens the improved village hall.

It is still sunny as I leave this fine village occasion, but I notice that the elder bushes are heavy with their black berries. It is autumn now.

At Geddington, I walk through a cobweb across the door. How is it that there are so many dead flying ants on the kitchen floor? Despite the Maginot Line of sea salt across the threshold to the dining room, a Blitzkreig of slugs seems to have stormed all over the carpet. Surprisingly large weeds have grown up in the garden path during my fortnight of absence, and the few remaining leaves on the tomato plants have turned yellow and sear through lack of watering, which induces a sense of guilt – as though we had failed to feed the cat. But the tomatoes themselves hang like festive red lanterns in the Tivoli Gardens. I think I shall eat one now.

AUTUMN

The Great Petrol Famine

Thursday September 7

I phone Sue Muirhead about Saturday and find there is no hunting yet. The farmers are late getting the harvest in because of the miserable summer. Another wet day like today won't help.

Friday September 8

I go to Waddesdon. In the main avenue, they have had a problem with badgers digging up the lawn. Clearly the badgers were after something delicious, and since badgers cannot be killed because they are protected, the best thing seemed to be to eliminate the food they were scratching for. It turned out to be a grub – the grub of a particularly rare sort of cockchafer, only found in this part of England. 'No, no,' cried the bug people, 'it is far too precious to destroy.' So the keeper of the aviary now go round with bags of peanuts and raisins each night, scattering them for the badgers. For £500 or £600 a year, it solves the problem.

I smell woodsmoke as I arrive in Geddington. It is autumn, and the cottage is cold.

Geddington is incredible for slugs. A bloke in the Star says he has 300 on his lawn each day. They go up the walls and devour the hanging baskets. Badgers come around wanting to eat them, as well as nosing in the bin liners by the back door. It is the same with snails. Lisa Wilkinson says there is a plant next door

which she assumed to have a particular type of knobbly leaf, but it turned out to be entirely snails – a snail plant!

Gordon, the clerk of works, comes by, and tells me he will soon be off to the Olympic Games at Sydney. He used to be a runner; now he coaches at Corby. He will have a Corby banner which I must look out for on television. His speciality is hammer throwing, and he coached the girl in the papers whose hammer killed an official who didn't hear the warning to stand clear.

Saturday September 9

I clear away yet more flying ants. In the garden, I saw down the brier-rose which sprouts directly out of the garden wall and has grown to a height of ten feet without its roots so much as touching the earth. I only just win the life and death struggle with its vicious thorns.

In the afternoon, I go to Lyveden New Bield with Naomi and the boys. I went there a month ago, on a golden late afternoon, and sat on the side of the moat, basking in the warm sunlight that slanted on to the lawn, as I ate a Loseley ice cream. I left, thinking life in England can be wonderful.

There is a single-track road that leads from the dual carriageway to Lyveden. As soon as you are on it, you forget Kettering, forget the busy roads, because you have stumbled into a very rural world. But it is a different kind of rural world from the other side of the main road: a big sloping landscape, enormous silent fields, ancient woods that frown on the horizon. You park in a lay-by, and it is a longish walk up a dusty track to the house. Last time, a tractor passed towing a fearsome new plough with shiny blades. A bean field stretches to infinity, black and awaiting harvesting. This is part of the Duke of Gloucester's Barnwell Estate.

Along the track we gather blackberries. They are supposed not to have plumped out, through lack of rain. This is only partially true. But they do bear out the observation made in the pub last night that blackberries these days never come with grubs. Unlike I remember from childhood, when every third blackberry

would have a caterpillar curled at its base. They used to float up to the surface of the water when the fruit was washed. Today's blackberries are completely free of insects, a reflection, presumably, of modern farming methods.

We ascend one of the viewing mounds, and then race to get ice cream, but the little kiosk is shut. Fortunately Mark is loading logs behind his cottage, so he unlocks for us. And we are able eat our ice creams as we wander around this strange caprice of a building, smaller than you would think, erected on the plan of a cross. Sir Thomas Tresham, who built it, was one of those wonderful show-off Elizabethans, who made a dazzling display at court; and yet this house, as well as the Triangular Lodge at Rushton, which he built on the theme of the Trinity, suggests that he was also given to private, mystical conceits. Certainly he was brave enough to convert back to Roman Catholicism, the faith into which he had been christened. Equally it is interesting to read that the amount he spent on his building whims each year was actually quite small in relation to his income. His projects proceeded slowly, and Lyveden New Bield was not finished at the time of his death. Thereafter, the family went on the slide, the descent from greatness being precipitated by his grandson Francis, who died in the Tower after implication in the Gunpowder Plot.

While so many country houses were demolished over the last century, this one, despite having never been finished, survived. It is part of the weirdness of it. The carvings of the frieze, which show emblems of the Passion, are still as crisp as when they were made. Now this curious, lidless house has been complemented by some hard-edged geometrical sculptures that look equally bizarre. As we leave, ducks waddle through the black, desiccated bean field, beaks to the ground, raising a startling, unearthly crackle from the brittle plants as they go.

We reach Geddington a little late for Roger and Brenda's housewarming next door at Court Farm. Drinks are served in a marquee borrowed from the Scouts, and Roger, too focused for conversation, beavers away with red and white wine. I would love a garden like this. It is completely secret within the bosom of Geddington. Jam jars hang from the trees and I realise, just

as I am going, that they have night lights in them. It is now dusk. Along the drive lanterns have been made out of paperbags punched with holes. The effect is a home-made Japanese print.

To Naomi, candles in jam jars are not enough to dispel another sort of darkness, that caused by distance from the metropolitan light. Growing up, she focused all her energy on escaping provincial Northumberland, and here I am wanting to cast her back into the night, where people bump clumsily around as though in a power cut, knocking their shins on the furniture, unable to find the way out. She has never met anyone who given a free choice would prefer the night lights of Geddington to the bright lights of London – except, unfortunately, me.

Sunday September 10

I go to church where there is a baptism, and I must say Giles Godber is awfully good, explaining what everything means all the way through. Last week the congregation was issued with paper oyster shells on which to write a pearl of wisdom. These were collected by a girl with a shrimping net. They were pinned to a board, and some read out. The idea is that at harvest festival the oyster shells will be distributed to the congregation and everyone will take away a different pearl from the one they submitted.

On the way out, I ask Giles if he knows the fat Catholic priest from Wellingborough whom I met in Brindisi airport. He doesn't, which is a pity because the priest has increased his congregation from six to 750.

We have lunch outside. This is the first time we have eaten outside this year without it being either too cold or threatening to rain. A gorgeous English day; perhaps a little close when the sun is behind the clouds, an effect exaggerated by the absence of summer clothes because of holiday packing, but who would fuss about that?

Monday September 11

I drove the family to London last night but this morning I came back again. On the M1, I stopped at Newport Pagnell service station to fill the car but only half the pumps were working. The one I chose coughed itself dry before the car's tank was replete. This is the result of the blockade of oil refineries up north by hauliers and farmers; everyone is panic-buying like mad.

On Saturday I went around turning on the night storage heaters, but now it is a glorious day, and the cottage is insufferably hot.

Friday September 15

It is pouring with rain, and darkness covers the land. I am able to get away about midday, with just under half a tank of petrol. The blockaders have left the refineries, but I wonder how much fuel has got through. Not much has, to judge from my journey northwards. I pass a two-hour queue outside Lord's Cricket Ground, where a garage has been supplied. It is like Russia. My colleague Sue Corbett says that, at her local garage, the pump attendant was visited by an aunt, and seeing a car in the forecourt, so many other drivers queued up behind that the police had to be called to move them.

I reach Geddington in time for lunch at the Star. Jim Harker is there, and the chap in the blazer with grizzled hair in a ponytail, and a couple of other men. In other words, it is as gloomy as ever, but I am greeted as a regular which gives me a warm sense of belonging. I expect to hear tales of 'going without' (as Mole would have said), with people unable to reach the shops. For some reason, though, Northamptonshire seems to have escaped the shortages. This may be because everyone filled up when the panic buying happened, and a tank of petrol lasts quite some time if you don't drive long distances. 'It's like the weather,' says the chap in the blazer. 'We never get the worst of anything, or the

best of anything. No heatwaves, no snow. We're the middle of England.' That's true.

There are reminiscences about old maths teachers and the Americans who used to come to the Star during the war.

The chap says: 'When I came to the village in 1952, it was full of characters. And I'll tell you what, they were all pensioners. Characters! They would be in every pub, on the steps of the cross, always drinking and talking. Never did any harm. Where have they gone now? There are no characters around today. Or they are lined up behind the windows of a nursing home, looking out at the street.' He raises his arms and lets them subside again in despair, his ponytail quivering.

Saturday September 16

I get up at six to look for petrol. There is a van with flashing lights on the A14, which I take to be a hopeful sign, and it is indeed the end of the queue for the pumps. It takes about twenty minutes. The van and various other vehicles peel off when they reach the home-made poster saying No Diesel.

Shortly before ten, I arrive at Naseby village hall, rebuilt on the scale of a carpet factory and in much the same style. It is a Millennium project and has provided the villagers with a badminton court. The local MP Phil Sawford is holding a surgery, and word has gone out that hunt supporters should mass there. The conversation is petrol.

'I got by on half a tank, and then the garage at Spratton of all places had some, and I only had to queue behind four cars.'

'Northamptonshire never seemed to run out completely.'

'My parents could use the red diesel from the farm; perfectly legal when the journey's for animal welfare.'

'Terrible in the Lake District, and for the Welsh farmers.'

'It's been wonderfully quiet on the roads when I've been riding.'

Most people seem to think the discipline imposed by the short-ages, forcing drivers to use petrol more carefully, is liberating. An awful lot of journeys don't have to be made. People carriers are shared for school runs, rather than taking just one child. Life becomes a crossword in which a certain pleasure can be derived from confronting a pointless challenge.

David Bletsoe-Brown, in jacket and tie, is there, in his haulage capacity. He is proud that it was Bletsoe-Brown lorries which led a slow drive along the A14, and then to the BP depot at Northampton, which made the front page of the *Kettering Evening Telegraph*. A lot of people come after hunting, including all the masters. Placards are raised. We form a good-humoured, slightly braying mob, marshalled by Jan, of Farmers for Action. And so we wait for the moment the MP will appear and be photo-graphed marching through our demonstration, until, shortly before ten, someone wonders if he has not got inside already. He has. On the other side of the village hall is a field full of caravans, and he must have walked through it. We go inside, and track him to a big room upstairs, but since only one person is allowed to go into the surgery at a time, we go out again. A man laden with cameras takes a photograph for the Market Harborough paper, and we all chat in a 'what shall we do next' sort of way. Just as I am wondering how I can get the car out, given that another row of vehicles has parked behind it, Mr Sawford emerges.

He looks like a butcher or a plumber, a solid man with a big nose. He began life as a carpenter's apprentice, but has more recently been working for the council. I could imagine him with Praise-God Barebones and the other Roundheads, legislating against dancing on Christmas Day. I hate this Cromwellianism; but he is a polite Roundhead who answers questions without flap or acrimony, despite various hunt members having a go at him. He isn't going to change his mind. He is castigated for not visiting a hunt, but why bother? He has belonged to the League Against Cruel Sports for years, and nothing will budge him. He has a stab at defending fishing, which he does not want to see banned, but has to admit under fire that he personally finds fishing to be cruel. All the while, voices of different types –

the bullying tones of prosperity, the genteel whine of the well educated, the Northamptonshire boom of the foot followers – barrack from all sides. 'Country boy? Bollocks to that. Probably born in Nottingham.' 'Says he understands the country. Crap.' Wrinkled faces beneath caps chortle at the verbal pasting such pungent commentary is thought to be giving him. Meanwhile, Donough McGillycuddy, with old-school manners, waits in the background with hand raised until invited to speak, and then thanks the MP for coming. A bit flowery, but it shows we are not a rabble. At the end, Michael Bletsoe-Brown, a Master, thanks him too, and Sawford asks, jokingly, if we are going to be at the surgery he is holding at Cold Ashby this afternoon. We have made our point; he doesn't accept it. There are general reflections on the small chance of his getting in next time, given that his majority is only 180. Then we go home.*

Hunting people en masse do not always do themselves favours. While we go away from the surgery thinking we have struck a blow for freedom – even though our demonstration will not affect Mr Sawford's voting intentions one whit – I fear that the people of Naseby, those who do not hunt, will form a different impression of us. They will feel that our protest has robbed them of an opportunity to raise matters such as the post office and village housing with their MP.

Friday September 22

I arrive in Geddington, to observations from the cross of 'Pink jeans – tasty', 'Pink gin.' Perhaps I just have to accept that pink corduroys are not worn in Northamptonshire.

* He did get back in on 7 June, 2001, with a majority of 665.

Saturday September 23

I wake up in the night, worried that I am oversleeping. I look at my watch and it says two o'clock, then three o'clock, four o'clock, five o'clock. Eventually it is 5.30 a.m., and I get up at that strange time when the world feels unreal. I go out to find the car damp from a rain I did not know had fallen. Over Boughton, threads of pinkish clouds are as fragile as frayed silk.

This is my first day's hunting of the season. The opening meet is still a month away, and we are still in the overture to the season proper, which used to be known as cubbing. My very first day's hunting was spent cubbing in Dorset. I was on a horse called Venus, and there could be no more happy augury than that. In those days it was still acceptable to beat any foxes you might see back towards hounds by banging your whip against your boot and making shrill, foxy noises – 'aye-aye-aye' and 'brrrr . . . rrrrp'. Nowadays foxy noises have been banned, and cubbing has been renamed autumn hunting, in an effort to soften its image. This is pointless really. Cubbing is when the most hunted foxes are killed, and foxes do have to be killed by one means or another. Unfortunately, no means of killing animals is very kind to them. Hunting has the merit that the death, when it comes, is very quick. All the alternatives to hunting allow the possibility of the animal dying in a long drawn-out agony, which would be more cruel. Furthermore, hunting is the only means of control which ensures that the weak and old foxes are killed, while the healthy and strong ones get away. Healthy foxes are not such a problem to farmers because they can live by hunting other animals, such as rabbits. It is when they get too slow to catch anything that they become cunning and attack hen coops. So the strongest foxes survive and they are the best ones to breed from.

People who follow the hunt during cubbing are not meant to be there for the sport, but to help the huntsman. For most of the time, though, you cannot see him, or hounds, because they are as likely as not in a wood. So all you can do is to stand around and

chat to people whom, in my case, you haven't seen since April. The joy is to be out on a horse, seeing the natural world at a time when you would normally be in bed.

It is still dark when we scramble into the horse lorry and drive off, past the Battle of Naseby monument, to the meet at Sulby. Storm snorts and whinnies as I get on, and sets off at a trot which is unlike anything I have managed to achieve on my hacks around Cottesbrooke. He knows he is hunting.

Sulby Hedge or Hedges are one of the landscape features mentioned in accounts of the Battle of Naseby. They were used by Colonel John Okey, who later signed King Charles's death warrant, to hide his company of dragoons from the Royalist cavalry. We pass plenty of hedges in the course of the day but none which would have existed in Okey's day, nor any that would have been much good at hiding dragoons – these days, they are too gappy for that. I imagined Sulby Hedge to have been a medieval boundary hedge, immense and perhaps double thickness, with a lane in between. Sue pictures Sulby Hedges as gorse bushes. Either way, there seems to be no sign of them now.

I encounter some other folk as I turn on to the little track that should lead to the meet. But the meet isn't where we imagine it to be, and we strain eyes and ears for a clue as to where the hunt has got to. 'Those sheep are lining up to look through that hedge.' 'Look in the distance, those cows are running away from something.' The dogs that we hear barking (unless they are hounds, in which case they are giving tongue) could belong to a farm. 'Or are they drawing the lily pond. In which case, they'll be coming to this covert next . . .' Eventually, we see, outlined against a hedge, the silhouette of horses in the early sunshine, looking as though they had been snipped out of paper by a contemporary of Jane Austen.

'Isn't it wonderful to be out now. I wouldn't want to be a slug in bed for anything.' And whoever said that was right. It is glorious to be watching the bullocks, spotting a fox who runs away from the wood, or a muntjak (which for a disgraceful moment I think is a hound) hurtling away like a clockwork mouse, or a hare with

his ears laid back. It is even better when we meet up with Dick Payne, the hunt secretary, and a couple of others, which means we have caught up with the hunt.

For an hour we stand about near a covert. The great worry is that hounds will go too far towards one end of it, since a third was recently sold to a newcomer who is anti. This man also owns a couple of paddocks. 'I can't see the point of moving to the country and then objecting to everything that goes on in it,' says Dick.

We hear eager cries from the hounds, punctuated at frequent intervals by the one blast on the hunting horn that is supposed to announce a kill. There hasn't been a kill. The horn is blown by some antis, a couple of whom eventually emerge from the covert. One seems to be a reasonably normal, blonde-haired modern woman, but the other is a medieval figure wearing a jerkin, his head wrapped in a black hood of the kind Piers Plowman would have known. Together they sneak furtively around a parked Land Rover and then drop down into a hedge, or rather the ditch beneath it, to hide. It is a sort of Okey manoeuvre. I like to imagine there might be a whole platoon of them down there, ready to surprise us. However, they never spring out, firing insults; in fact we do not see them again.

There are some more riders on the other side of the stubblefield, and when we eventually move off, I am astonished at the number who are out. There must be 120. I don't know where they all come from. The sound of the stubble crunching under the horses' hooves – well, it doesn't become deafening, but it makes quite a loud rustle. The riders advance on a broad front, everyone trying not to get ahead of the Master. Was it a tiny bit like this for Prince Rupert's troops?

We find ourselves in a wasteland of ploughed fields. By now, we are all regretting the waistcoats we have put on. It is becoming warm, too warm for scent. I peel off, with half a dozen others, and head towards Naseby. However, the directions I have been given are more optimistic than accurate. When I ask a local, on crutches, I find that I have been going the wrong way. 'You know the New Covert? You can go round the back of it, along a bridleway, head

south over the fields – I don't know if they have gates, though – and you'll reach the Welford road.' I ask if it would be quicker to go by the roads: 'Depends how much time you've got,' he says with some scorn. So I follow the first route, and there is nothing lonelier than trying to hack home after hunting, when you are tired, uncertain as to whether you will find a way out of the enormous field you are skirting, and you are lost.

Storm is patient as I leap down to untie gates, haul up gates that have fallen off their hinges or unhook the tightly drawn tapes that are the new sort of electric fence. He is still patient as I haul myself back up again. But my own heart fills with despair. Will I ever see my family again? I have forgotten the mobile. I am man against farm land. Eventually, since I hear the road, I can navigate by ear, and never have I been more pleased to see a skinny car than the one I glimpse sprinting along behind a hedge. Then I meet a farmer who can tell me which direction along the road to go. 'I thought you had come to buy some hay,' he says hopefully. 'Another time perhaps?' There is disappointment in his voice.

I only go a few yards down the road, when there, rendered incorporeal by mist and sunshine, is the spire of Naseby church, a skinny finger pointing towards God. It is still a long hack, but eventually we come to the A14. I find myself singing, as I encourage Storm over the raging dual carriageway below.

At the station, I race over the new footbridge – to discover that the train is late. Technically, it is not the train at all, but the one before, and that is so late that it isn't even on time for the one I am meant to be meeting. The footbridge has not yet got its lift, so everything – boys, pushchair, luggage – has to be carried up the steps, with the danger that the boys will run off while I am collecting the next item.

Later, we go to Kirby Hall, the ghostly ruined shell of an Elizabethan prodigy house. It is a golden afternoon, though windy enough for some giant kites to be flying from the lawn. I lie on the mount, while the boys tumble down banks.

Our treat is to eat at the Star. We arrive shortly after seven

o'clock to find that the dining room is booked out. They have put in subdued lighting and candles. Our table is at the back of the bar, where it usually is, which pleases the boys. The food is about the same as when Mike cooked it, but 50 per cent more expensive.

I carry Johnny back from the pub. He is too busy counting the stars to notice the 'fancy a spliff' comments that hover around us like moths.

Friday September 29

Earlier this week, at the Labour Party Conference in Brighton, the Deputy Prime Minister John Prescott taunted the pro-fox hunting protesters with a jibe about 'the contorted faces of the Countryside Alliance' (it got the biggest cheer of the week). To which all I can say is, I wouldn't want to photograph Mr Prescott in a jacuzzi and publish the results in my magazine.

Saturday September 30

Last night I did not reach Geddington until 12.30. I looked for my whip, going back to the wardrobe about six times even though I had conclusively proved, by removing everything from it, that, as a matter of science, it wasn't there. I get up at 5.30 a.m. today, but the morning dawns whipless. At Naseby, I find the whip in Sue Muirhead's lavatory, hanging on a peg behind some coats.

I set out towards Cottesbrooke with the grooms Pauline and Debbie, and Harry, who is helping; the last two riding Sue's young horses. One of the pleasures of hunting is the joy that the horses take in it; but to young horses the unfamiliar sounds, the crowd of a hundred or so other horses, the hounds underfoot, the tension, the jostle need to be taken in small doses, under strict supervision. Today, Storm is acting as nanny to the excitable youngsters. He will show them that there is nothing to be frightened about, and no reason to misbehave.

There is fog all the way to the meet, and it never clears. For me, the most exciting part of the day is when at the meet my saddle slips and I slither off Storm. Otherwise I stick close to the four-year-old mare Diva, whose eyes stare out of her head at the number of other horses, every sinew in her young body taut. So we circle around on the outside of the meet, until Richard Spencer, the Master, announces that there will be a hunt breakfast afterwards, and we set off.

Because of the young horses, whose outing will take them only as far as the first cover – enough excitement for one day – we linger at the back of the hunt, where it is quietest. We do not realise that it has divided, with the rear half diverting to a hillside that is out of earshot of any action for hours. The hill is also out of sight of it, but that is not surprising because of the fog. We stand around, viewing each other as though through heavy veils of net curtain. Desperate for any clue as to the whereabouts of the hunt, experienced types say: 'Here they come. I saw two pheasants fly up from that hedge.' We strain our ears for the sound of hounds or horn. Even Storm begins to lose patience from want of activity.

Eventually, the hunt comes breaking through the hedge at the bottom of our hill, having not achieved a great deal. Then we set off, thundering around the broad headlands around the fields and up grass-covered hills. I know Cottesbrooke from many, many rides, but it is all unfamiliar in its dress of white tulle.

As I leave, the hunt is cantering across bumpy fields, and I hear Dick Payne, the hunt secretary, saying: 'Master, we seem to have one, no two, people on the floor.'

I hack back to Naseby, and return to Cottesbrooke village hall at eleven o'clock. Cottesbrooke is a manicured stone village, with perfect lawns in front of the cottages, but the village hall is no more than a wooden hut with a loyal picture of HM the Queen as the only decoration. It is a splendid scene. There are lines of metal trays, whose lids are lifted to reveal quantities of food. There is cooking bacon on slabs. There are huge teapots and urns. There is a mixture of people sitting at trestle tables, laughing and sharing a common purpose. It is a breakfast fit for warriors, a grand

celebration of England. Julie Connell comes round collecting for the Two Hundred Club, with tickets at £17 for hunt funds. I eat a breakfast of sausage, egg, fried bread, kidneys, bacon, tomato, beans, mushrooms, enormous rolls, with buck's fizz and coffee. I sit next to David Bletsoe-Brown who explains the resentment of hauliers. It isn't just that diesel tax is higher in Britain than the rest of Europe, but the insurance of vehicles – costing £140,000 for his company – has gone up by 40 per cent this year. The union of farmers and hauliers during the blockades was not so strange because the lorry drivers are often country people, and I myself have met farmers who have turned to lorry driving to make up their income.

The hall is still half full when I leave about noon. I cannot tarry, though, or I shall not get to Twywell for our steaks before F. E. Cole and Son shuts. Frank advises rump because it has hung that bit longer than the sirloin, and slices off a couple of steaks which he lovingly pats into shape with his knife. The steaks for the children he cuts horizontally to make them thinner. You don't get this from a supermarket shelf.

Naomi and the boys arrive at five o'clock. The estate agent's sign has come down from the Slum. 'I suppose some wretched person has bought it,' she mourns. Rupert Golby, the gardener, comes, and we drink mugs of tea in the garden, as the light goes. We consider trees. Even a pear (pears go straight up) would require a great sacrifice, looking nice from the square but casting too much shade over the garden. I suggest an espaliered pear on the wall. I shall ask John, the gardener, to remake the trellis in a rustic style, from hazel poles.

It is too late to cook the steaks for the boys but ours, consumed after they have gone to sleep, are sublime.

Lotus eaters

Sunday October 1

There are no bells, and when I walk across to the church, it is padlocked. Since Naomi is still asleep, William and Johnny are doing feet printing in black paint, and I am already ten minutes late; I feel a guilty pleasure at this. I wonder if the clocks have changed. Later, Naomi goes out to buy the papers, and comes back with the intelligence that there will be a harvest festival supper at 5.30 p.m. in the village hall.

We eat our lunch outside – yes, on October 1. Not that it is particularly warm.

In the middle of the afternoon, the church bells peal out for the harvest festival service which is being held at four o'clock as I now know. But we have already made up our minds to visit a garden in Bulwick, which is near Deene. This is something of an irony since the garden belongs to a rectory.

The boys are fast asleep in their car seats by the time we arrive. We park by the church and decide to visit it until the boys wake up. A purposeful lady in a faded red sweatshirt and with flying grey hair strides past, obviously the vicar's wife. She is letting an infirm woman in by the vestry door. Inside, there is a good Elizabethan monument on the wall, and a touching line of tomatoes, sweetcorn, large potatoes and apples along the window ledges and on the pulpit. They are demonstrably home-grown – a true harvest. We manage to persuade the boys out of the car and on to my shoulders or into the pushchair, and we enter the garden of what must be one of the last proper rectories in England. The rectory I remember from childhood was like this, a big, interesting

house, with bees and vegetables in the large garden, the whole being rather too much for a family on a clerical income to manage. This garden is managed substantially on organic principles, which could mean, to those who don't understand these things, it is full of weeds. But ignore the weeds, feel the spirituality. This is a garden of love and sacrifice, home values and the Church of England.

At the gate, a pretty, shy girl with blonde hair and blue fingernails, obviously the vicar's daughter, sells honey and plants. People are walking past with plastic bags full of apples.

The first thing to do is to chase a chicken, in an attempt to stop the boys complaining. This takes us through a yew hedge and into a space with a stone gazebo, which has an upper floor reached by a rickety ladder. Once the boys have seen this they are happy, while we are condemned to stand at the bottom of the ladder as they climb up and down. From the viewing platform comes the voice of a man explaining the values of astrology, using Tony Blair as an example. The young woman with him accepts that, since the stars were created by God, there could be something unfathomable in it. Her father proclaims himself to be another vicar by wearing a combination of pinstriped trousers, blouson and deer-stalker hat.

The gazebo looks down over untidy yew hedges and apple trees. There are lots of different varieties, identified by scribbled writing on pieces of cardboard attached to branches by string. Waiting for the boys to stop climbing the ladder and the astrologer to stop talking, we look at the piece of paper given to us when we paid our £1.50 admission. The garden can be interpreted as an allegory of life. '1. Start at the dovecot. This may be taken as the cave of birth. 2. Turn right through the little gate on to the long lawn. Here is a place for the pre-school child to play. 3. When you are ready, turn left under the arch in the yew hedge. Now living becomes more serious. 4. On the right is the tree of learning. Climb the steps of ascent to acquire skills and a viewpoint. 5. Now with adolescence there enters choice and variety. Judgement must be exercised. The path divides, but perhaps a person will need to work out how he can divide his time between the two. Turn

right and you will come to a small rectangular enclosure that is hedged and protected with holly. Within is a table and chair. I call this variously a table of earthly delight to be protected against all comers, and a secure home.' And so it goes on, down to 12. 'I am sitting in the summit of earthly blessedness,' says Naomi.

After I fall down some steps carrying Johnny in the pushchair, we meet the vicar himself, in dog collar and Husky. A figure from an age before male vanity and beauty products, wisps of white hair protrude from his ears, nose and collar, as well as his head, and he has funny teeth. He tells us he will be retiring soon. And so the Church of England will want to sell the vicarage, and perhaps some rich man will come and put a swimming pool where all the symbolism is. The vicar is trying to encourage them to think of using the house for various spiritual purposes, other than the dwelling of a new vicar, for which it would be too big. He says that he used to do all the garden himself. Now he has a lady gardener to help him for an afternoon a week. He tell us that gardening fits in with the clerical life. 'It is a big house and we do not heat it to excess. I find that an hour's gardening before lunch in the winter is a good way of warming up.' His wife does not garden; she keeps horses.

'What will you specialise in when you leave school?' asks the astrologer of the honey-selling daughter.

'Lotus eating,' the vicar's wife replies for her.

How splendid; oh thank you God for the human harvest You give us through Your Church of England. We leave with the bells crashing for the service, and the gardening rector heading – without so much as a change of trousers – for the church.

Sunday October 15

At church today, the Gospel is about the rich man going through the eye of the needle. So Giles asks for volunteers from the congregation to be the camel, with two humps, and others to act the wall; then the camel is piled up with imaginary bags of

carpet, spices, jewels, silks and so on. They have to be shed for him to get through the gate. I must say he is invigorating the congregation.

Monday October 16

It is raining. Downstairs, the parlour smells strongly of bonfires, and I wonder whether the thatch is smouldering, but it isn't. I find that my boots, which I had thought were clean, aren't, so I am late leaving for Naseby.

'Tighten your girth,' are Sue Muirhead's head groom Pauline's last words before I get into the lorry. Sue drives me all the way to Sywell, parking at the Aviator Hotel. By now it is only grey, and not raining. There are not more than a couple of dozen people out today. Storm has been turbocharged with a blood tonic and an injection and is on top form. It is so heavy going now. Not another wet winter, I hope.

We spend a long time on the edge of a kale field. Some people regard this as less than gripping, but I do not mind. I love to see the hounds leaping like dolphins above the wavy green leaves. It is a scene that could have come from a tapestry.

I tease David Bletsoe-Brown by wondering what it would be like with jets screaming overhead. The Bletsoe-Browns, who own the airfield, are hoping to put the runway down to tarmac.

At one point, Storm shies when a pigeon for some reason literally falls out of a tree. I ask one of the farmers what has happened to it and he says he doesn't know. We jump over a log and a couple of ditches. I want to give a point-to-point horse a lead through a hedge that is a bit tight and overhung with branches but nothing else to it, but Storm won't go. I just sit there kicking, waving my whip and swearing. While we wait above a valley filled with scrub, a brace of foxes is killed. They say it is a brace; of course, we saw nothing and only heard the horn. At about ten o'clock, I discover that Storm has lost a front shoe. We are on the only bit of tarmac around. Jane Spencer tries to persuade me to go on, saying I will have a couple of jumps

and the rest is grass. But I can't risk Sue hearing that I have jumped without a front shoe. So I ride back through a wood of purple leaves and red berries. The grey day has turned back into rain, and it runs off the rim of my hat. But once I have found out that Storm's hoof is not badly worn away, and in any case he must have stood on the shoe, so it isn't really my fault, I feel what a wonderful thing it is to be out, when any sensible person who isn't hunting would stay inside.

I walk around the car park, waiting for Sue, with my jacket thrown over Storm's rear end. There are little light planes lined up beside the airfield. Someone else's folly, and just as expensive as hunting, I remind myself.

At home, I realise that the bonfire smell in the parlour comes from the damp logs that we collected from Cambridge yesterday. Fortunately, the mouldiest, most mushroom-covered are in the shed.

Tuesday October 17

The Environment Agency has published its flood relief plans for Geddington. This is another triumph for the campaigners. The proposal is to make a shallow cut along the side of the park, otherwise the playground. The Ise makes a sharp turn after the bridge, and the cut will short-circuit it, when the water rises high enough. At other times, which is to say generally, it will be dry. The saplings along the banks of the river will have to be cut down, but they'll grow up again; and a few smallish trees will be sacrificed. But there will be more trees and landscaping to replace them, and since the cut is only three feet deep, the result could, in a few years, be more pleasing than now.

Friday October 20

A nice man from the council phones to say that the reason the rubbish bin outside our cottage hasn't been emptied for weeks,

despite various offerings of dog's poo being among the contents, is that the lock has been vandalised. Who would vandalise the lock to a rubbish bin?

Saturday October 21

The hunt meets at Aldford Thorns. Someone says the antis will be out today. There will be eight of them, and eight policemen. Storm and I mill around the field where the meet is, and after a while they turn up. They wear combat gear, woolly hats and hiking boots. Probably the antis increase our sport, since we try to outmanoeuvre them. At one point, I am on the edge of a field and Peter Jones, the huntsman, goes by. I ask if they are putting the hounds off, and he says not at all. There is delight when we go through a gateway, deep with mud, and a female anti is seen picking her way around the outside, not wanting to get her shoes muddy. It is hard work being an anti. They run to keep up with the horses, and often across ploughed fields. I'm afraid it is even harder work for the police who follow them, because they do not know so many short cuts. This means they have to run further. Polly Spencer doesn't think much of the antis' horn blowing. Nor do their guttural, Jonesified cries of 'Leave it' and 'Get your heads up' deceive more than a couple of foolish hounds.

'Forty or fifty years ago, the police would have given them a good thumping. Not that you had antis then. Just any layabout they found, they would have got into a doorway and thumped.' The old ways, thought the old gentleman who said this, were the best. I think the same person said exactly the same thing the last time the antis were out.

It is very up and down here, and it is unlike anywhere else. There are very steep banks, and then a gallop up the other side. We hack home, along the Market Harborough road, passing Edward Fitzgerald's monument to the Battle of Naseby. Two hundred yards to either side the council have erected big brown signs to alert motorists both to the monument and the existence of a parking bay. This, on a quiet country lane, for a monument

that hardly anyone visits. They want to iron the poetry out of life, the people who put up such signs.

Coming back into Geddington, I see that the old camper van on the A43, which was removed after a horrendous accident, has been replaced by a new one. It is still illegally parked. Presumably the insurance has paid out.

Sunday October 22

I just don't believe it. Someone, I won't say who, has posted a circular through the door campaigning against the flood relief measures, on the grounds that they will inflict a scar on our beautiful park. After the last flood, one family had to live in a hotel for six months until their house was dried out, cleaned and disinfected. The loss of amenity to the park is nothing by comparison. And besides, I don't think there will be a loss.

When I go out to the post, Peter Spence is walking past with his dogs. 'Someone asked me to go to the end of the lane where there are mushrooms, and say what they are. There usually are mushrooms under the oak tree there. I found thirty of them, great big things.' He holds his hands apart, forming a soup plate. 'But they are totally sodden with rain, so they are useless.'

Naomi says that the new baby was conceived at Geddington, which makes the name easy. Eleanor if it is a girl. If it is a boy, Storm.

Monday October 23

It is half term and Naomi, the boys and I have just arrived in Barbados. I am arduously researching the fashion for serious house-building which, for better or worse, is turning this former colony into England's equivalent of the Hamptons. There will be an article in *Country Life*.

The man who is credited with starting the era of glamorous home-making on the now ultra-fashionable west coast – the

so-called Platinum Coast – is Sir Ronald Tree. In 1947 or so, he built the house called Heron's Bay, to the designs of Geoffrey Jellicoe, and attracted lots of friends from both sides of the Atlantic to join him. He also founded the Barbados National Trust.

Tree was by birth an American who was brought up in England and preferred living there to the United States. His mother was a Field, as in the Marshall Field department store, so he was rich. His first wife was a Virginian called Nancy. She lived for riding – particularly hunting – and he loved her so much that he agreed to live in Virginia. He had nothing to do, and got pretty bored. Then she had a riding fall and broke her back. This meant she had to spend six months lying down. He got even more bored, and the Trees decided to put down new roots in England. Ronald's ambition was to get into politics, and he took soundings from his English friends about what to do. They said he should become Master of the Pytchley Hunt. That way he would meet everyone of influence in the shires and beyond. So Nancy and Ronnie, as they were known, rented Kelmarsh Hall, and hob-nobbed with royalty.

When Nancy was frightened by the size of the hedges, she comforted herself by the sight of so many old men with long beards and ancient ladies 'going very well and riding frightfully short'. Some of those old people were astonished by the Trees' 'extravagance and dash.' As one of them said: 'The Pytchley was an old-fashioned country and some of us had never seen anything like it.' Nancy did not leave any detail to chance. 'You had to be very particular with your veil,' she remembered. 'I used to sit in front of my mirror for an hour stripped stark naked fixing my hat and veil until I got it right.' That was in the 1920s when hunting really was hunting, and the Pytchley was tops.

Tree was not much of a success in the House of Commons. He was barely able to get a word out when he faced his first party meeting at Lutterworth. But during the Second World War, having bought Ditchley Park, the Trees hosted Churchill and the Cabinet war machine. They came whenever the moon was bright, which would have enabled German bombers to identify

Chequers. Soon after the war, Nancy and Ronald divorced. She married a Major Lancaster, and as Nancy Lancaster acquired the decorating firm of Colefax and Fowler. She and John Fowler were the greatest influence on the look of English country houses for three decades. It must owe something to Nancy's visual flair that the garden at Kelmarsh, which became her sister-in-law's home, is so wonderful for us to visit. Ronald withdrew to Barbados every winter, invigorated by the contrast that the climate made with that of the 'flying countries' around Market Harborough and the end of any need to make political speeches there.

The reach of association made by Midway Cottage has no limit. There is no escape from it, Naomi might say. The long shadow that falls upon the fleshy-leaved, purple ground cover in the flower beds here could come from a cabbage palm or tamarind tree, but it is really cast by the Eleanor Cross.

EPILOGUE

Queen Eleanor smiles

The twenty-third of October marked the end of our first year at Geddington. Queen Eleanor, looking down through the crust of ages that veils her three pairs of eyes, may not have thought it was much of a year. It could hardly be said that the heart of England missed a beat. After 700 years on her cross, she must have witnessed some that were more eventful – years, at least, when the Ise rose and, for a few days, the inhabitants of this village in the middle of England found themselves unexpectedly in Venice. But it was a big year for us.

One winter's day I walk into the Star and find that the old shabbiness has been dispelled. They have painted the walls, put a couple of sofas into the eating area, and laid a new carpet, thereby removing the need for the tape over which one used to trip when collecting drinks from the bar. With the new decoration has come a new chef, and it is getting difficult to make a reservation on popular evenings: he is that good. That has not been the only change in these parts. On the other side of the square, the borough council have finally chopped down one of the trees against which my neighbour Anthony Griffin has been waging a war, and the lower branches of another tree have been lopped off, opening up the view of the church. 'It took us five years to do it,' Anthony comments after the victory. Traffic on the A43 slows to below 30 mph in front of the speed cameras. There is even talk that the Action Group will notch up another triumph by getting their by-pass.

When I step out from the Star into the thin sunshine of the afternoon, I almost fall over Jerry Lee, the chairman of the parish council, who is inspecting potholes with council workers

from Kettering. Work on the bund to relieve the Ise in times of spate is scheduled to begin today. Soon a pair of enormous yellow JCBs are moving up and down the edge of the recreation field in a kind of courtship dance. Rolls of mud ooze out of their caterpillar tracks in a sticky brown dough. This is another muddy winter. The digging of the channel, which temporarily converts a broad swathe of the Geddington recreation field into a mudscape, sets the seal on it. But the grass will soon grow, and we hope that the trees have been protected by the guy ropes that have been keeping them up while work proceeds.

Floods may have become a thing of the past. As though in anticipation, the proprietors of the Star have already taken down the photographs of the great Geddington floods of the 1950s, replacing these doom-laden images of English stoicism with blander, less apocalyptic flower paintings. Before the flood relief was in place, the Ise did manage to fit in one last – we hope it was the last – swirling fandango. With such a November of unprecedented and relentless rain, coming on the heels of a year during which it had rained more than anyone could remember, it would have been plain unreasonable if it had not flooded then, and it did. It didn't flood when, looking at television pictures of floods in Kent, Herefordshire and York, we all thought it would, nor the first time that an emergency flood warning was issued, nor the second. The brook flirted with the idea for several days before doing anything about it.

The precise conditions which caused the floods two years ago did not recur. Then, rain had deluged on to the high ground of Geddington Chase, turning the road running down from it into a stream, which rushed into the brook which had already become a bloated and overburdened river. This time, while rain seemed to be falling continually everywhere, Geddington Chase remained relatively dry. The flood, when it came, was large enough for my neighbour to be shown on the front page of the local paper in a boat, floating on what would normally have been the road approach to the ford; but it stopped within an inch of Burwells, and a long way from our cottage.

The Geddington Volunteer Fire Brigade had been busy filling

sandbags. Often, sandbags are more an expression of hope, a gesture of sympathy, than a practical defence against water, which has a habit of going over the top of them. This time they did a good job. Not a perfect job, since water did get into a few houses. But the working of bilge pumps meant that it did not rise to more than a couple of inches, and it was fairly clean water, having been filtered by the sandbags; the really unpleasant filth was kept out. On this occasion Geddington dried out, and gave itself over to contemplating the mysteries of the British climate, whose idiosyncrasies are now but a subsection of the greater mystery of the greenhouse effect.

'There is no such thing as a bad day's hunting,' says my friend Paul Hopwell. There can, however, be extremely wet days, and we have a lot of those. The opening meet is wetter even than the previous year. Then just to prove that Surtees's adage about hunting before Christmas is true, even in the age of global climate change, we have something we had almost forgotten about – snow. The boys toboggan down the little slope of Church Hill, opposite the cottage, as though it were the Cresta Run. Hunting stops and then it starts again. It ends for good when foot and mouth disease descends like a plague, not quite on a par with the Black Death which wiped out Geddington in the fourteenth century but bad enough to close the countryside down.

Psychologically, everyone must be affected. Fields that would normally be packed with sheep and lambs are now empty. The view along the great avenue towards Boughton House looks forlorn. One day, after visiting a sale in the Aquascutum factory in Corby, we drive to Oakham, and Naomi mourns the deserted look of the countryside. Cottesbrooke Hall has been given the Garden of the Year award by Christie's, but I can no longer ride over the estate because it is closed.

Even so, Northamptonshire has been lucky. In Cumbria, the pyres built to burn thousands of animal carcasses smoulder for weeks. It is as though Cumbria has just been sacked by an army from the Thirty Years' War. Throughout Britain, farmers put down straw doused with disinfectant in their gateways, which –

not being very effective as a method of killing the foot and mouth virus – serves in the manner of a talisman against the disease. In Scotland, the epicentre of the outbreak is Lord Dalkeith's Langholme Estate.

On 22 February there is a market at Northampton, and some sheep infected with foot and mouth pass through it. (This, incidentally, is after the European Union has banned the export of animals from Britain. The market authorities had phoned the Ministry of Agriculture to see if it ought to take place, and were told it should.) About a month afterwards, ministry officials start trying to trace the animals that went there. They could have come from anywhere. Strangely, we learn it is routine for animals in Britain to be transported hundreds of miles, as part of a food system that has mostly lost any sense of local identity. My friends in the Star remember the days when every town in Northamptonshire had its livestock market, even Corby. 'At Kettering, it was better still. The beasts were walked round to the abattoir at the back as soon as they had been sold.' There is still a Sheep Street in Kettering; it was not so long ago that flocks of sheep were driven into town, to be sold. But that was before farming changed, and villages like Geddington changed with it.

Because, of course, Geddington isn't a farming village any more. It is a village of people, who are not generally attached to the immemorial hierarchy of the hunt, but have invented new structures, with just as much ritual, such as the Volunteer Fire Brigade. It is a village of consumers, taking their bootloads of packaging to the Dump, who will soon be as remote from the farm land that surrounds them as the butterflies on Grand Canary are from the sea. It is a village, like most other English villages, which has developed a whole calendar of fairs and flower shows to assert its identity. It is a village that is now having to do without Burwells, the club that had already grown into being an institution when we arrived, but closed and was put up for sale when the owners' marriage fell apart. It is a village of old people, newcomers, teenagers, of nurses, steel workers and businessmen, part of whose life is lived out in the triangle that could just about be called a square that encases the cross. With bowed head, Queen

Eleanor may reflect on the strangeness of the evolution she has witnessed; an evolution of which we are all part, contributing our own ounce of human experience to the sum compounded in the village.

And so it is that one pair of her stone eyes can hardly avoid resting on the row of stones that poke up like jagged teeth on top of the old wall in front of her, unattractively revealed when the mat of woody clematis that used to hide them was torn down by the new owners. Now, she may just be able to spot the sappy green shoots of new roses – Paul's Himalayan Musk and Sanders White – pushing between the dentition, while on sunny days a new born baby (who narrowly avoided being called Emanuel, from his birthday just before Christmas) gazes up at the clouds moving across the sky. Sometimes they look like horses, and sometimes like foxes, and sometimes like the sheets of polystyrene that the washing machine came in, but he is too young to know that yet.

I like to think Queen Eleanor smiles.

Credits

Extracts from *The History of the Althorp and Pytchley Hunt* by Thomas Guy Frederick Paget reproduced by kind permission of HarperCollins*Publishers*

Extract from *In the Heart of the Country* by H E Bates reproduced by kind permission of Laurence Pollinger Ltd and the Estate of H. E. Bates

Extract from *Old Kettering and its Defenders* by Tony Ireson (Kettering T Ireson, 1984) reproduced by kind permission of Tony Ireson

Extract from the recorded memories of Andrew Kyle taken from manuscripts of reminiscences of Geddington in 1900. Reproduced by permission of Northamptonshire Records Office.